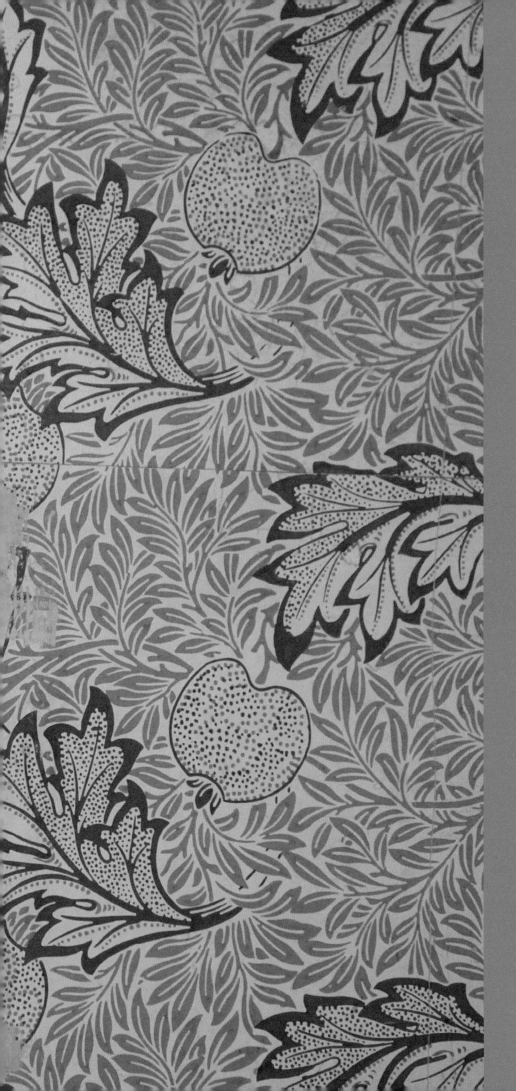

W9-CJC-192

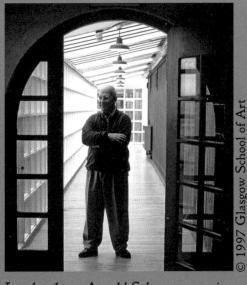

London-born Arnold Schwartzman is a renowned graphic designer and the recipient of the Academy Award® as producer and director of the feature documentary "Genocide" (1981). He is the author of a number of books on the subject of 19th and 20th century architecture.

In 1982, he was appointed the Director of Design for the 1984 Los Angeles Olympic Games.

Among his recent design projects are two murals for Cunard's "MS Queen Elizabeth", and the U.N. Peace Bell Monument, Seoul, South Korea.

In 2002, Schwartzman was appointed an Officer of the Order of the British Empire (OBE), and in 2006 was conferred the distinction of Royal Designer (RDI) by the Royal Society of Arts.

Arnold lives in Los Angeles, and works in collaboration with his wife, Isolde.

Cover:
Staircase, entrance hall,
The Gamble House, 1908-09,
4 Westmoreland Place,
Pasadena,
California, USA.
Architects:
Greene & Greene.

Endpapers:
Wallpaper,
Red House, 1859-60,
Bexleyheath,
London, UK.
Designer:
William Morris.

ARTS & CRAFTS

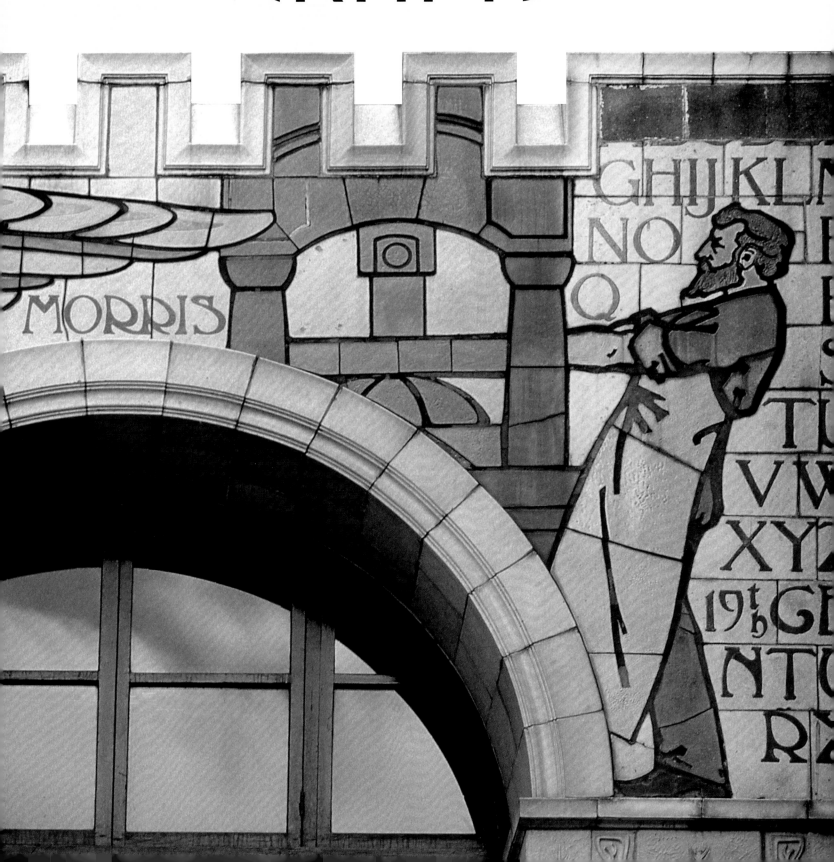

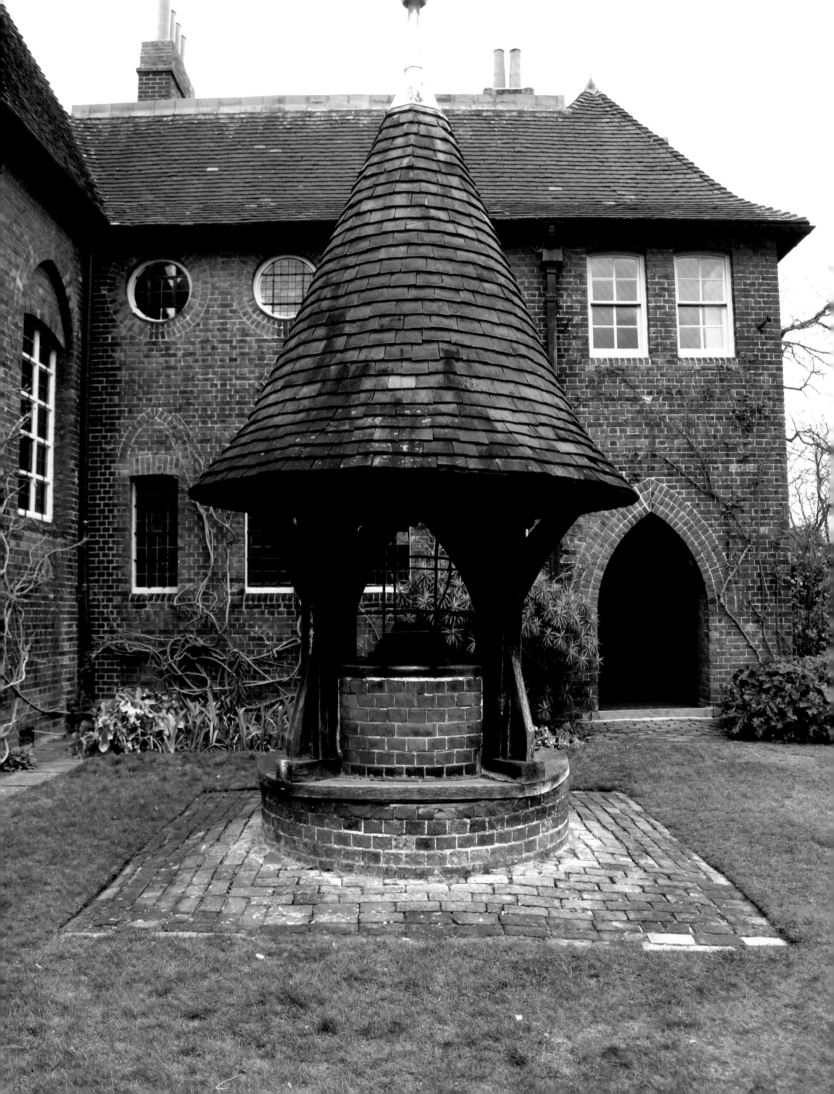

ARTS & CRAFTS

From William Morris to Frank Lloyd Wright

Arnold Schwartzman

PALAZZO

Dedicated to my wife, Isolde. My cup runneth over for her unwavering dedication to the production of this book.

Above:
"Isolde",
stained-glass window,
1902.
Glasgow School of Art,
167 Renfrew Street,
Glasgow, Scotland, UK.
Artist: D.C. Smyth.

Half title:
Carrera marble tile facade,
the former
Edward Everard's
printing works, 1900,
37-38 Broad Street,
Bristol, UK.
Ceramics:
William James Neatby.

Title page:
Red House, 1859-60,
Bexleyheath,
London, UK.
Architect:
Philip Webb.
Designer:
William Morris.

PALAZZO

This edition published in 2021 by
PALAZZO EDITIONS LTD
15 Church Road
London
SW13 9HE

www.palazzoeditions.com

A CIP catalogue record for this book is available from the British Library.

ISBN 978-178675-065-5

Printed and bound in China.

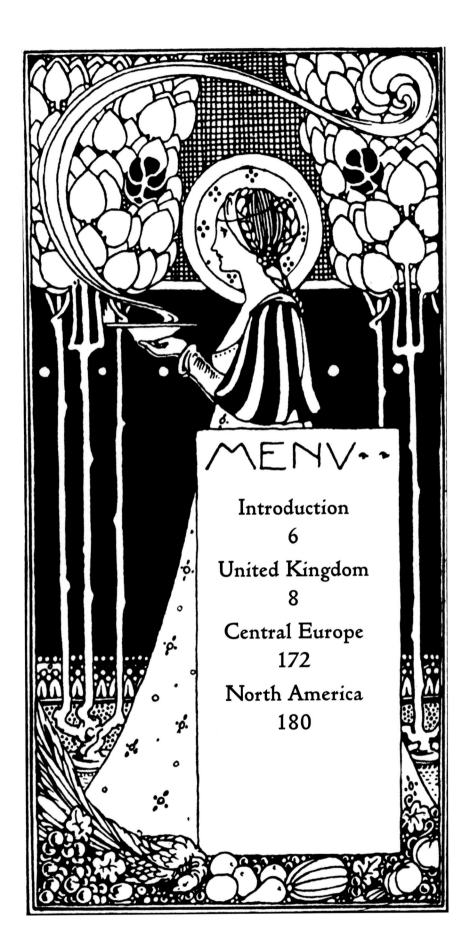

MENV ..

Menu,
Illustration,
"The Studio", 1899.
Artist:
Frank M. Jones.

Overleaf,
Introduction page:
Border,
"The Nature of Gothic",
Kelmscott Press, 1892.
Design: William Morris.

Introduction

We shall have had no Morris, no Street, no Shaw, no Webb, no Bodley, Rossetti, no Burne-Jones, no Crane, but for Pugin. — J. D. Sedding, 1888.

PARADISE LOST AND FOUND...

Due to the loss of our family home during the Blitz, my remaining time in my birthplace of London, England, was short-lived. After the war, my parents and I moved to the seaside town of Margate, Kent. ❦There I discovered that I was geographically placed between the homes and resting places of two of the 19th century's founding principals of our story: Dante Gabriel Rossetti, in the neighboring town of Birchington-on-Sea, and Augustus Pugin's "The Grange" was situated in the nearby town of Ramsgate. ❦There I enjoyed the occasional visits to pay homage to their love of "honest"craftsmanship. This experience allowed me to learn of the Pre-Raphaelite Brotherhood and of their romance with neo-Gothic revival. ❦In reaction to the mid-19th century's industrial revolution, a group of British artists, architects, sculptors, poets and critics banded together in 1848 to form a round table of like-minded craftsmen calling themselves the Pre-Raphaelite Brotherhood. Among the members of this "medieval court" were: William Holman Hunt, John Everett Millais and Dante Gabriel Rossetti. They, along with Rossetti's disciple, William Morris, turned their backs on the machine age's output of what they deemed to be inferior products. ❦The Brotherhood believed in a return to Arthurian times as a source of inspiration, embracing the Gothic forms of Britain's churches of yesteryear. ❦Calling for a return to "Camelot", these latterday Knights evoked "Merlin" of legendary times by magically waving their creative wands to enchant the slavish thinking of the establishment to reform. ❦Twenty years had passed before I returned to live in London and was able to enjoy the architectural riches of the city. You will discover within the pages of this book some of the finest examples of the capital's Arts & Crafts architecture movement supported by biographic profiles of some of the creators, including C.R. Ashbee, Charles Holden, W.R. Lethaby, Richard Shaw, C.H. Townsend, C.A. Voysey and Philip Webb, as well as sculptors Eric Gill, Gilbert Bayes, Sir Alfred Gilbert and Nathaniel Hitch. ❦I frequently had the opportunity to cross the English Channel where I discovered how these British craftmen's aesthetic and style spread and inspired the creative minds of the European countries. There I appreciated the architectural designs of the Vienna Secession, notably by Otto Wagner and Joseph Olbrich, and learnt that architect Charles Rennie Mackintosh much admired the work of Josef Hoffmann. He declared: "Our aim is to create an island of tranquility in our own

country, which, amid the joyful hum of arts and crafts, would be welcome to anyone who professes faith in Ruskin and Morris." Hoffmann, along with artists Koloman Moser and Gustav Klimt, were the founders of the Wiener Werkstätte (Vienna Workshop). ❡Inspired by Great Britain's Arts & Crafts societies, Craftsman groups sprung up in the United States, including The American Art Workers' Guild, The Arts & Crafts Society of Boston, Chicago, and Minneapolis. ❡Significant "Craftsman" practitioners included the brothers Greene & Greene, Bertram Goodhue, Myron Hunt, Gustav Stickley and Frank Lloyd Wright. ❡As well as adapting the neo-Gothic forms of architecture, they were inspired by past cultures, including Pre-Columbian, Colonial and Mission Revival. ❡A further twenty years later I was invited to work in Hollywood, California. "The Last of England", Ford Madox Brown's painting depicting immigrants leaving England to start a new life, sadly brought to mind that I was to lose my close connection to the architectural splendors of Great Britain. However, to my relief, I found myself surrounded by some of the world's greatest Craftsman architectural gems. In Los Angeles alone I found several buildings designed by Frank Lloyd Wright, and in close proximity in the city of Pasadena, the work of the brothers Greene & Greene masterpieces, such as their "Gamble House", as well as the city's sixteen-block "Bungalow Heaven", which is credited as America's greatest concentration of craftsman homes. I had indeed found myself now living in a craftsman's paradise! ❡These past forty years, I have frequently returned to the UK to document with my camera more of the numerous Arts & Crafts examples dotted around Great Britain. ❡Among my most favored structures is Rennie Mackintosh's Glasgow School of Art, where in 1997 I was invited to give a lecture to the school, however my brief visit to the school unfortunately provided me with little time for photography. ❡On a subsequent visit to the UK in the spring of 2018 I contacted the school, stating that I would be happy to give another lecture to their students, confessing that I had an ulterior motive: to undertake more photography of the school for this book. Their positive response was that they would be delighted for me to return, regrettably it was during the students' exam time, and so they would appreciate it if I could possibly leave my visit to a future date. Sadly, three weeks later the building was destroyed by a devastating fire. I'm most grateful to be able to provide the reader with at least the few images of the since-lost building that I was able to capture that time. ❡This experience highlighted the need to document and cherish our architectural heritage for future generations to appreciate the Arts & Crafts/Craftsman Movement that flourished in the United Kingdom, Europe and North America.

Arnold Schwartzman, Hollywood, 2021

The Grange, 1843/44,
adjoining
St Augustine's Church,
1845.
St Augustine Road,
Ramsgate, Kent, UK.
Architect:
Augustus Welby
Northmore Pugin.

**Augustus Welby
Northmore Pugin,**
1812/1852,
British architect,
designer and critic.
Other notable projects:
The Houses of Parliament,
Nottingham Cathedral.

UNITED KINGDOM

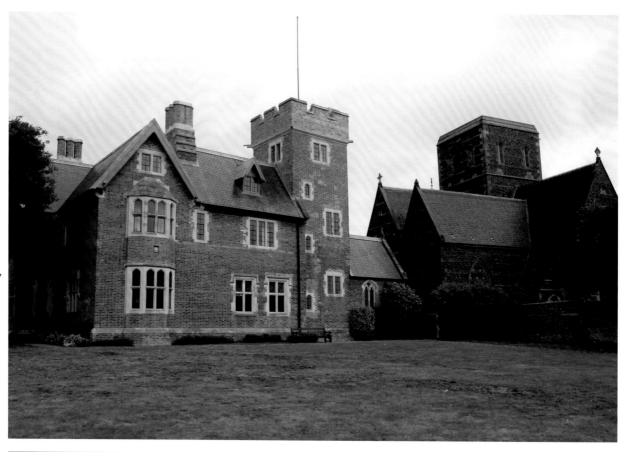

Metal gates,
St Augustine's Church,
1845.
St Augustine Road,
Ramsgate, Kent, UK.
Architect and Designer:
Augustus Welby
Northmore Pugin.

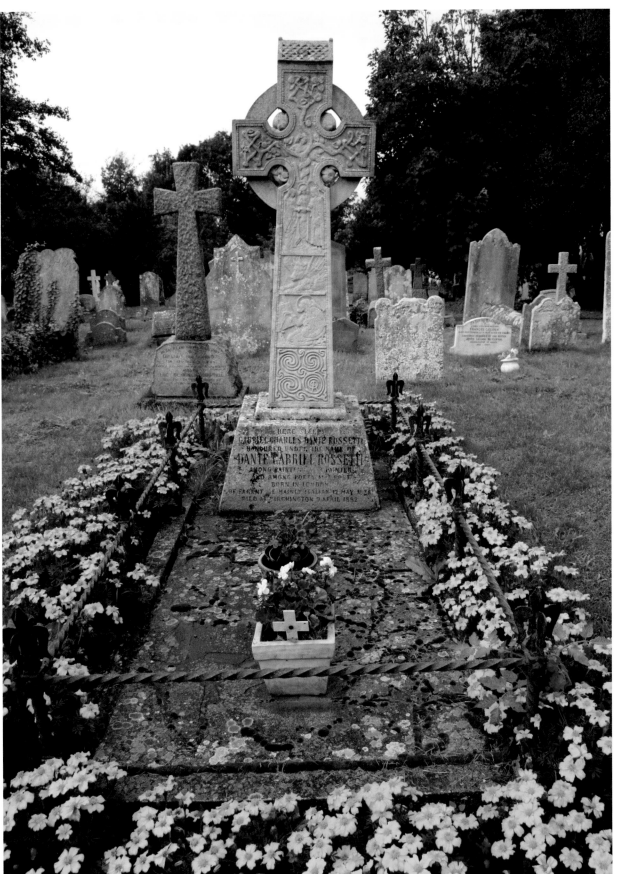

Gravestone of
Pre-Raphaelite poet
Gabriel Charles
Dante Rossetti,
All Saints Church,
Birchington-on-Sea,
Kent, UK.
Celtic cross designed by
Ford Madox Brown.

Dante Gabriel Rossetti,
1828-1882.
British poet, illustrator,
painter and translator.
Founder of the
Pre-Raphaelite Brotherhood.

Other notable work:
Paintings of scenes from
Shakespeare,
Robert Browning,
Dante,
Sir Thomas Malory's
"Le Morte D'Arthur" and
Alfred Lord Tennyson's
"Idylls of the King", set
in the medieval Arthurian
period. His wife
Elizabeth Siddal was
his often-used model.

"A Sonnet is a moment's
monument,—
Memorial from the
soul's eternity
To one dead
deathless hour."
—Dante Gabriel Rossetti.

Ford Madox Brown,
1821-1893.
British painter of moral
and historical subjects in
the Pre-Raphaelite style.

Notable paintings:
"Work",
"The Last of England"
and The Manchester Murals
for Manchester Town Hall.

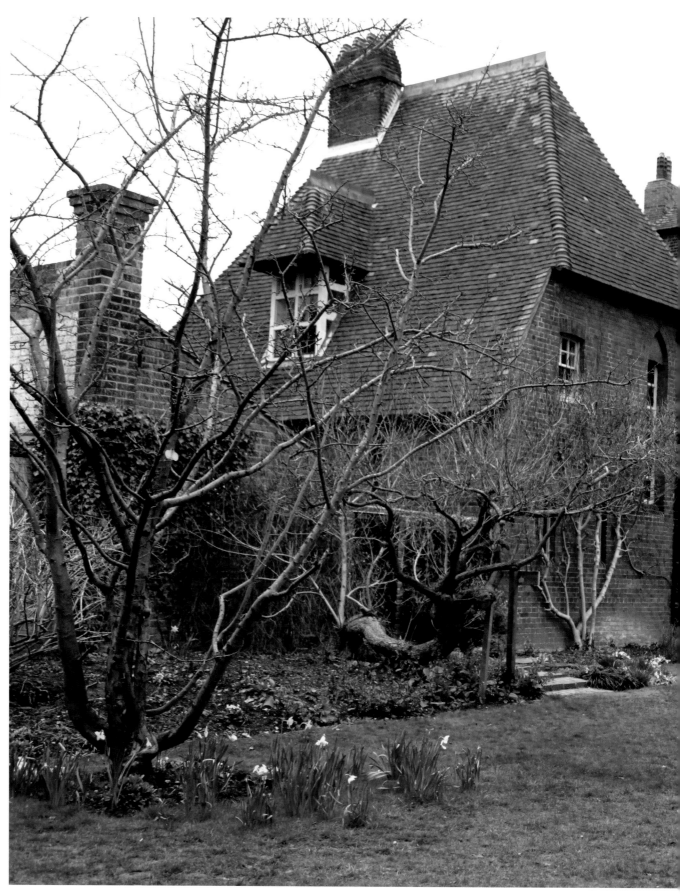

GREATER LONDON COUNCIL
RED HOUSE
built in 1859-60
by Philip Webb, architect,
for
WILLIAM MORRIS
poet and artist
who lived here
1860-1865

Red House, 1859-60,
Bexleyheath,
London, UK.
Architect:
Philip Webb.
Designer:
William Morris.

William Morris,
1834-1896.
British textile designer,
architect, poet, novelist,
translator, and socialist
activist. A founder of the
British Arts and Crafts
Movement and the
Society for the Protection
of Ancient Buildings.

Other notable works:
"Self-portrait",
"Strawberry Thief",
"La belle Iseult",
"The Worship of
the Shepherds",
"Acanthus",
"Windrush",
"David's Charge
to Solomon",
"Peacock and Dragon",
"Saint Cecilia"and
"The Vision of the
Holy Grail".

"Beauty...is a positive
necessary of life. "
—William Morris.

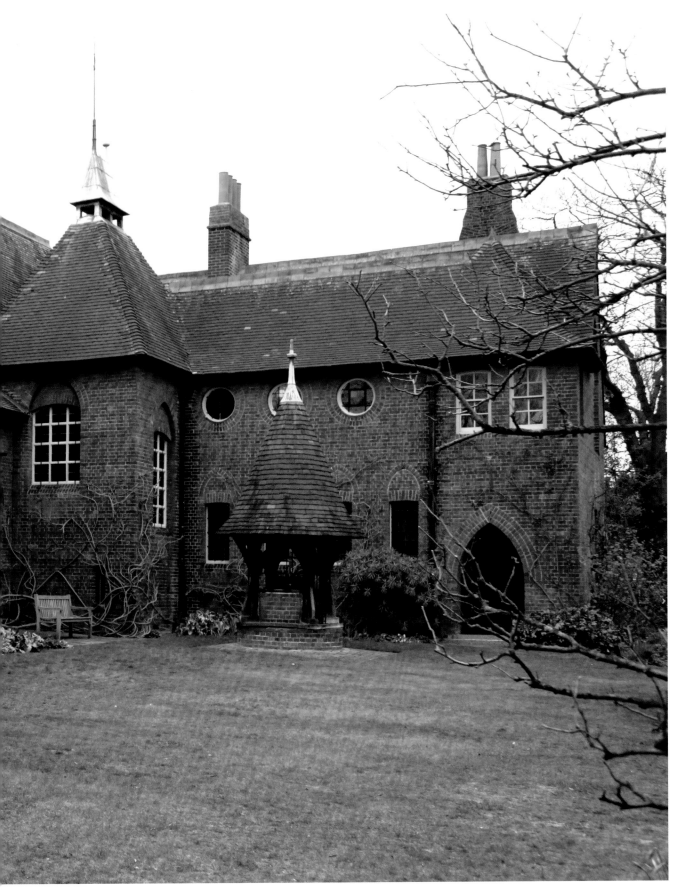

Philip Speakman Webb,
1831-1915.
British architect, and
designer of furniture,
wallpaper, tapestries
and stained-glass.

Other notable works:
Country houses, such as
"Clouds", Wiltshire, and
Standen, Sussex, UK.
Town houses include
1 Palace Green and
19 Lincoln's Inn Fields,
London, UK.

"The Red House, the
beautifullest house in
the world." — Burn Jones.

Detail,
"Nibelungenlied",
unfinished painted
panel,
settle-cum-dresser
designed by
Philip Webb,
Red House, 1859-60,
Bexleyheath,
London, UK.
Architect:
Philip Webb.
Artist:
William Morris.

"The past is not dead,
it is living in us, and
will be alive in the future
which we are now
helping to make."
— William Morris.

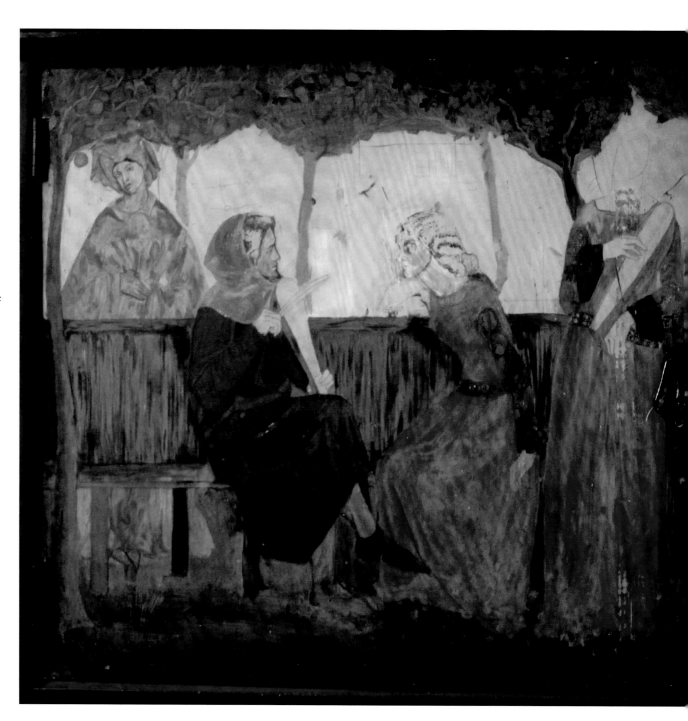

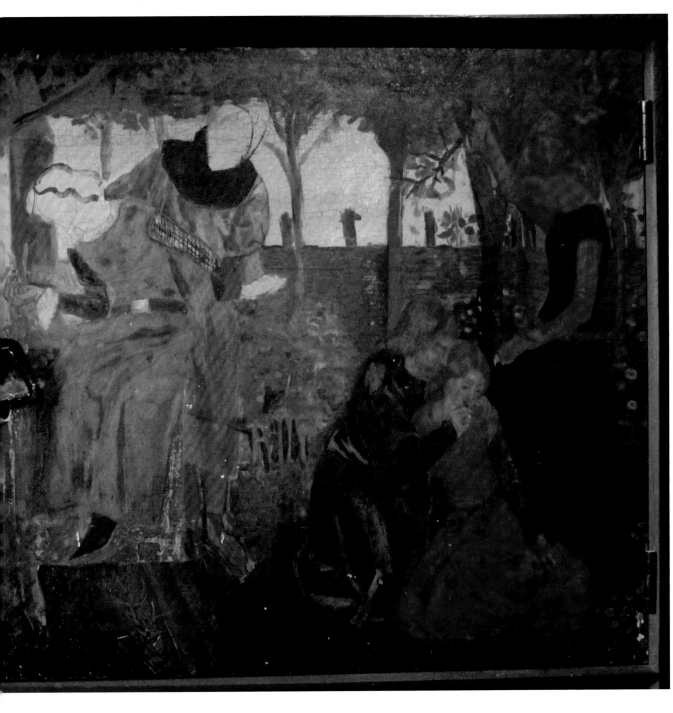

Above:
Portrait, 1870,
William Morris,
1834-1896.
Artist:
Charles Fairfax Murray.

Above:
Royal Mail stamp.

Right:
Red House, 1859-60,
Bexleyheath,
London, UK.
Architect:
Philip Webb.
Designer:
William Morris.

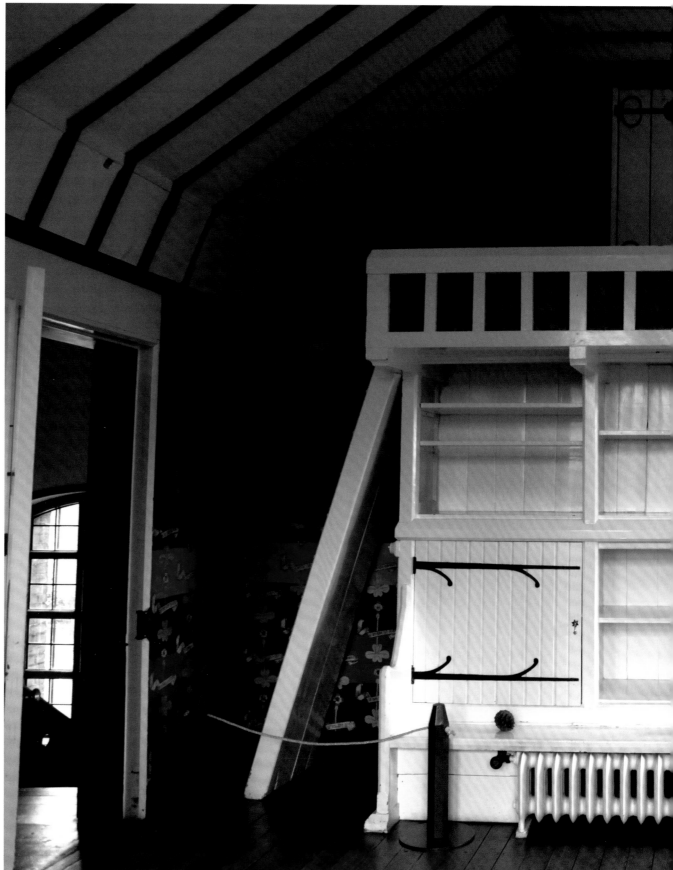

14

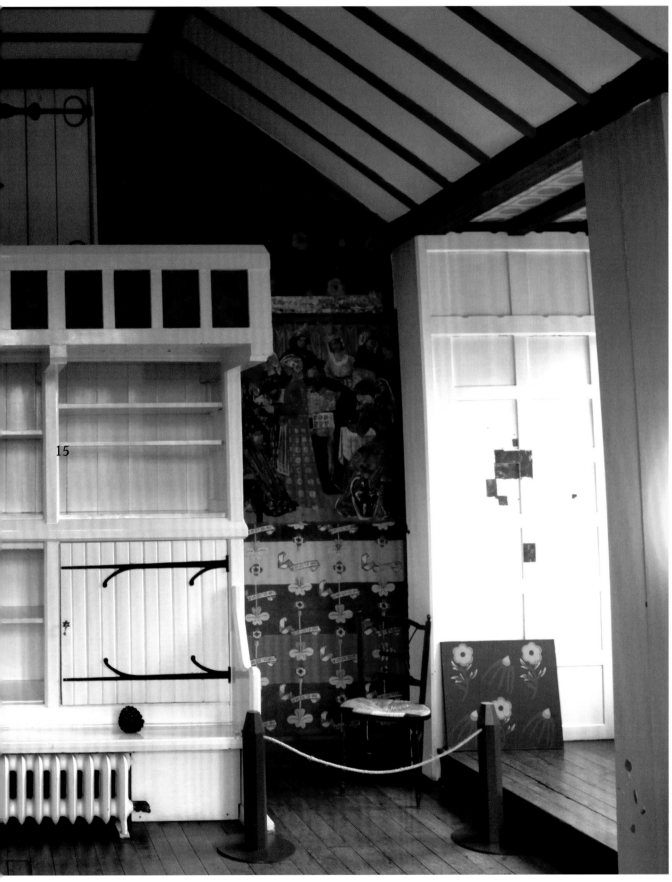

15

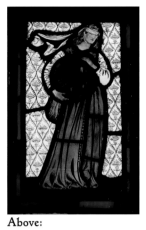

Above:
"Fate", St Catherine,
stained-glass window,
Red House, 1859-60,
Bexleyheath,
London, UK.
Designer:
Sir Edward Burne-Jones.

Red-brick living room
fireplace, painted with
Morris' motto:
"Ars Longa Vita Brevis",
(Life is short,
but art endures).
Red House, 1859-60,
Bexleyheath,
London, UK.
Architect:
Philip Webb.
Designer:
William Morris.

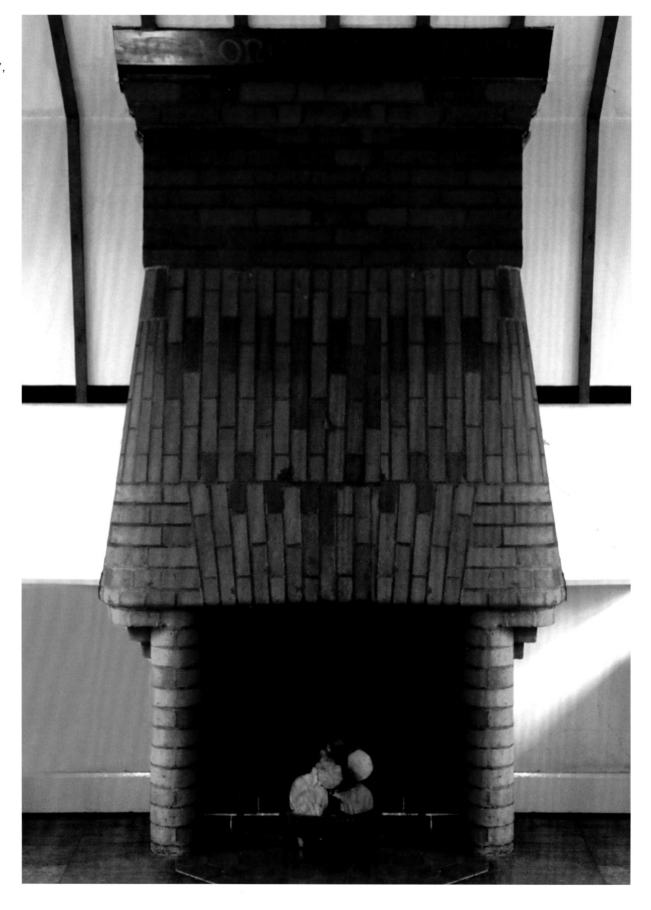

16

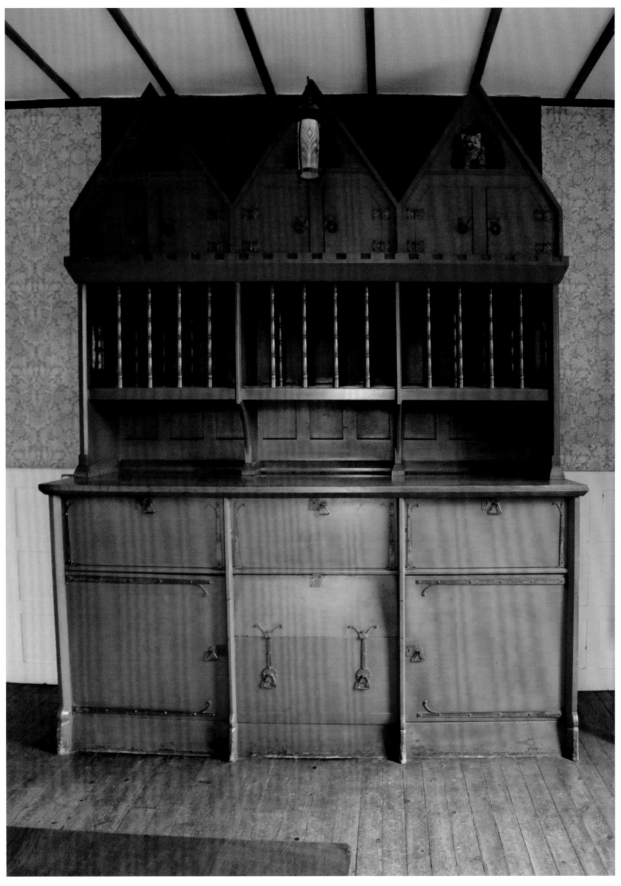

Kitchen hutch,
Red House, 1859-60,
Bexleyheath,
London, UK.
Architect:
Philip Webb.
Designer:
William Morris.

"Have nothing in your
house that you do not
know to be useful, or
believe to be beautiful."
—William Morris

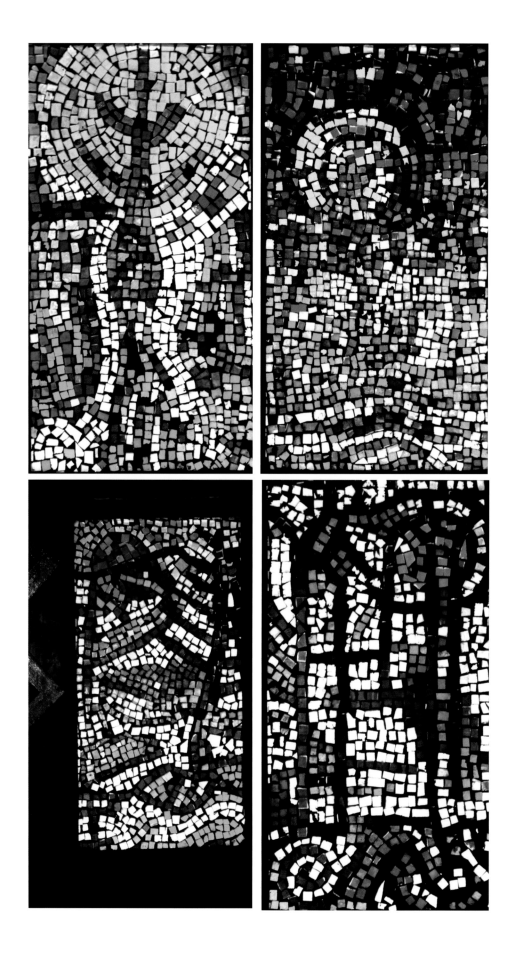

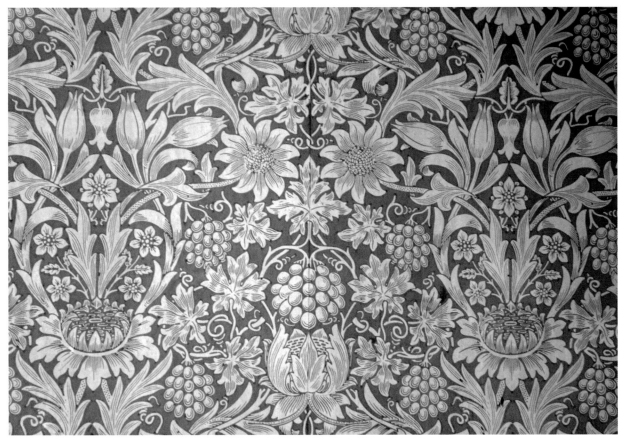

Above:
Royal Mail stamp.

Left:
A selection of wallpapers,
Red House, 1859-60,
Bexleyheath,
London, UK.
Designer:
William Morris.

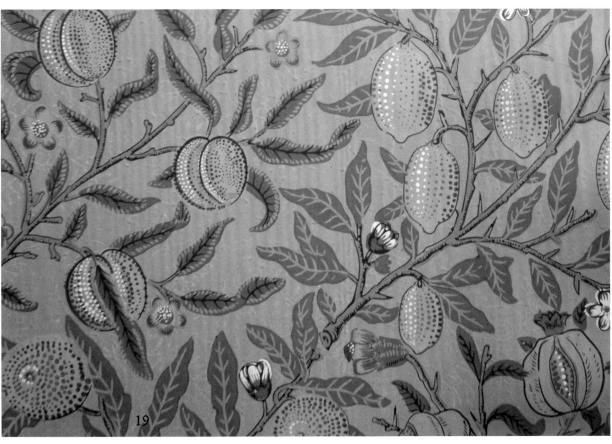

19

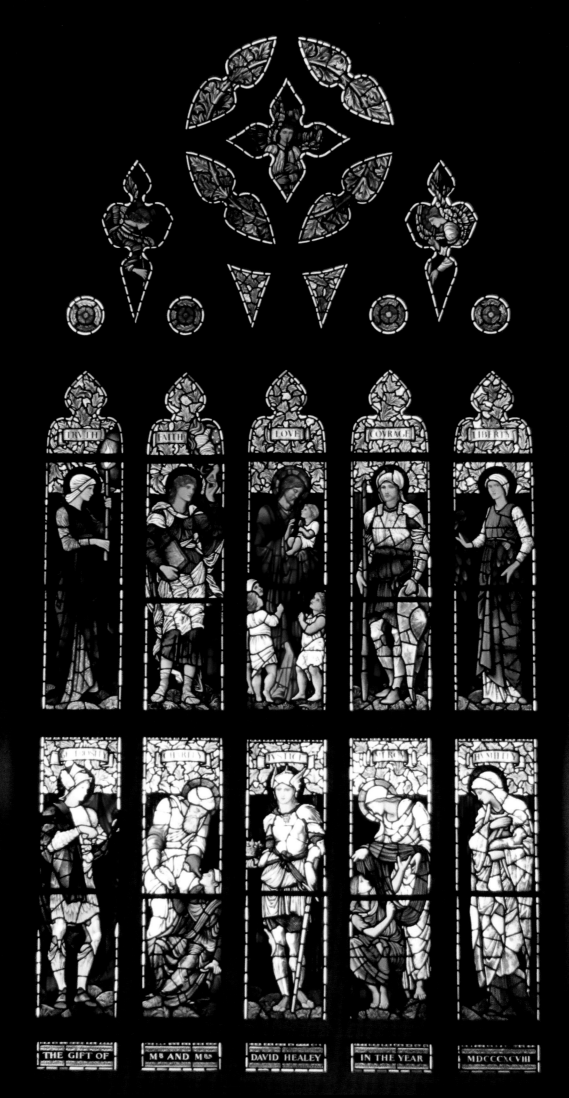

Chancel East window,
Bradford Church, 1864.
Bradford,
West Yorkshire, UK.
Collection of
The Huntington Library,
Art Collections, and
Botanical Gardens,
1151 Oxford Road,
San Marino,
California, USA.
Designers:
Dante Gabriel Rossetti,
Ford Madox Brown,
Sir Edward Burne-Jones,
Philip Webb.
Maker:
Morris and Company.

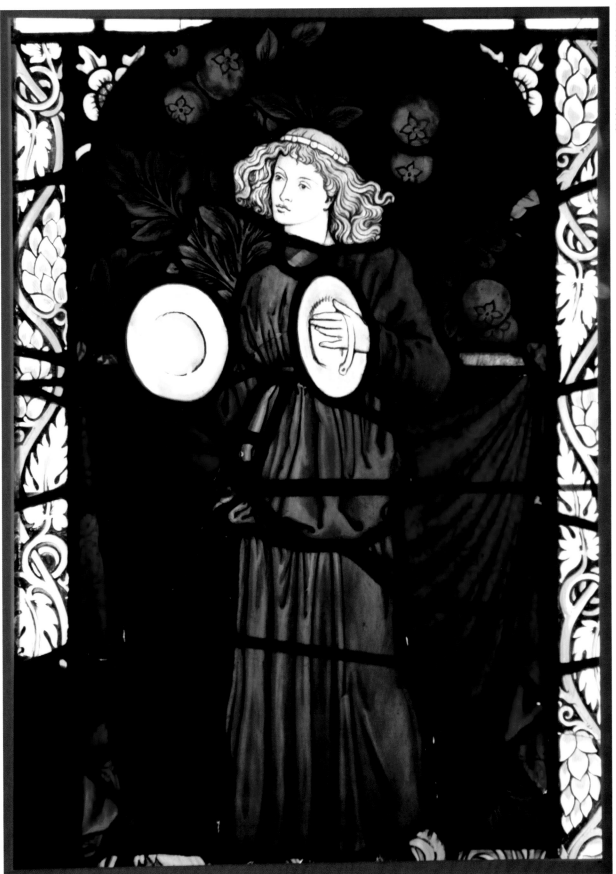

£1.10

Edward Burne-Jones c.1864

Above:
Royal Mail stamp.

Left:
Angel with cymbals, 1868,
stained-glass window,
William Morris Gallery,
Lloyd Park, Forest Road,
Walthamstow, London, UK.
Artist:
Edward Burne-Jones.

**Sir Edward Coley
Burne-Jones,** 1st Baronet ARA,
1833-1898. British artist and
designer associated with the
phase of the Pre-Raphaelite
movement. He worked with
William Morris on decorative
arts as a founding partner
in Morris, Marshall,
Faulkner & Co.
Burne-Jones was involved
in the rejuvenation of the
tradition of stained-glass art
in Britain.
Burne-Jones's early
paintings show the
inspiration of
Dante Gabriel Rossetti,
but by the 1860s
Burne-Jones was discovering
his own artistic "voice".

Other notable windows:
St Philip's Cathedral,
Birmingham, UK.
Holy Trinity Church,
Sloane Square, Chelsea,
London, UK.
St Michael's Church,
Brighton, UK.
All Saints, Cambridge, UK.
St Edmund Hall and
Christ Church, University
of Oxford, Oxford, UK.

Facade,
Glasgow School of Art,
1896,
167 Renfrew Street,
Glasgow, Scotland, UK.
Architect:
Charles Rennie
Mackintosh.

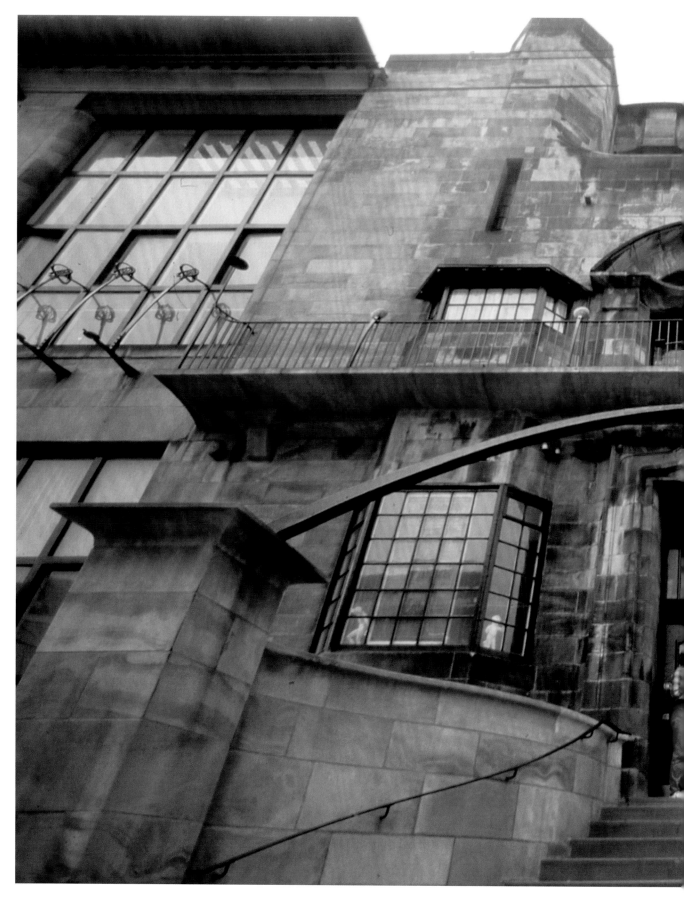

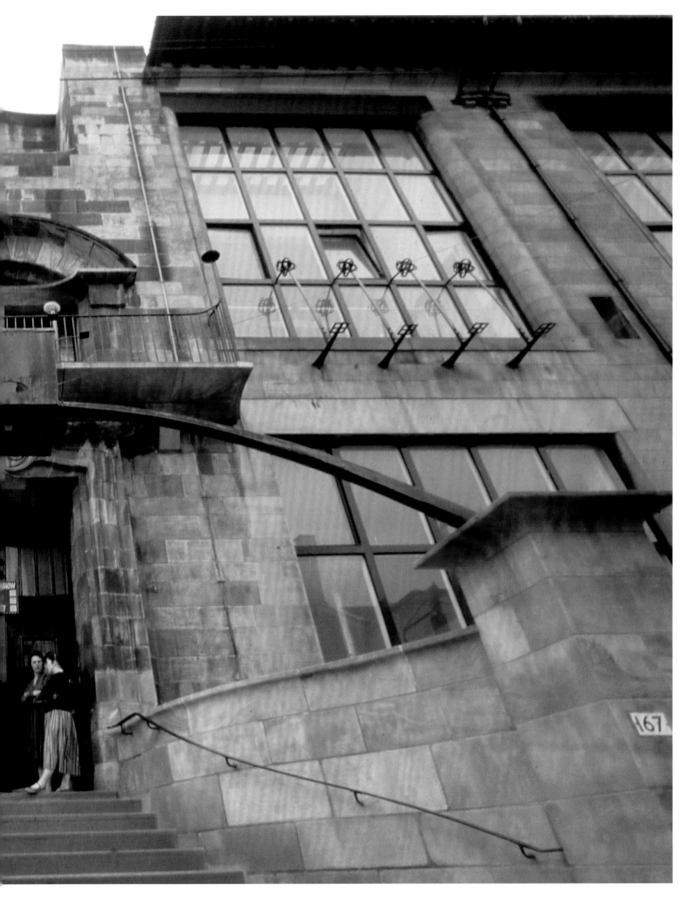

Above:
Royal Mail stamp,
The School of Art,
Glasgow, UK.

Charles Rennie Mackintosh,
1868-1928. Scottish
architect, designer,
water colorist and artist.
His work was much
aligned with European
Symbolism, being
influential on European
design movements
such as Art Nouveau
and Secessionism.
Mackintosh greatly
admired the work of
Josef Hoffmann.

Other notable works:
The Willow Tearooms,
Hill House,
Queen's Cross Church,
Scotland Street School,
Glasgow, Scotland,
UK.

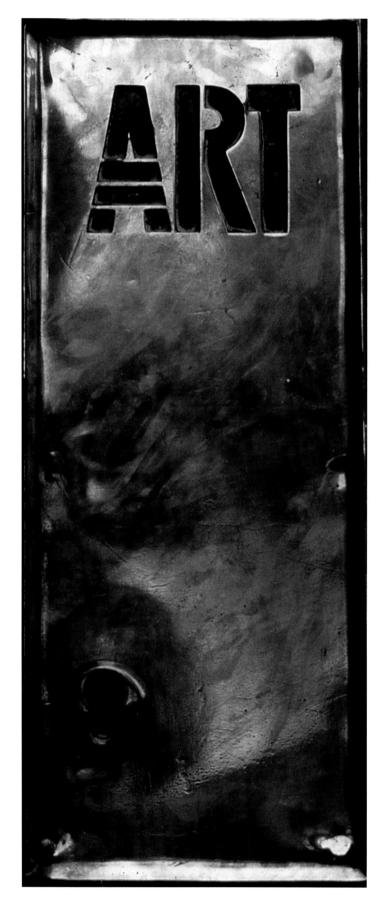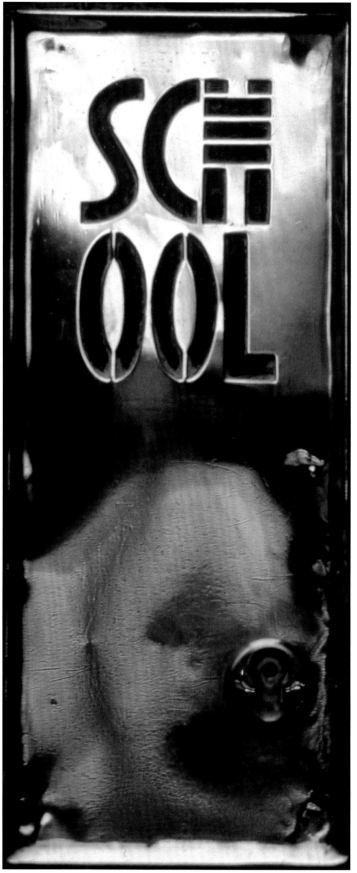

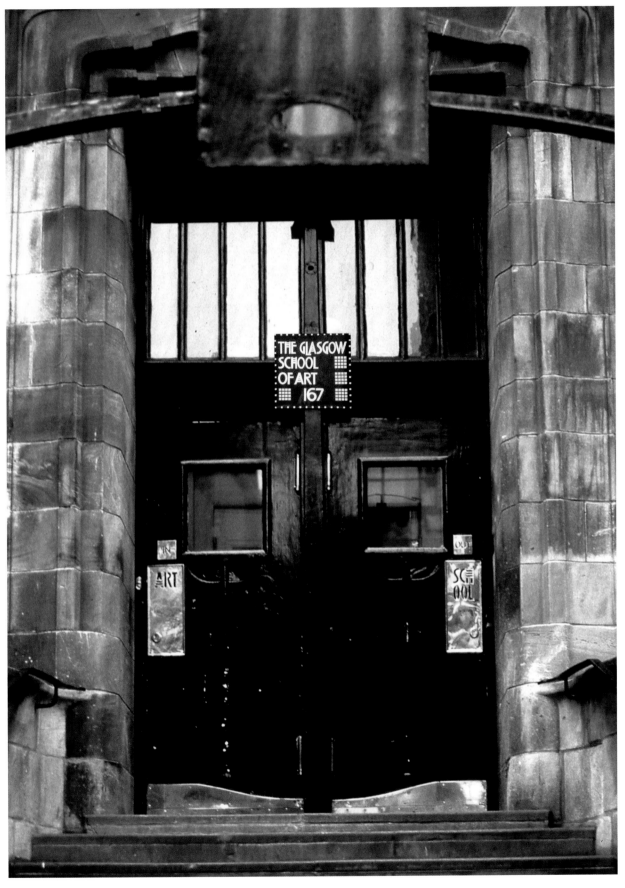

THE GLASGOW SCHOOL OF ART 167

Above:
Charles Rennie
Mackintosh.

Right and below:
Copper studio door
numbers,
Glasgow School of Art,
167 Renfrew Street,
Glasgow, Scotland, UK.

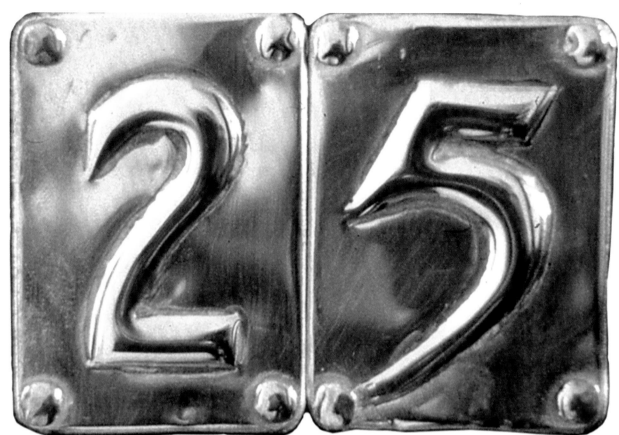

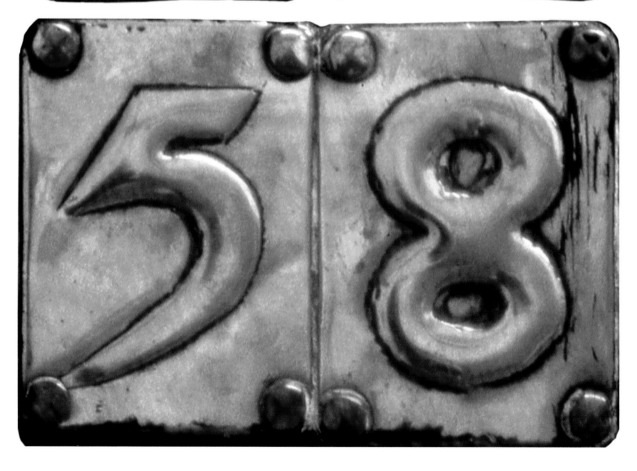

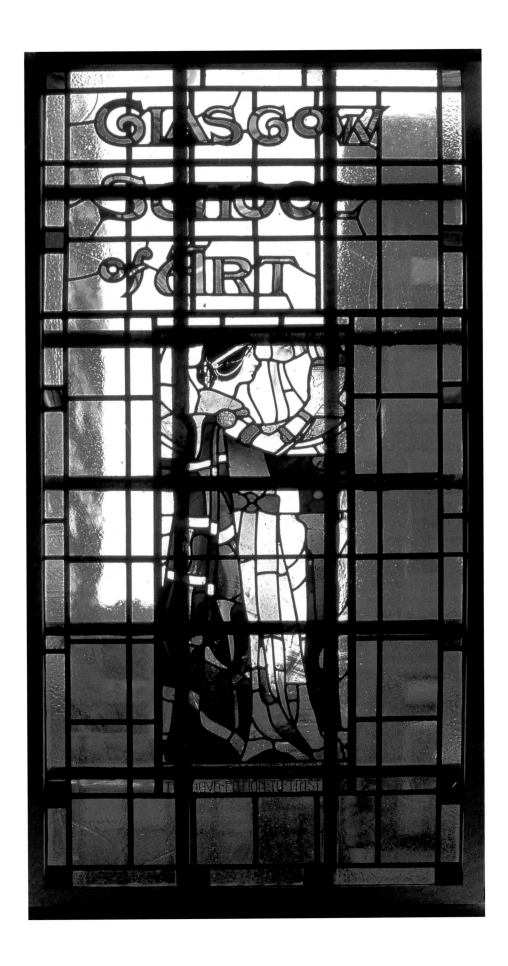

"Isolde",
stained-glass window,
1902,
Glasgow School of Art,
167 Renfrew Street,
Glasgow, Scotland, UK.
Artist:
Dorothy Carleton Smyth.

Dorothy Carleton Smyth,
1880-1933. Scottish artist.
In 1914 she became the
head of the Commercial
Art Department of the
Glasgow School of Art.
Smyth later accepted the
position of the school's
Director. Sadly, she died
shortly after.

Relief,
Glasgow School of Art,
1896,
167 Renfrew Street,
Glasgow, Scotland, UK.
Architect:
Charles Rennie
Mackintosh.

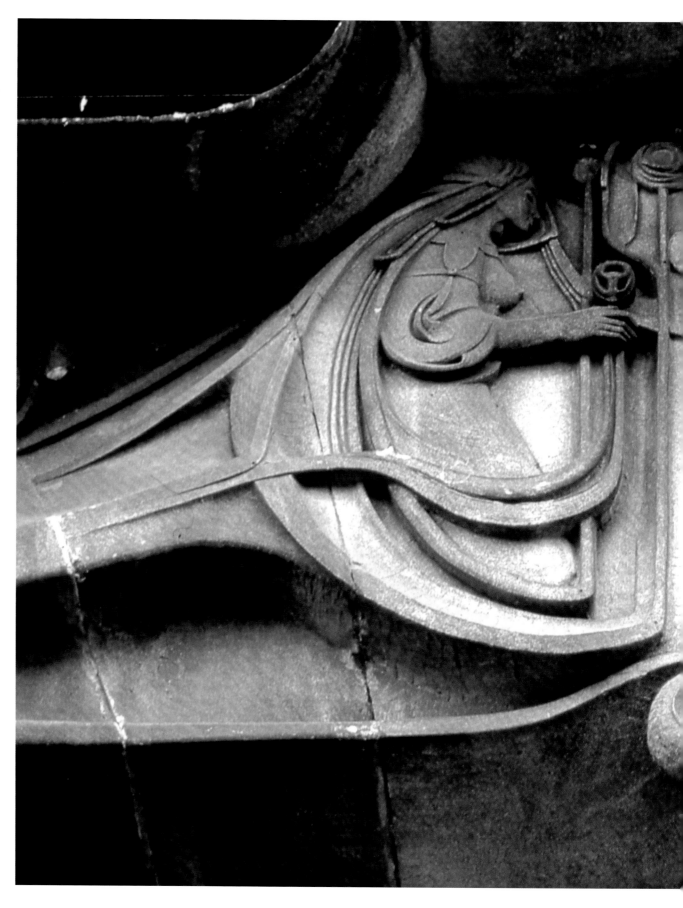

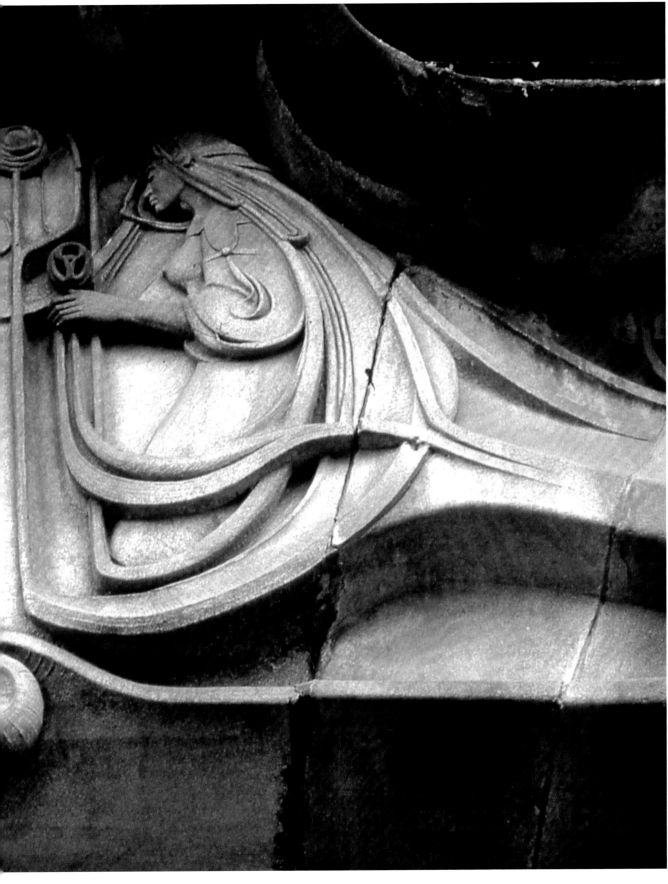

Above:
Quotation,1901,
Charles Rennie
Mackintosh.
"There is hope in
honest error, none
in the icy perfection
of the mere stylist."

Right:
Facade,
and below:
Railings symbol,
Glasgow School of Art,
1896,
167 Renfrew Street,
Glasgow, Scotland, UK.
Architect:
Charles Rennie
Mackintosh.

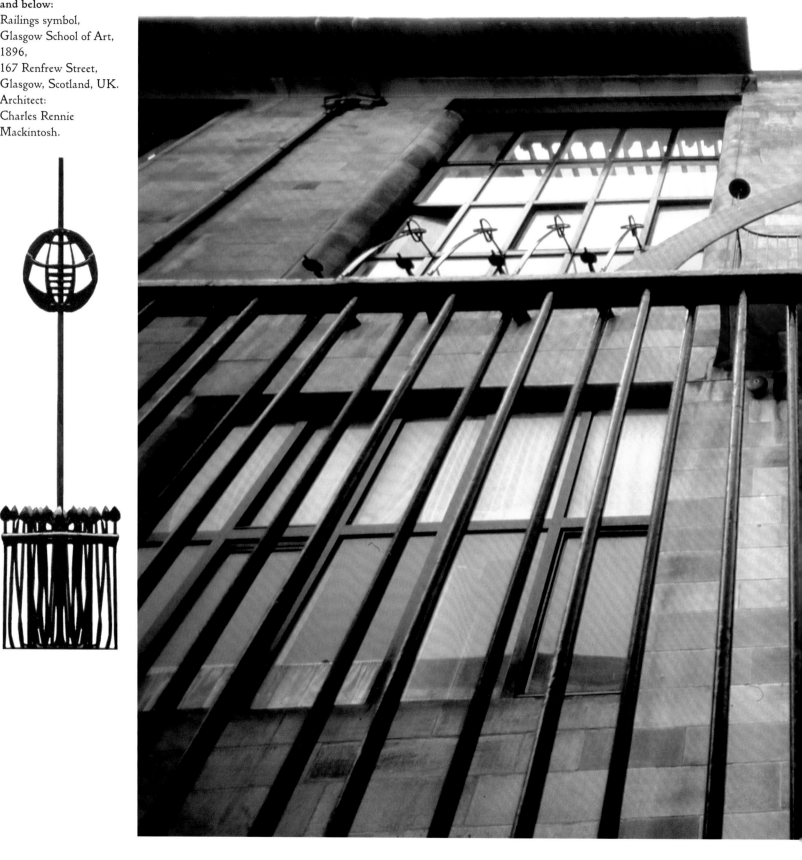

30

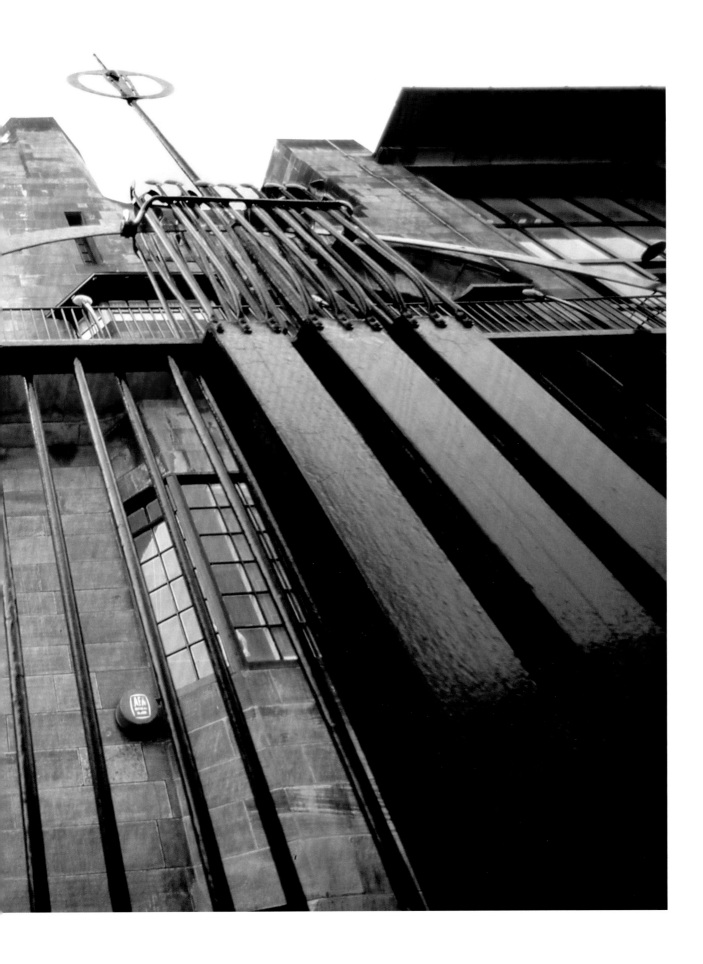

Wall clock,
Glasgow School of Art,
1896,
167 Renfrew Street,
Glasgow, Scotland, UK.
Designer:
Charles Rennie
Mackintosh.

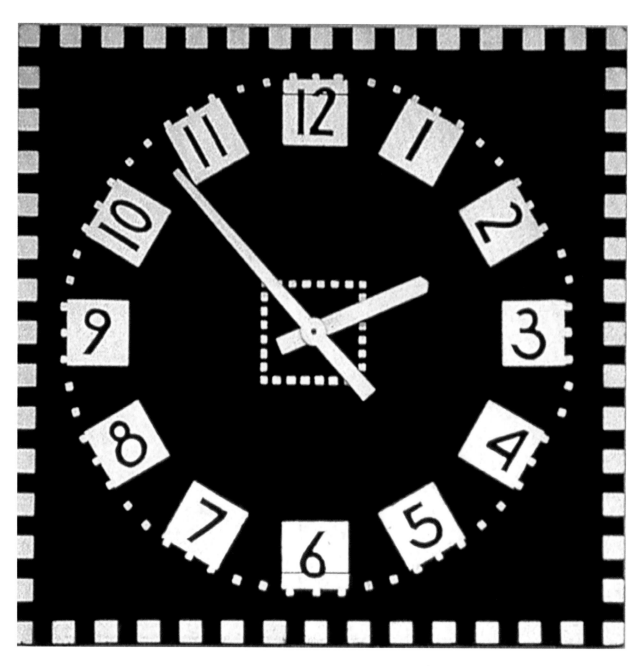

Above and left:
Staircase tiles,
Glasgow School of Art,
1896,
167 Renfrew Street,
Glasgow, Scotland, UK.
Designer:
Charles Rennie
Mackintosh.

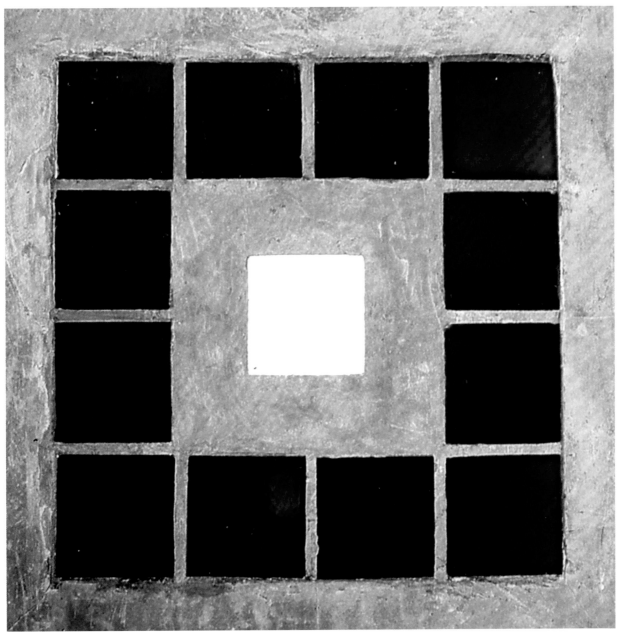

Metal decoration,
Glasgow School of Art,
1896,
167 Renfrew Street,
Glasgow, Scotland, UK.
Architect:
Charles Rennie
Mackintosh.

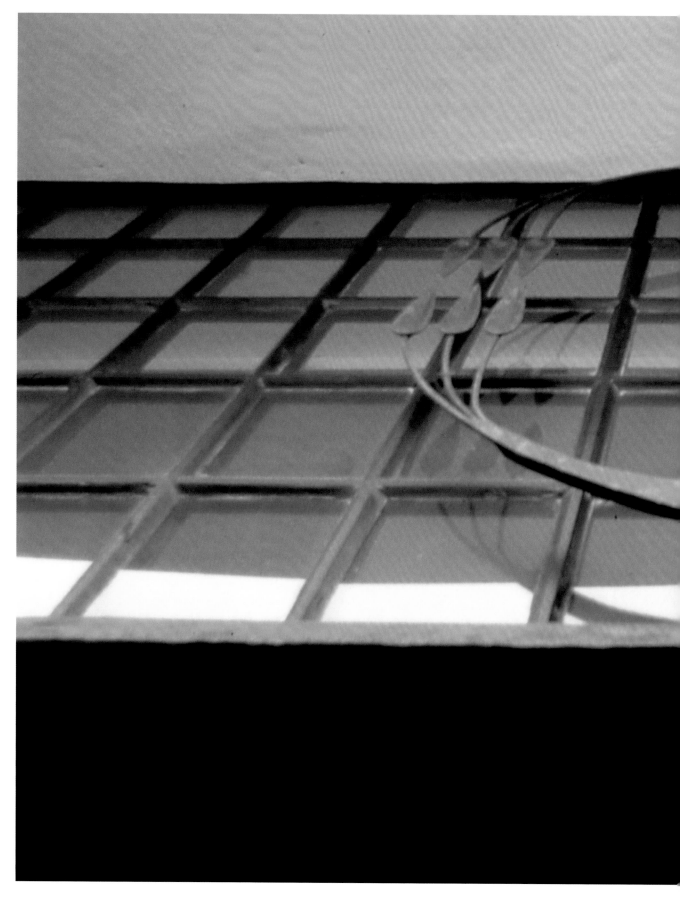

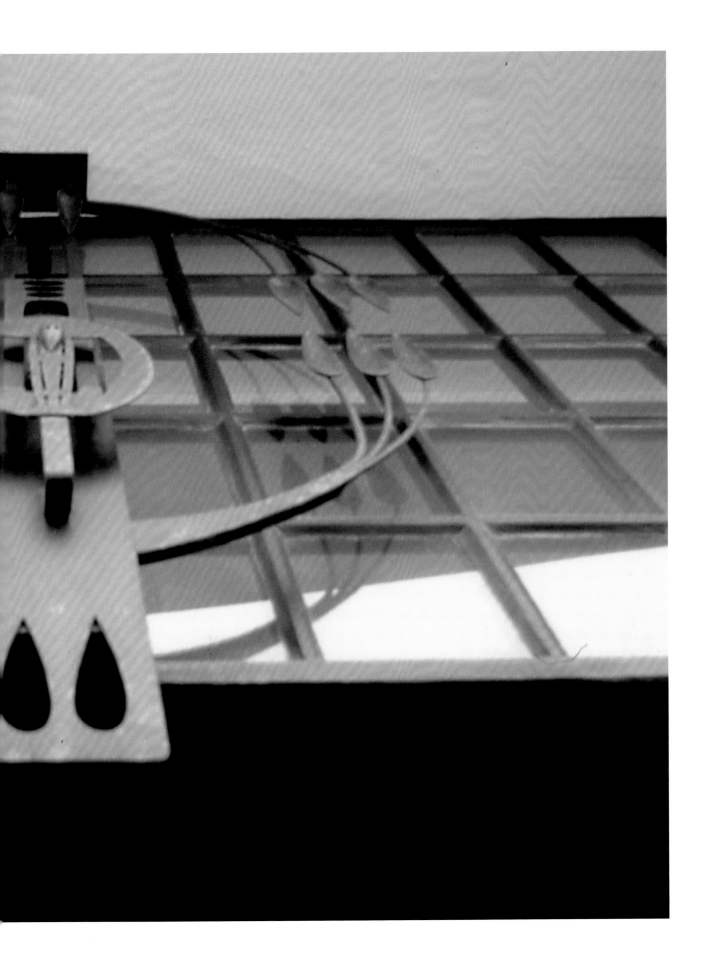

Above:
Window,
and right:
Detail, relief motif,
sandstone facade,
Glasgow School of Art,
1896,
167 Renfrew Street,
Glasgow, Scotland, UK.
Architect:
Charles Rennie
Mackintosh.

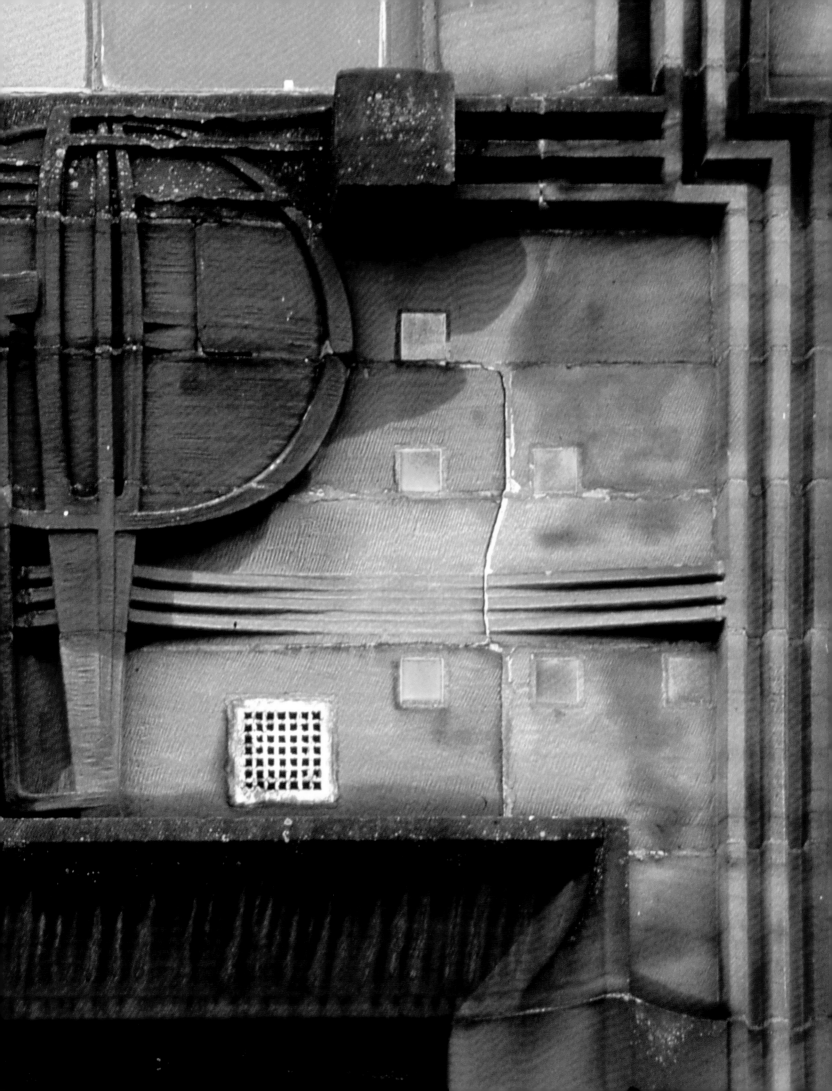

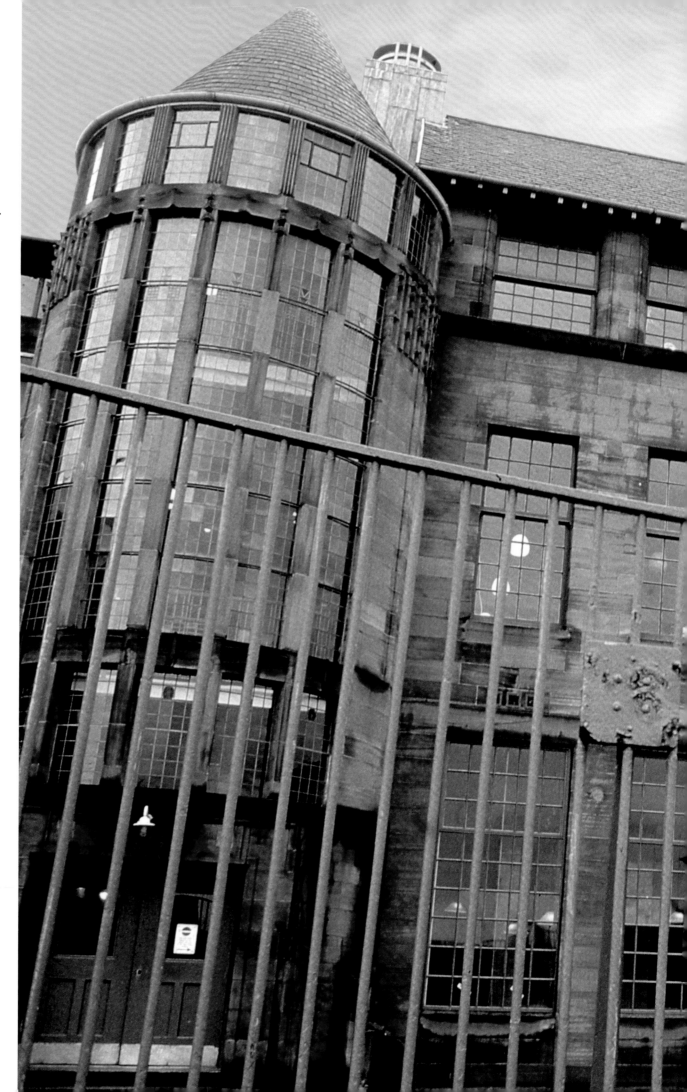

Front elevation
and railings,
Scotland Street School,
1903-06,
(now Scotland Street
School Museum),
225 Scotland Street,
Glasgow, Scotland, UK.
Architect:
Charles Rennie
Mackintosh.

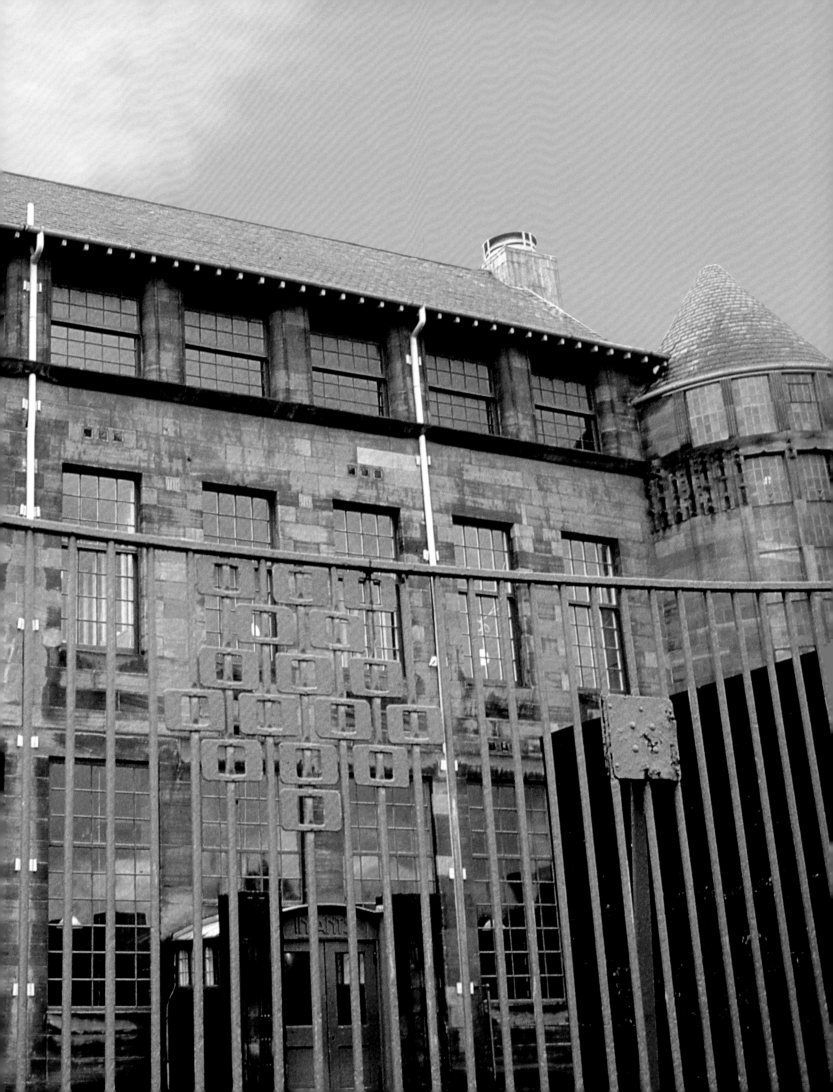

Infants entrance,
Scotland Street School,
1903-06,
(now Scotland Street
School Museum),
225 Scotland Street,
Glasgow, Scotland, UK.
Architect:
Charles Rennie
Mackintosh.

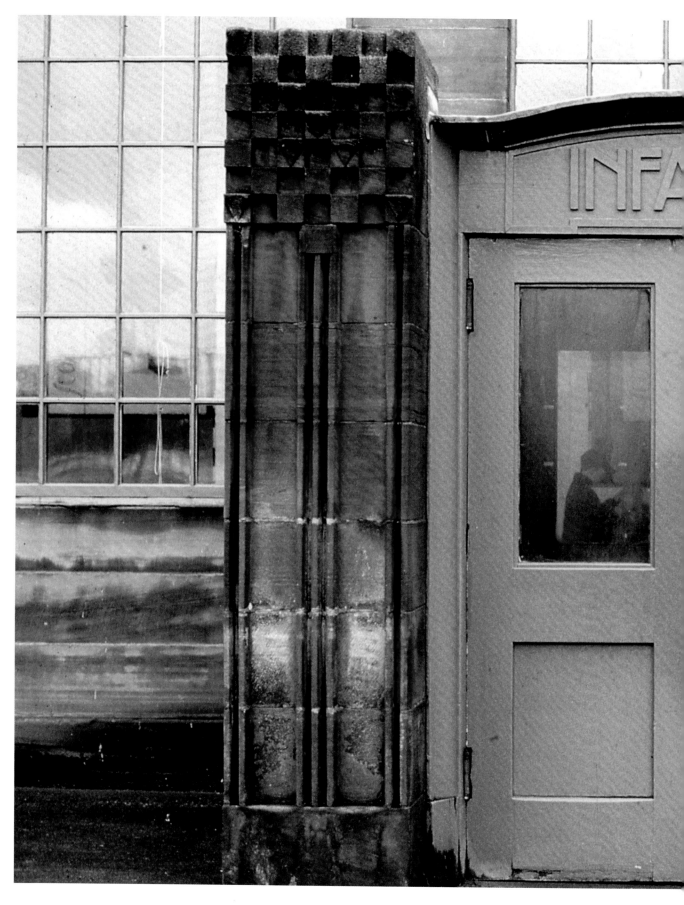

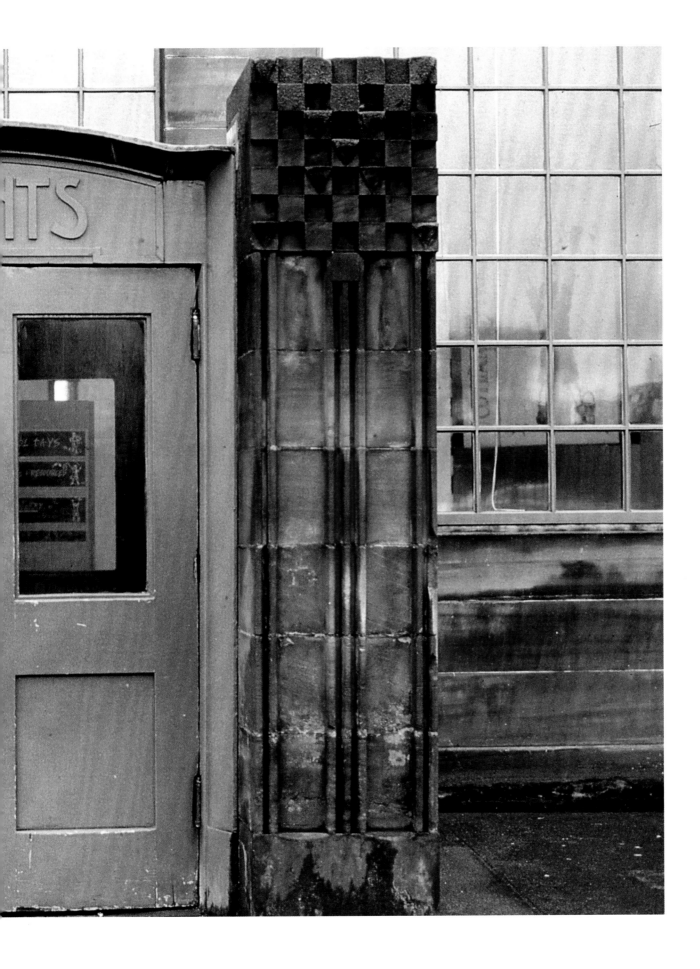

Decorative metal railings,
Scotland Street School,
1903-06,
(now Scotland Street
School Museum),
225 Scotland Street,
Glasgow, Scotland, UK.
Architect:
Charles Rennie
Mackintosh.

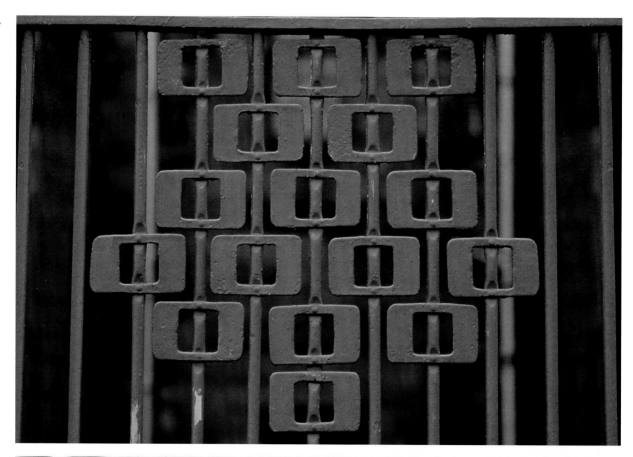

Detail, boundary wall,
red Locharbriggs
sandstone,
Scotland Street School,
1903-06,
(now Scotland Street
School Museum),
225 Scotland Street,
Glasgow, Scotland, UK.
Architect:
Charles Rennie
Mackintosh.

42

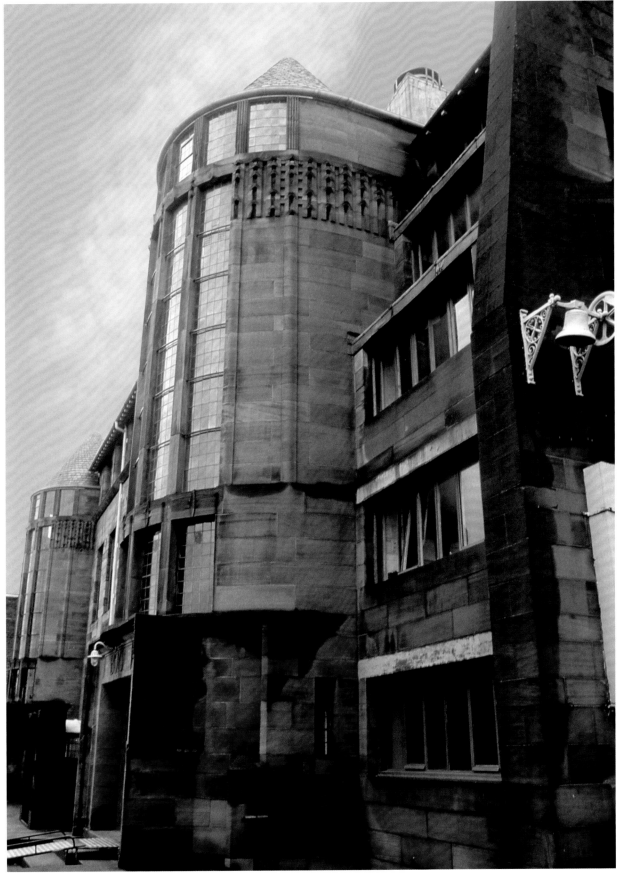

Main entrance
and stairwell.
External walls are
red Locharbriggs
sandstone ashlar.
Scotland Street School,
1903-06,
(now Scotland Street
School Museum),
225 Scotland Street,
Glasgow, Scotland, UK.
Architect:
Charles Rennie
Mackintosh.

Stained-glass leaded
bay window,
"Hatrack" Building,
1899,
144 St Vincent Street,
Glasgow,
Scotland, UK.
Architect: James Salmon
(The Wee Troot).
Designer:
Oscar Paterson.

Oscar Paterson,
1863-1934, Scottish
stained-glass designer.

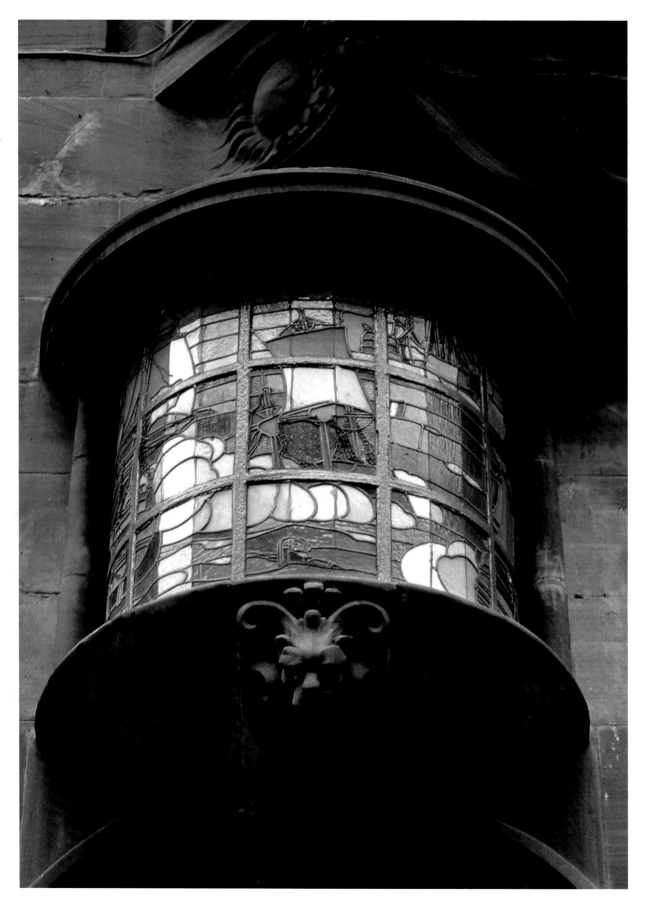

44

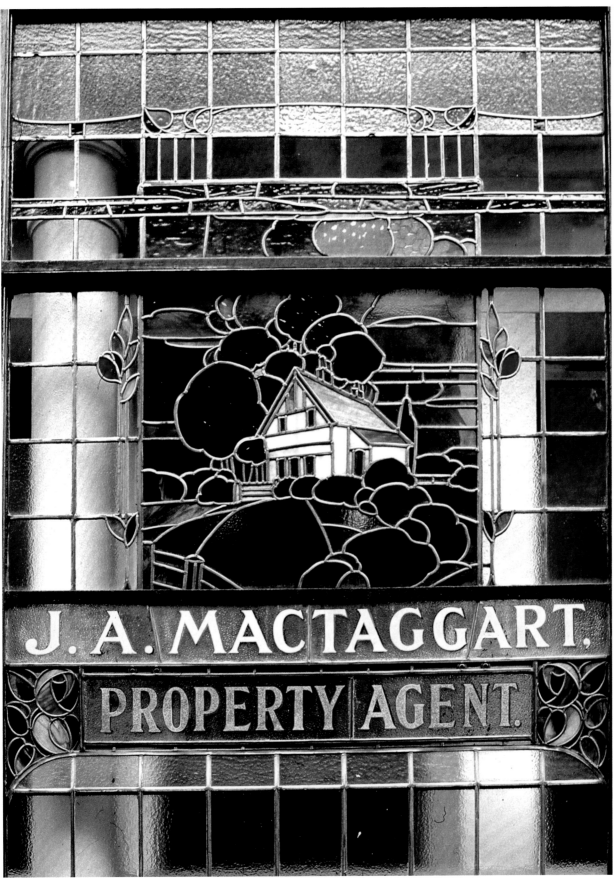

Leaded stained-glass
window,
J. A. Mactaggart
Property Agent, 1896.
Now the Glasgow
Acting Academy.
63 Bath Street,
Glasgow,
Scotland, UK.

J. A. MACTAGGART.

PROPERTY AGENT.

Ceramic tiles,
New Palace Theatre
of Varieties, 1898,
121-123 Union Street,
Plymouth, UK.
Architects:
Wimperis & Arber.
Ceramics:
William James Neatby.

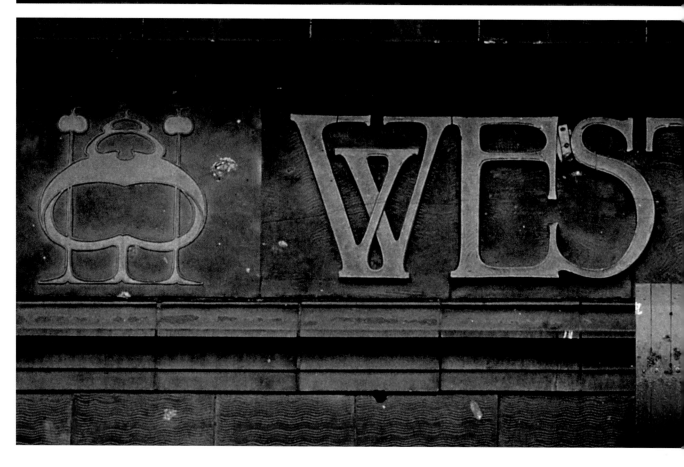

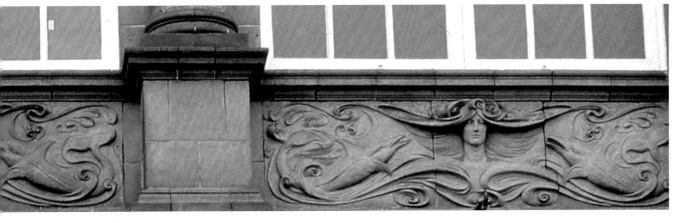

Above:
William James Neatby.

William James Neatby,
1860-1910.
British ceramic designer and
terracotta sculptor for the
Doulton Company.

Other notable works:
Harrods Food Hall,
London, UK.
Edward Everard Building,
Bristol, UK
The Royal Arcade,
Norwich, UK.

This page and opposite:
Ceramic tiles,
New Palace Theatre
of Varieties, 1898,
121-123 Union Street,
Plymouth, UK.
Architects:
Wimperis & Arber.
Ceramics:
William James Neatby.

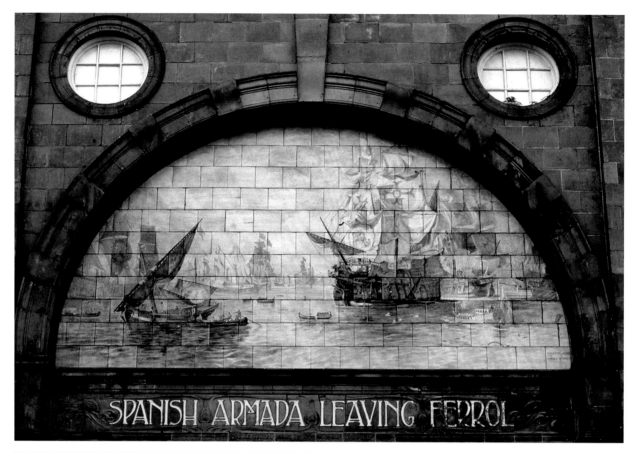

SPANISH ARMADA LEAVING FERROL

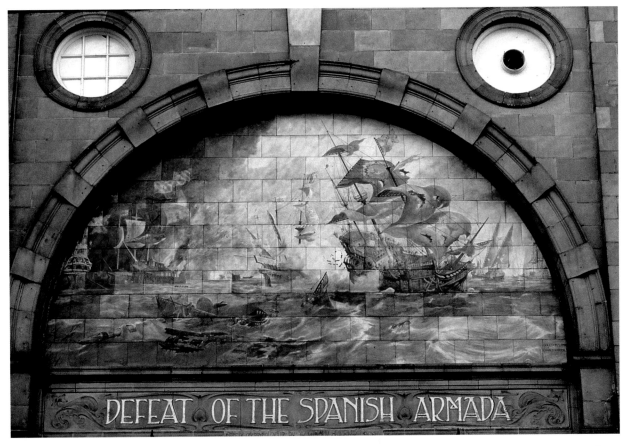

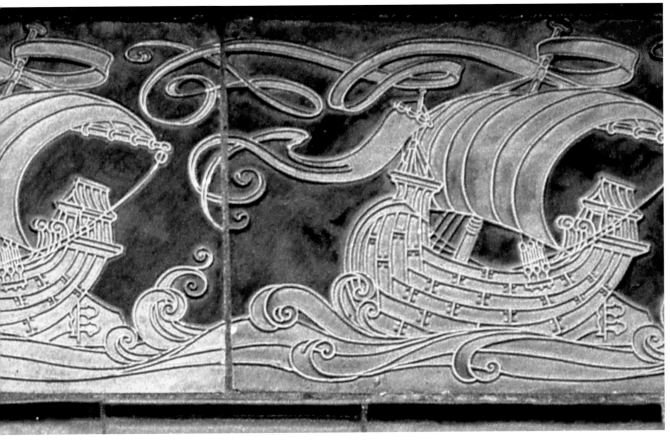

This page and opposite:
Ceramic tiles,
Food Hall,
Harrods
department store, 1902.
87-135 Brompton Road,
Knightsbridge,
London, UK.
Ceramics:
William James Neatby.

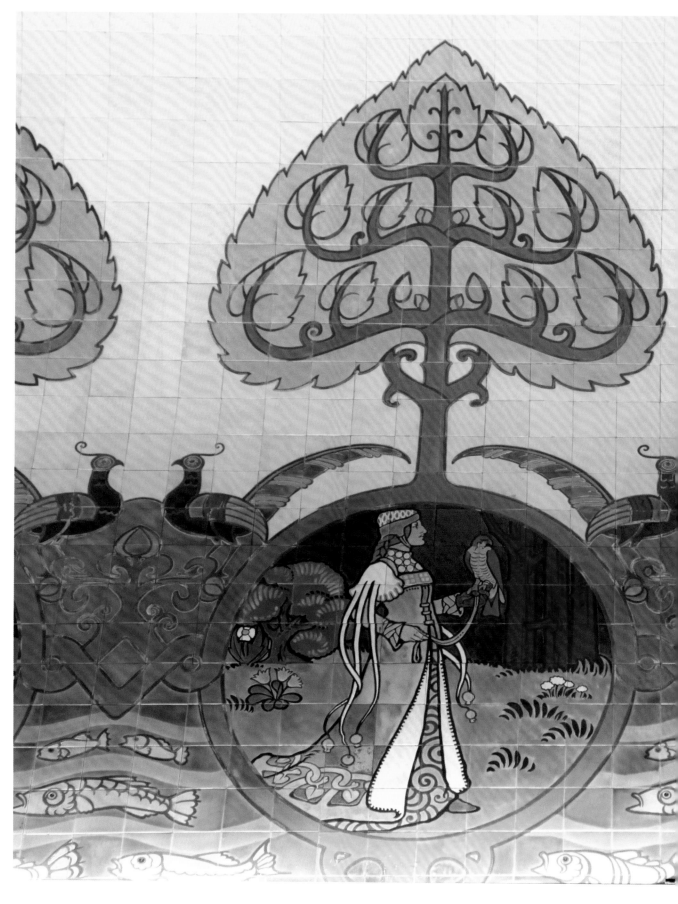

50

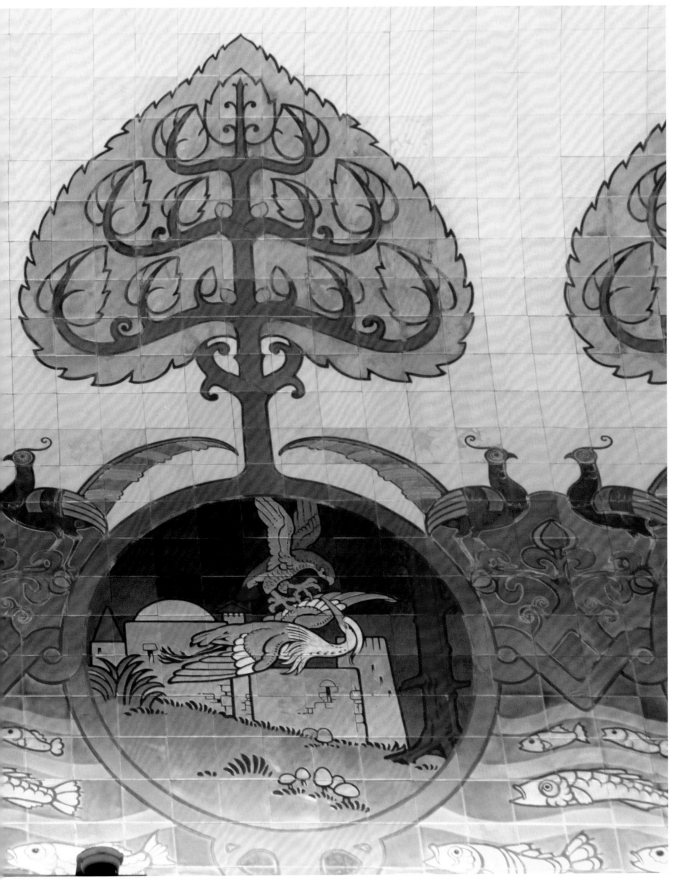

This page and opposite:
Ceramic tiles,
Food Hall,
Harrods
department store, 1902.
87-135 Brompton Road,
Knightsbridge,
London, UK.
Ceramics:
William James Neatby.

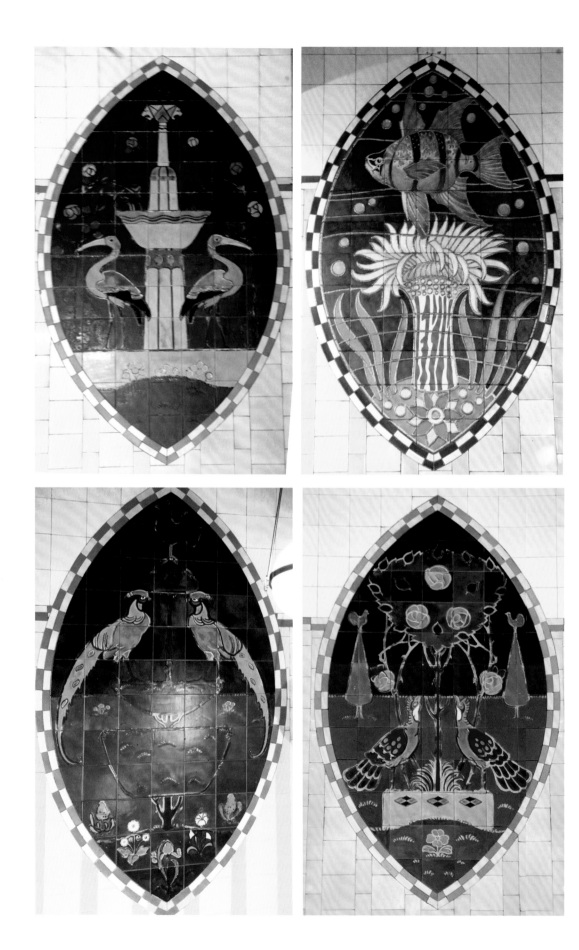

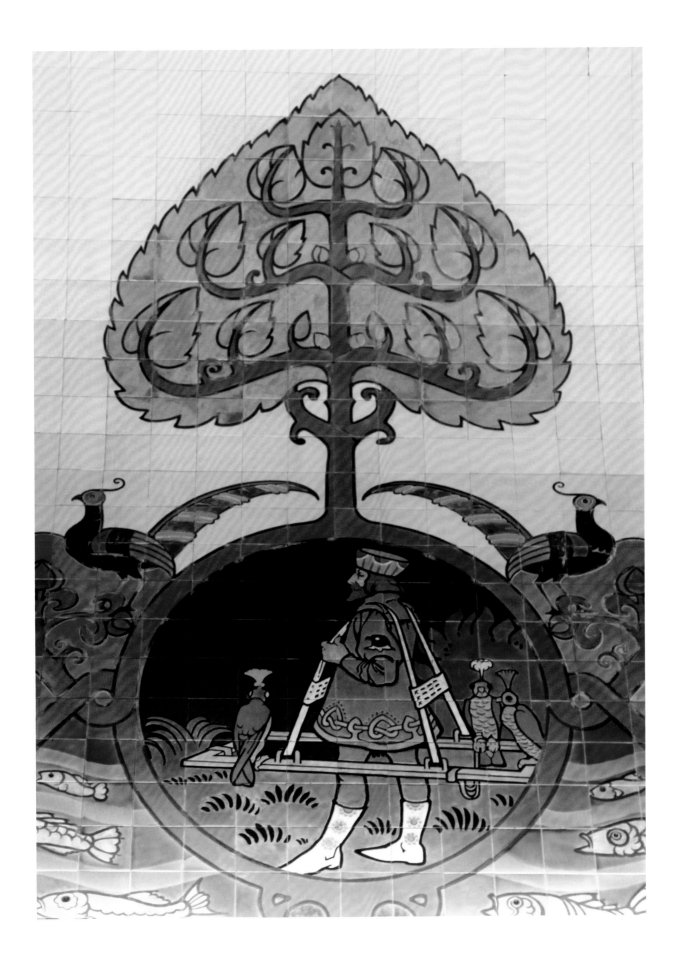

Interior lanterns,
The Royal Arcade, 1899,
Castle Street,
Norwich, UK.
Architect:
George J. Skipper.

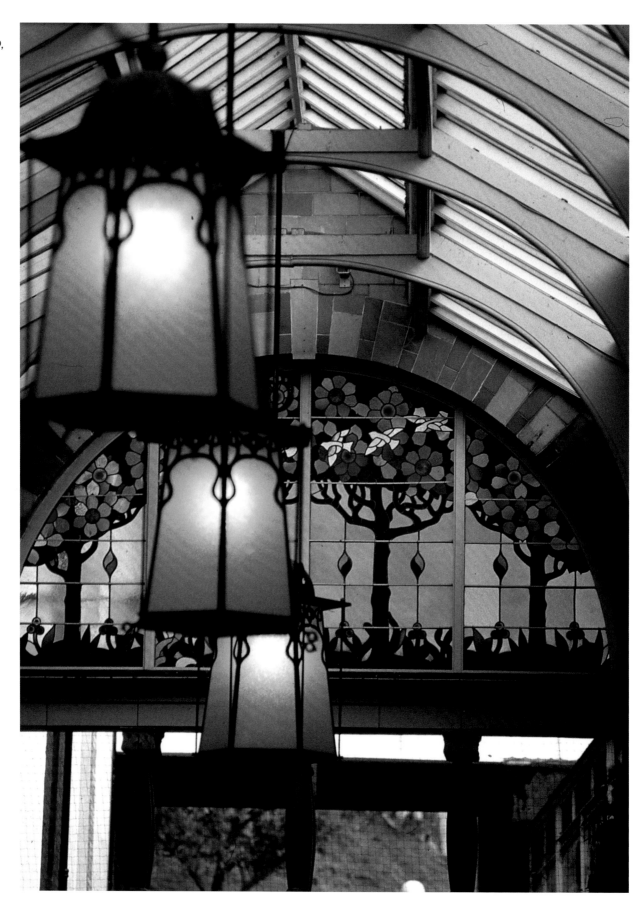

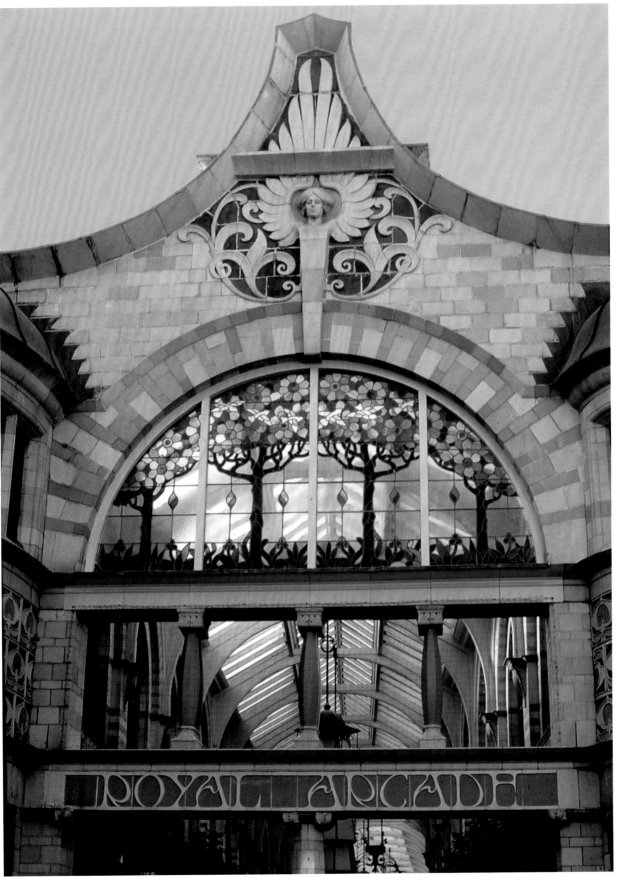

Tile and stained-glass
façade,
The Royal Arcade, 1899,
Castle Street,
Norwich, UK.
Architect:
George J. Skipper.
Ceramics:
William James Neatby.

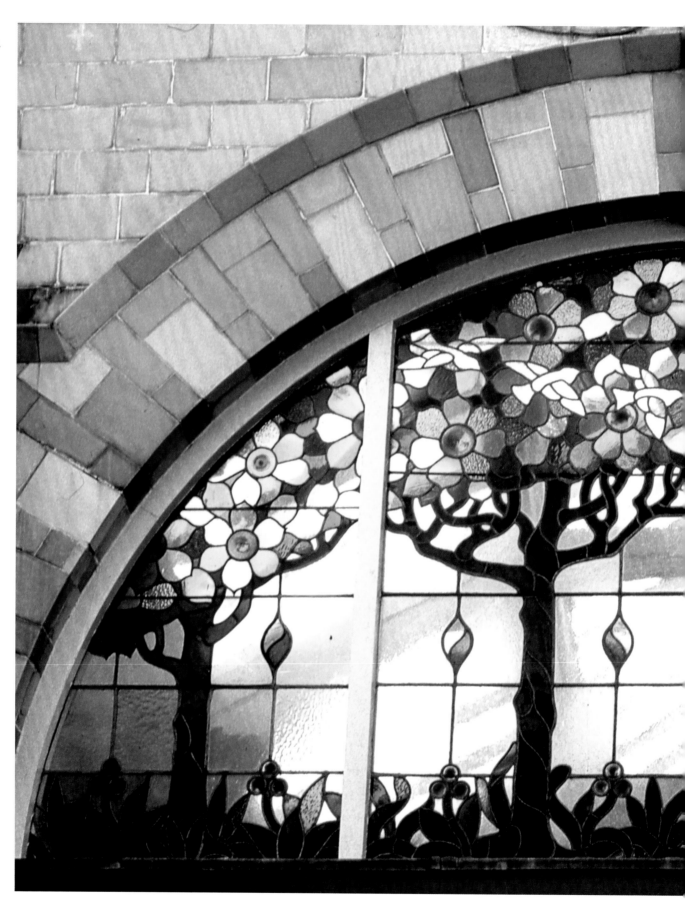

Stained-glass window,
The Royal Arcade, 1899,
Castle Street,
Norwich, UK.
Architect:
George J. Skipper.

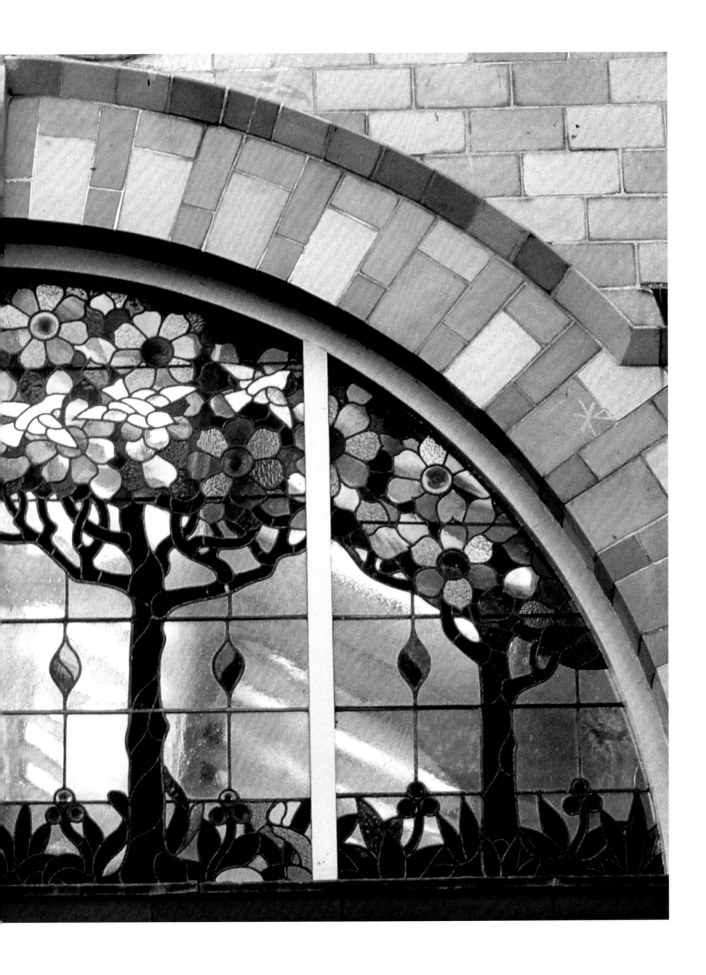

Glazed ceramic tiles,
The Royal Arcade, 1899,
Castle Street,
Norwich, UK.
Architect:
George J. Skipper.
Ceramics:
William James Neatby.

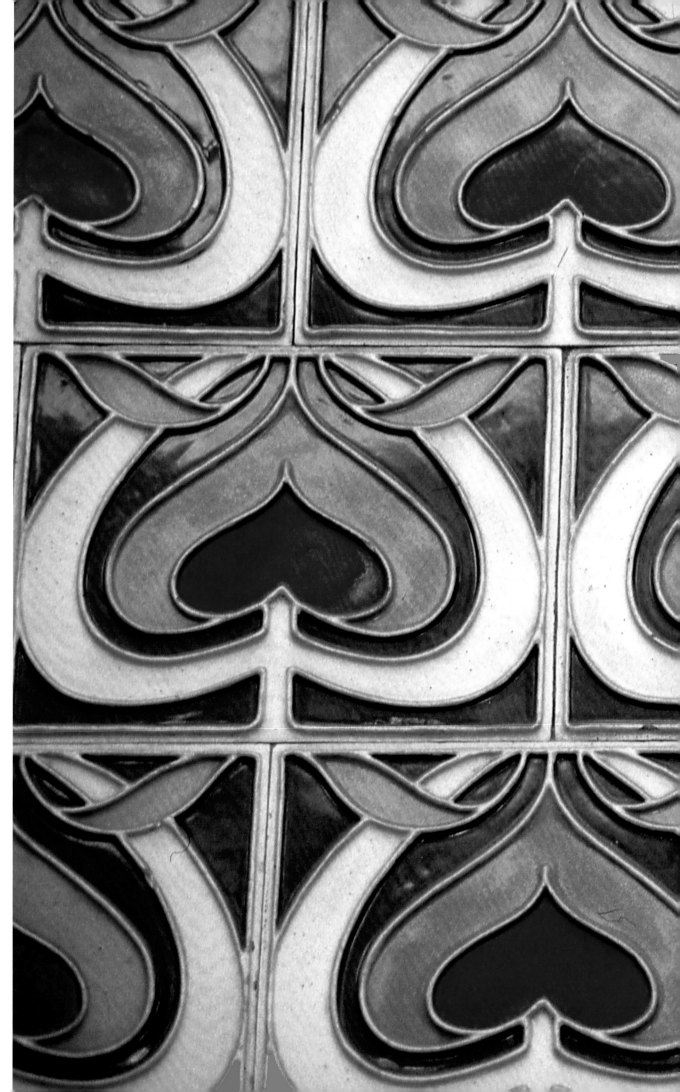

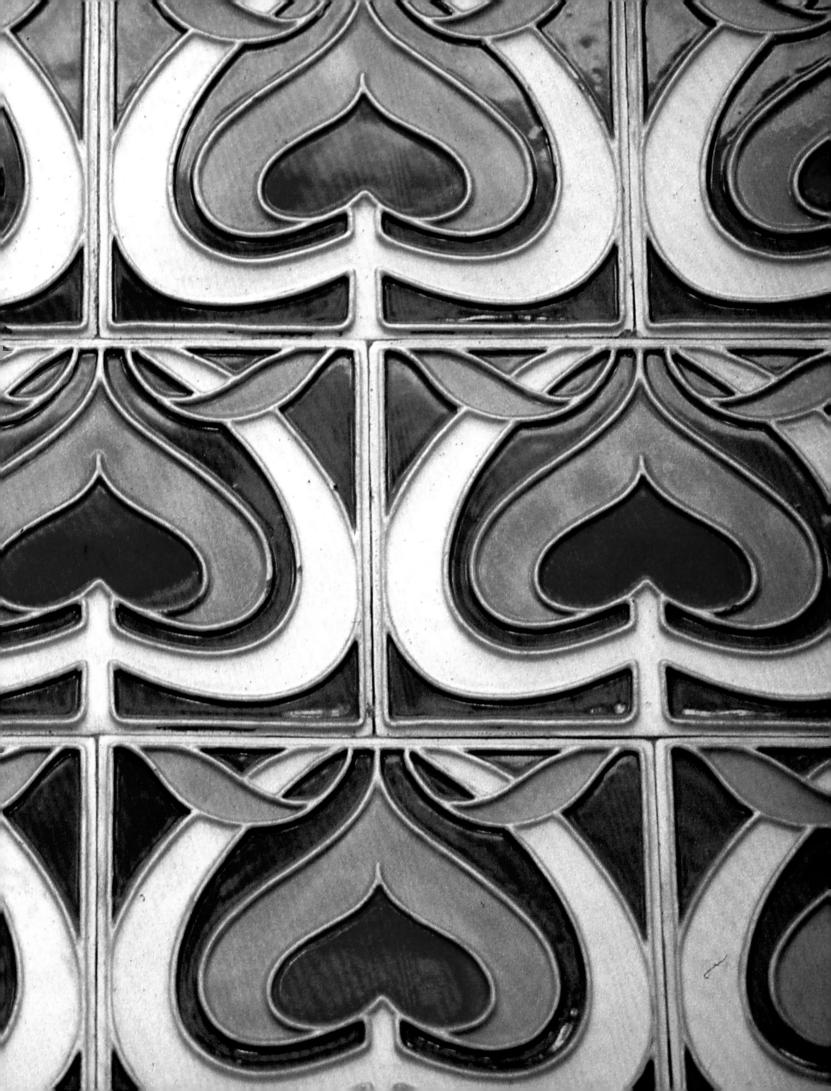

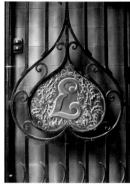

Above:
Brass initial gate,
and right:
Carrera marble tile facade,
the former
Edward Everard's
printing works, 1900,
37-38 Broad Street,
Bristol, UK.
Architect:
Henry Williams.
Ceramics:
William James Neatby.

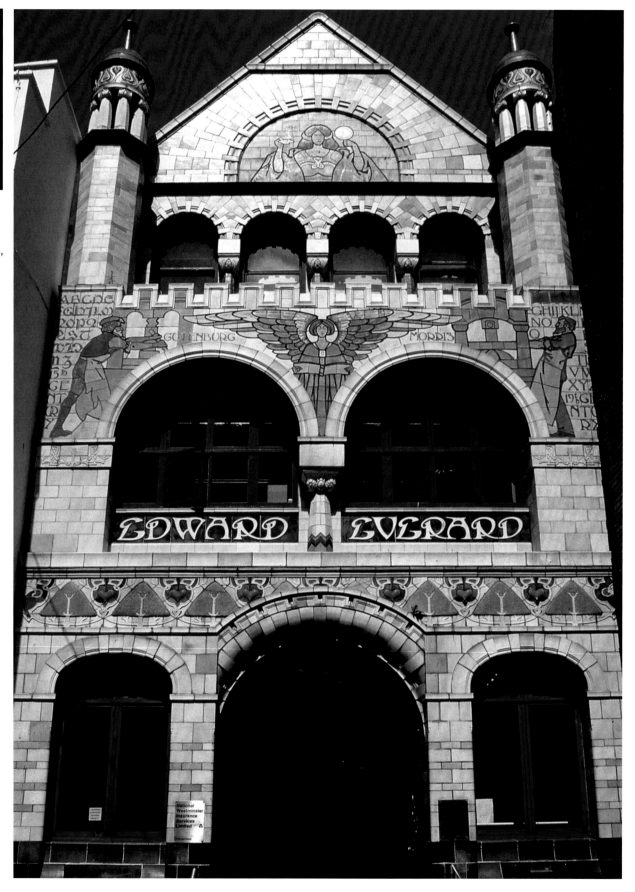

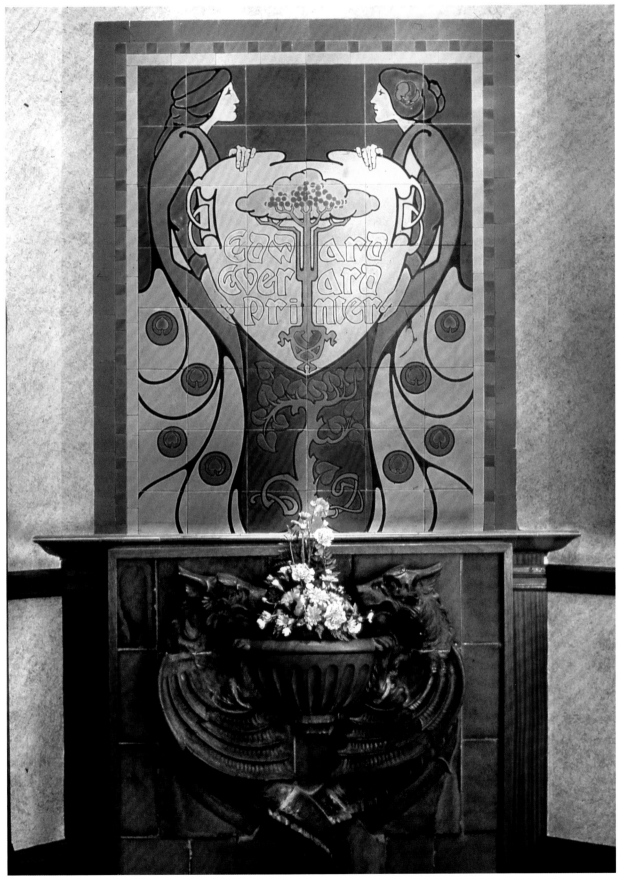

Tiled mural,
the former
Edward Everard's
printing works, 1900,
37-38 Broad Street,
Bristol, UK.
Artist:
William James Neatby.

Detail,
Carrera marble tile facade,
the former
Edward Everard's
printing works, 1900,
37-38 Broad Street,
Bristol, UK.
Architect:
Henry Williams.
Ceramics:
William James Neatby.

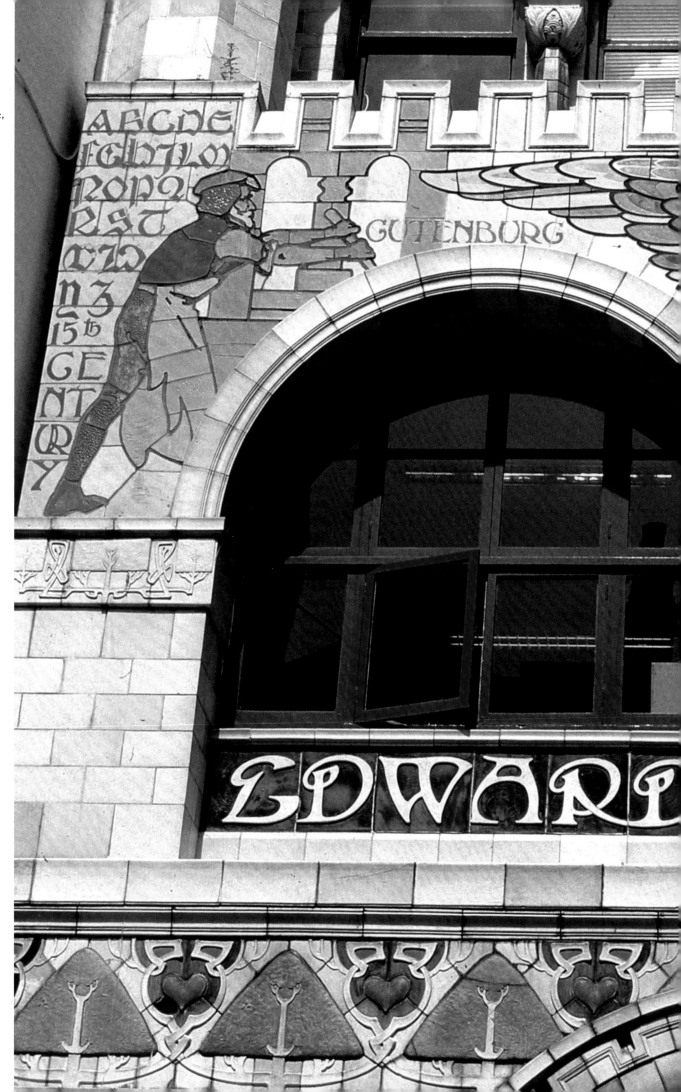

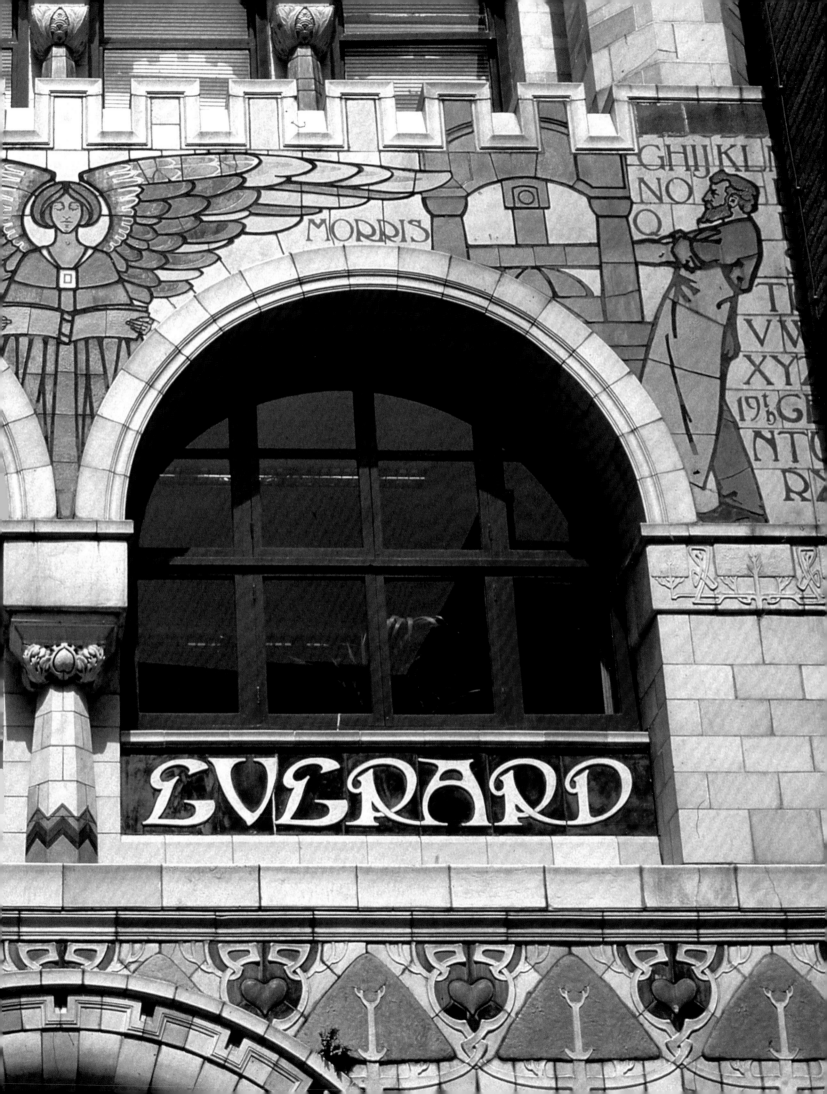

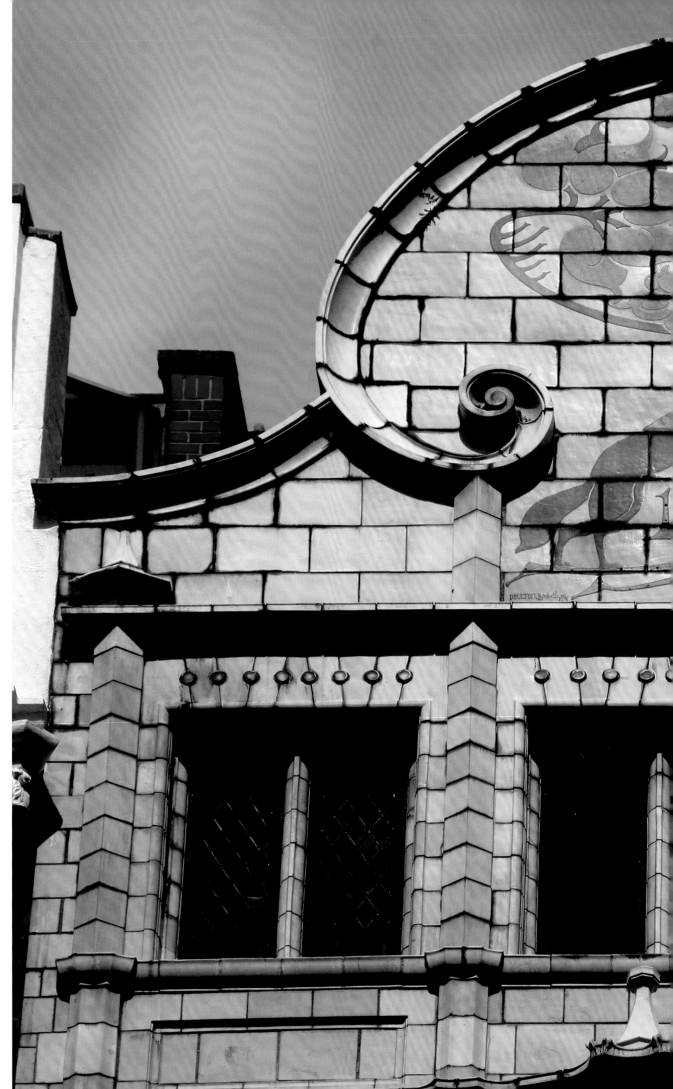

Tiled facade,
Fox & Anchor
public house, 1898,
115 Charterhouse Street,
London, UK.
Architect:
Latham Withall.
Ceramics:
William James Neatby.

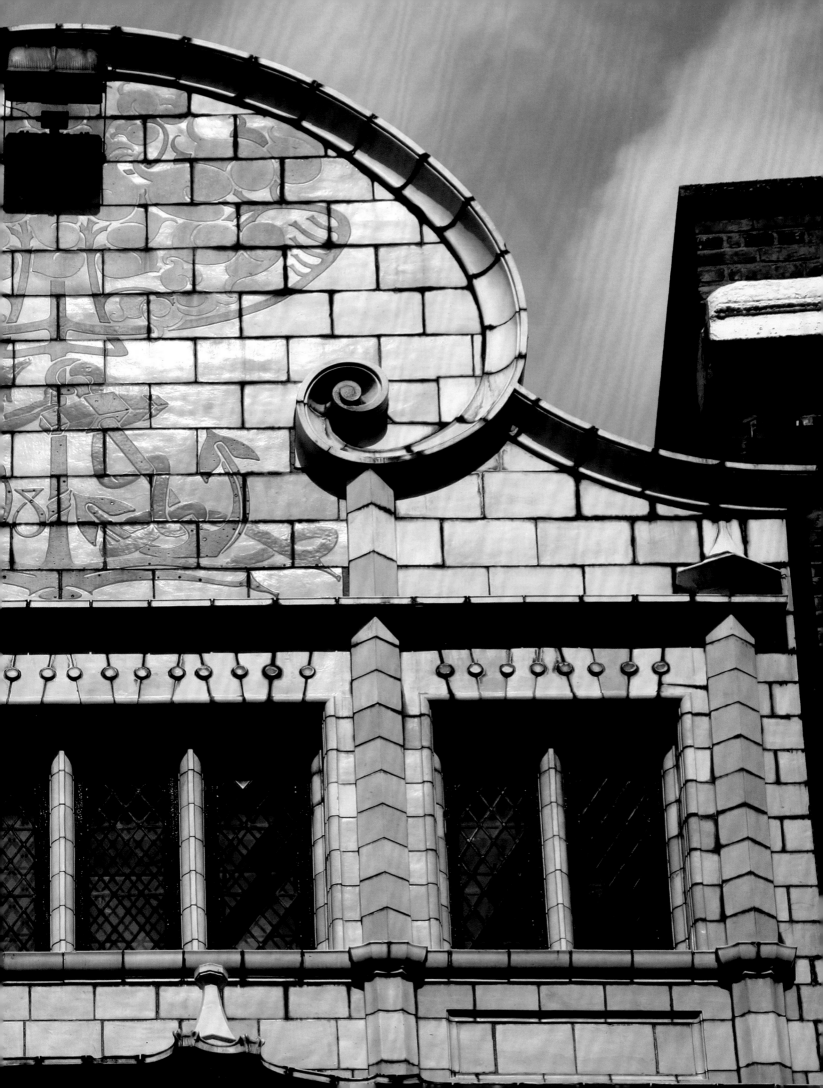

Tiled facade,
Fox & Anchor
public house, 1898,
115 Charterhouse Street,
London, UK.
Architect:
Latham Withall.
Ceramics:
William James Neatby.

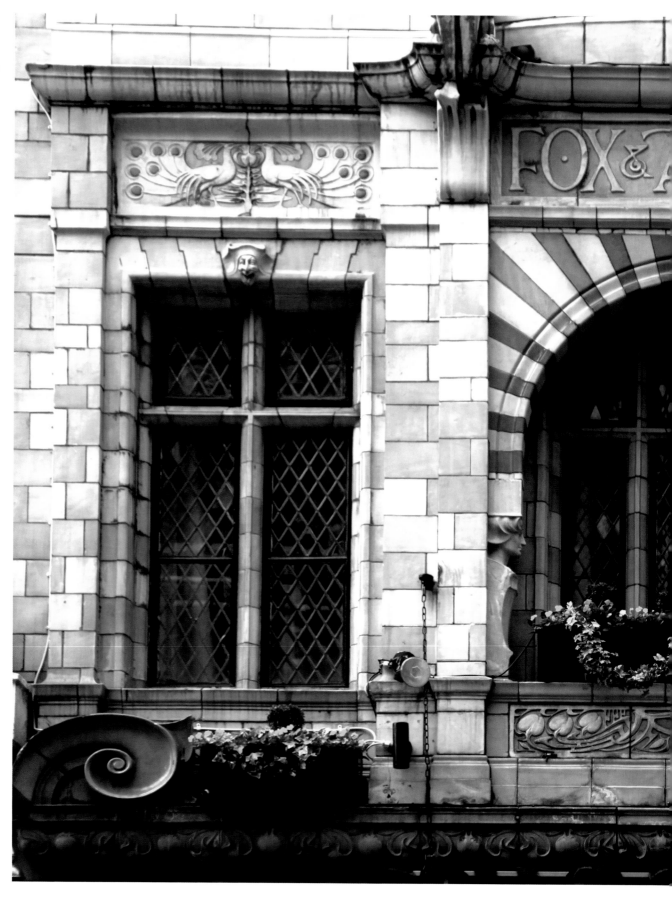

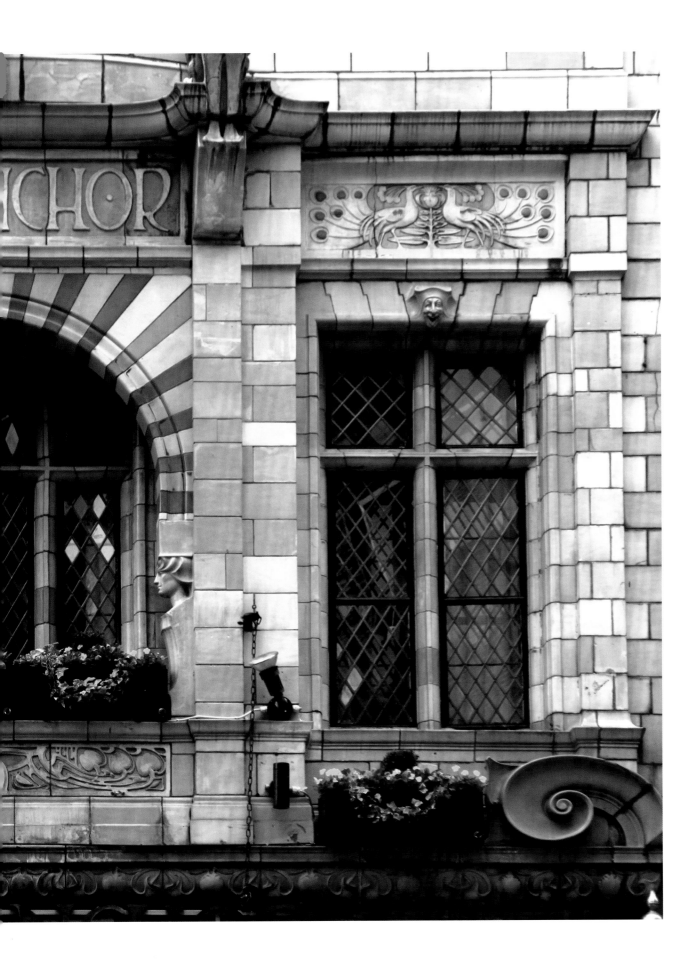

Mosaic front door step,
Fox & Anchor
public house, 1898,
115 Charterhouse Street,
London, UK.
Architect:
Latham Withall.

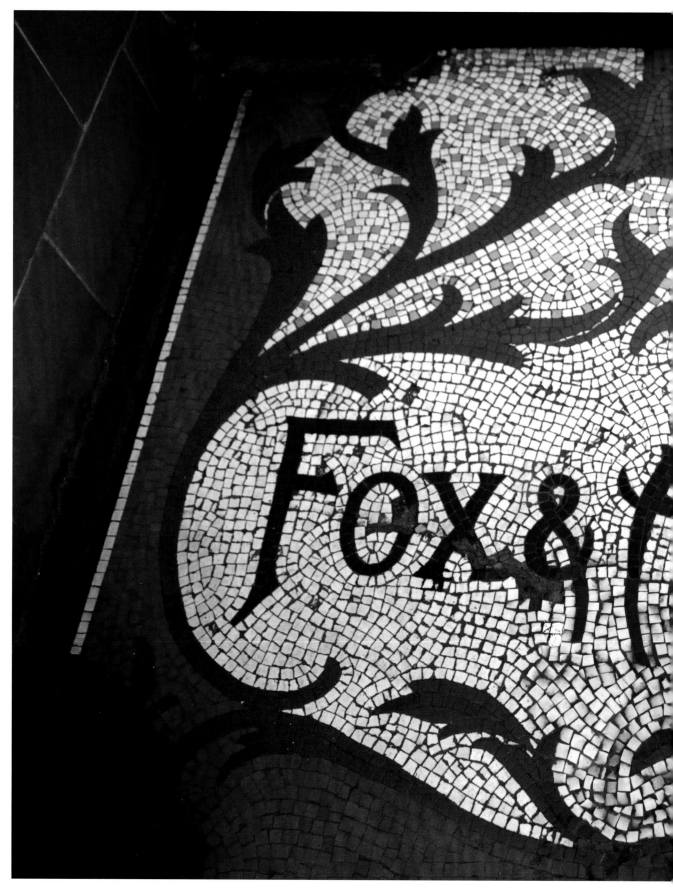

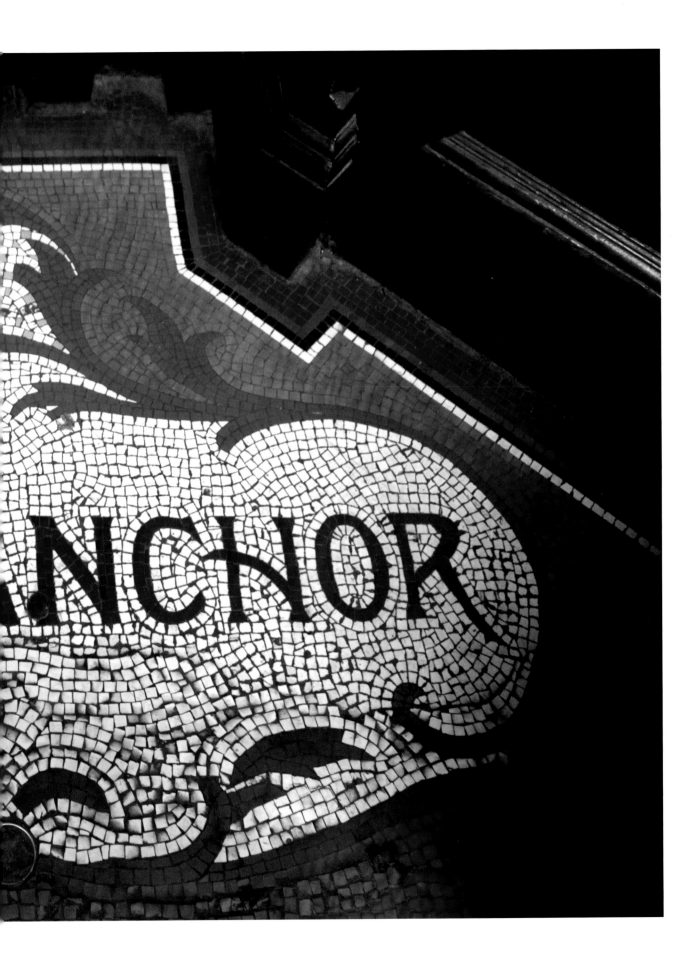

Detail,
tiled facade,
Fox & Anchor
public house, 1898,
115 Charterhouse Street,
London, UK.
Architect:
Latham Withall.
Ceramics:
William James Neatby.

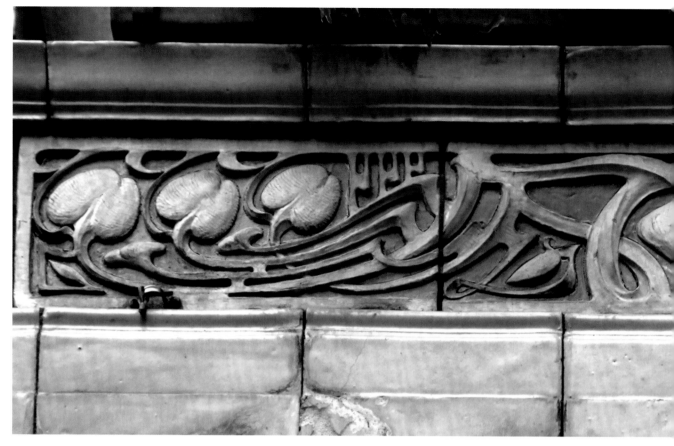

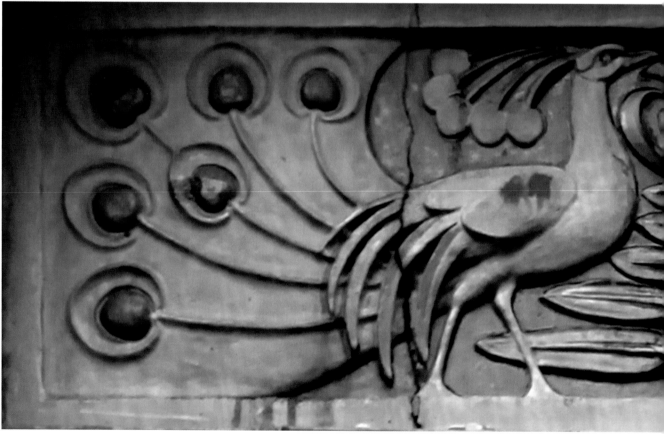

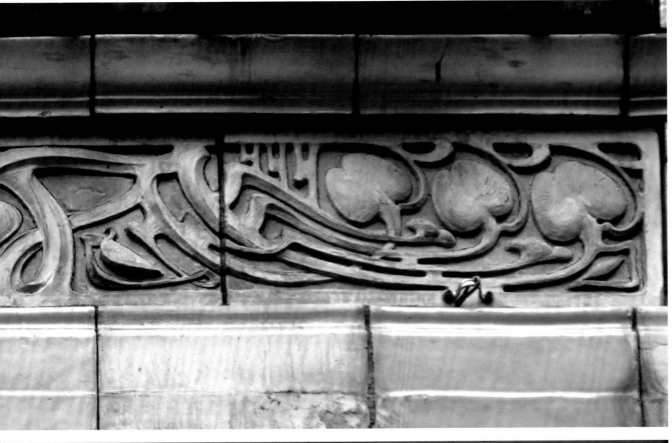

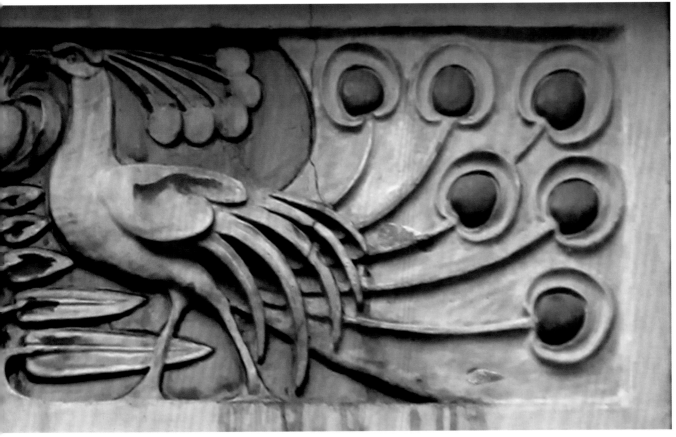

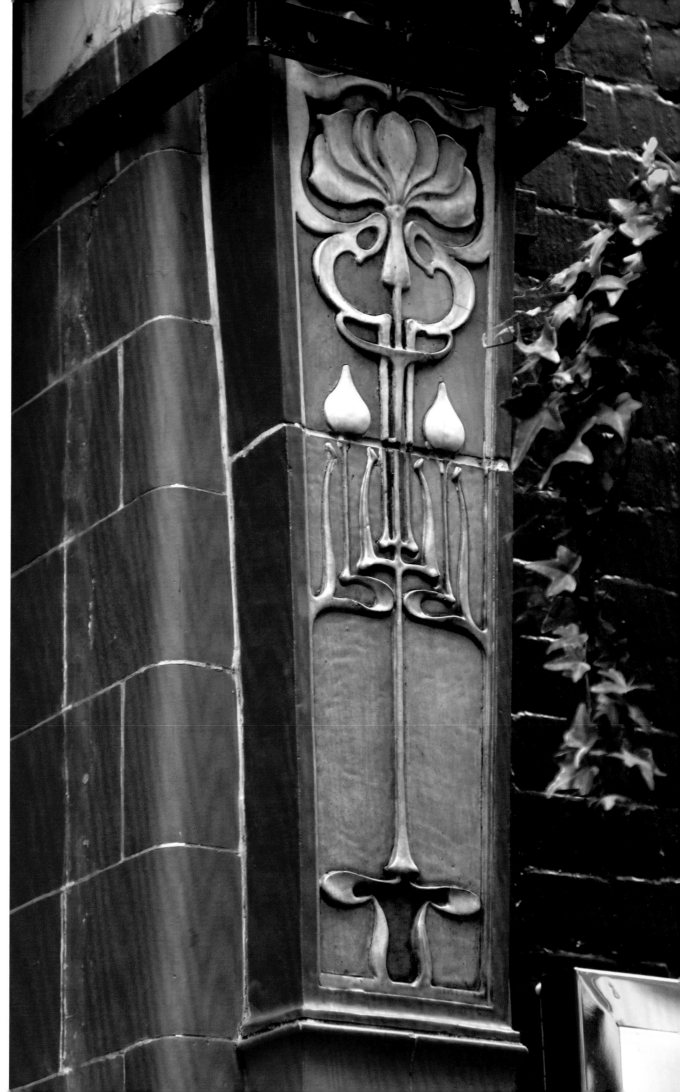

Detail, tiled facade,
Fox & Anchor
public house, 1898,
115 Charterhouse Street,
London, UK.
Architect:
Latham Withall.
Ceramics:
William James Neatby.

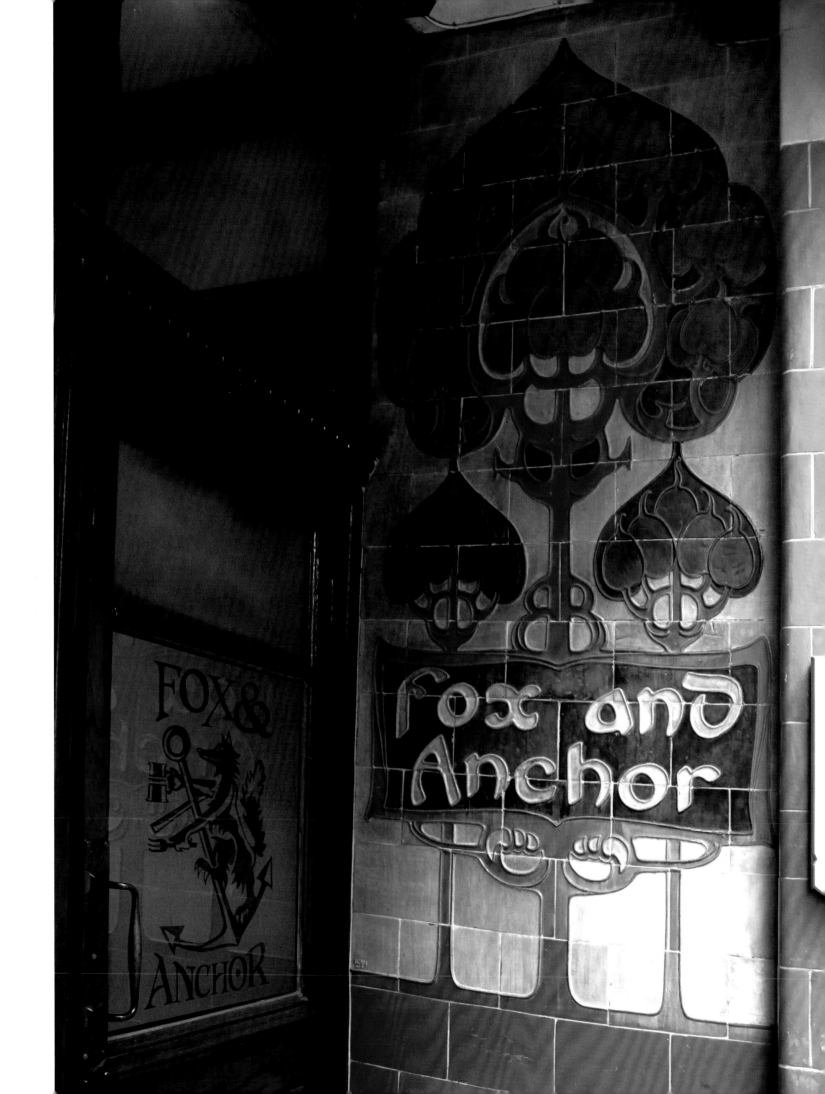

Doulton terracotta relief,
1898,
Orchard House,
Abbey Orchard Street,
Westminster,
London, UK.
Artist:
William James Neatby.

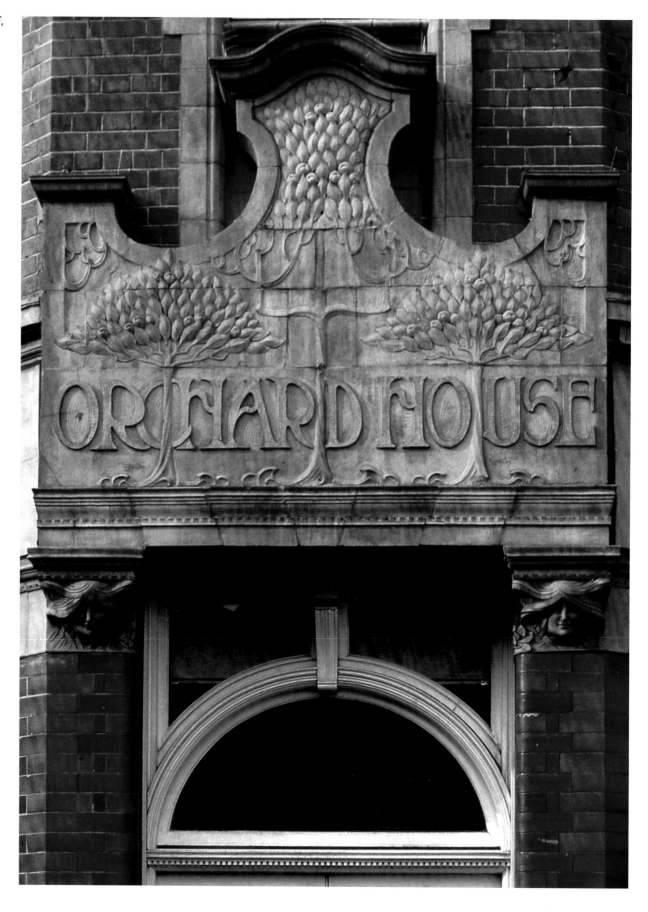

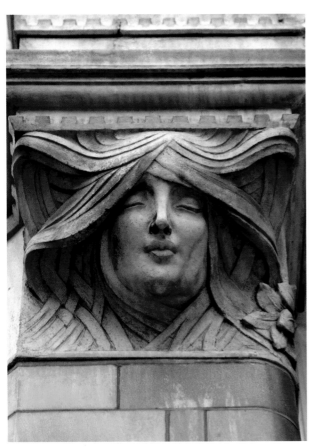
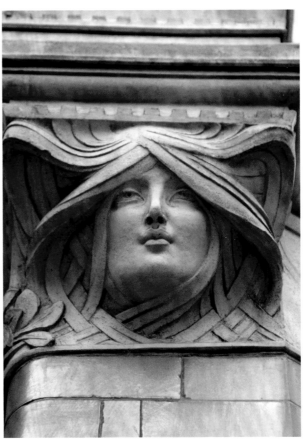

Doulton terracotta bosses,
1898,
Orchard House,
Abbey Orchard Street,
Westminster,
London, UK.
Artist:
William James Neatby.

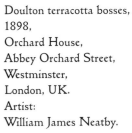

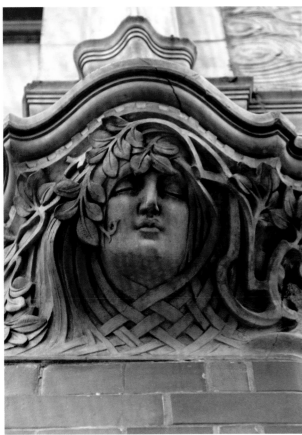
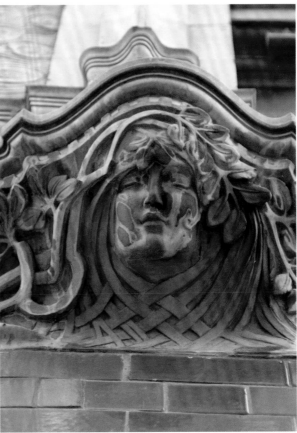

Doulton terracotta panels,
1898,
Orchard House,
Abbey Orchard Street,
Westminster,
London, UK.
Sculptor:
William James Neatby.

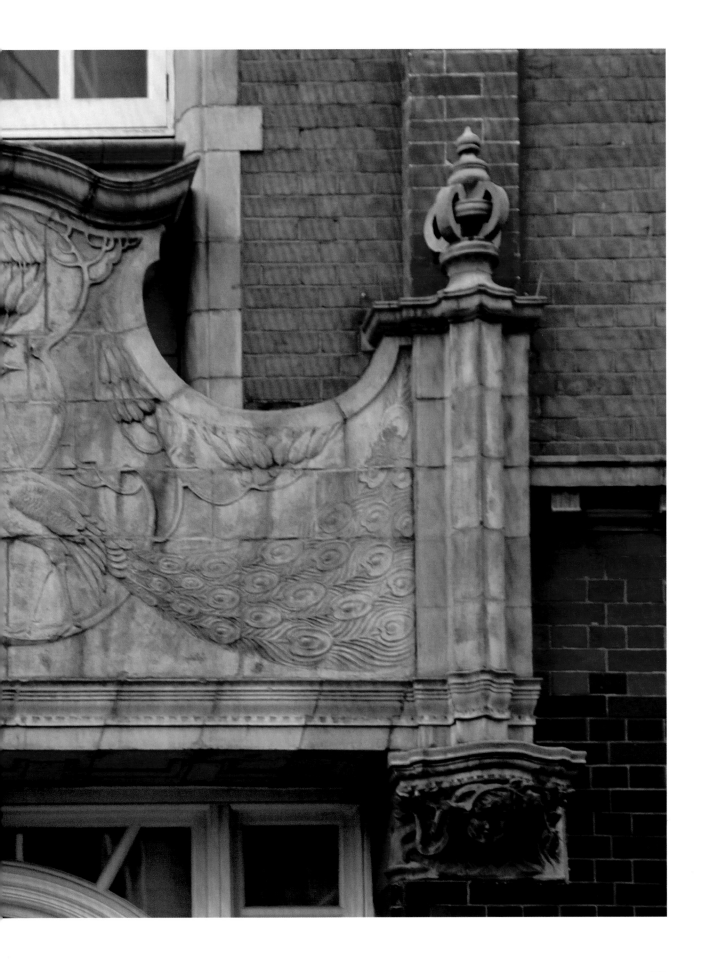

Wall tiles, 1917.
J & W Wade & Co,
Flaxman Tile Works,
Burslem, UK.

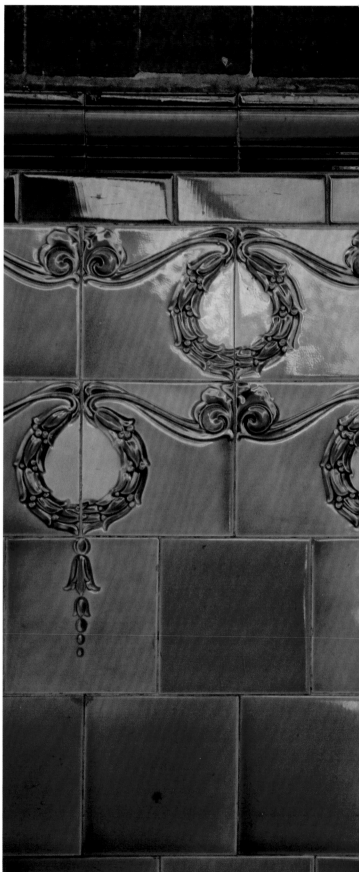

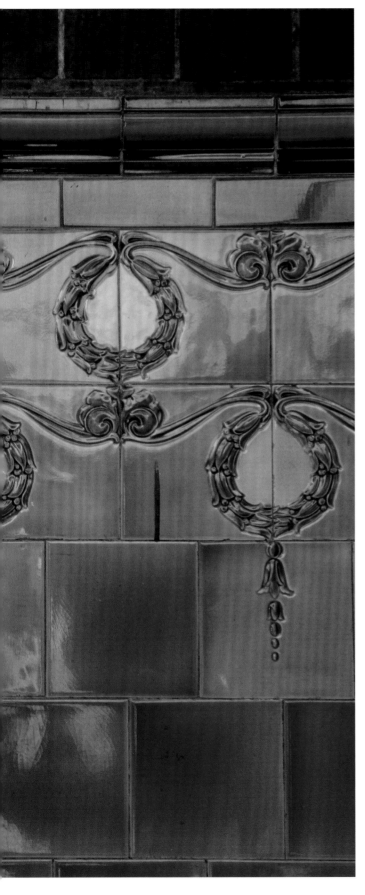

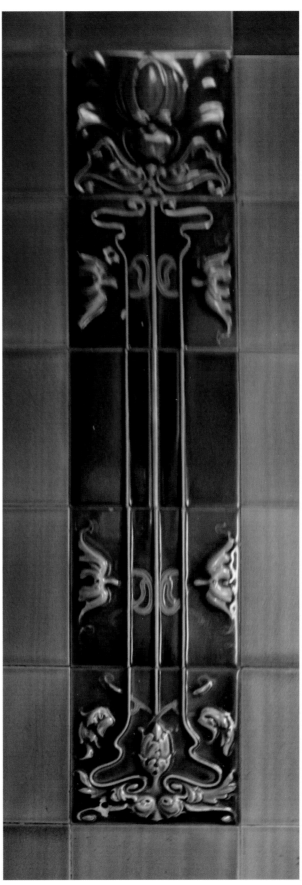

Above:
Brass plaque of architect
Charles Holden,
and right:
Brass door plaques,
The Municipal Central
Library, 1906,
College Green,
Bristol, UK.
Architect:
Charles Holden.

Charles Henry Holden
Litt.D, FRIBA MRTPI RDI,
1875-1960.
British architect.

Other notable structures:
Belgrave Hospital
for Children, Kennington,
London, UK.
A number of
Underground stations,
London and
Bristol Central Library, UK.

Red brick,
Belgrave Hospital for
Children, 1900-1903,
1 Clapham Road,
Kennington,
London, UK.
Architect:
Charles Holden.

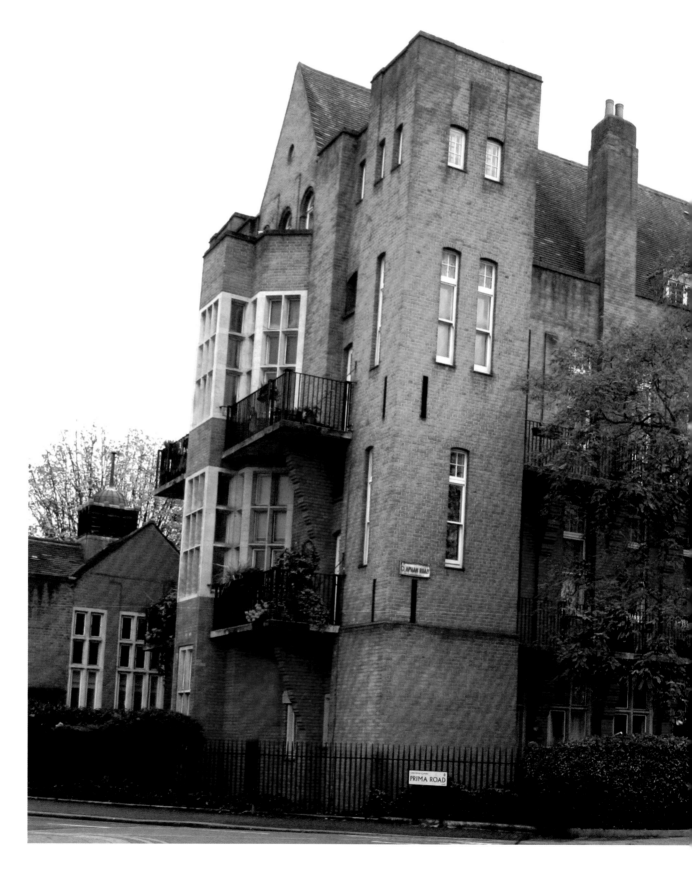

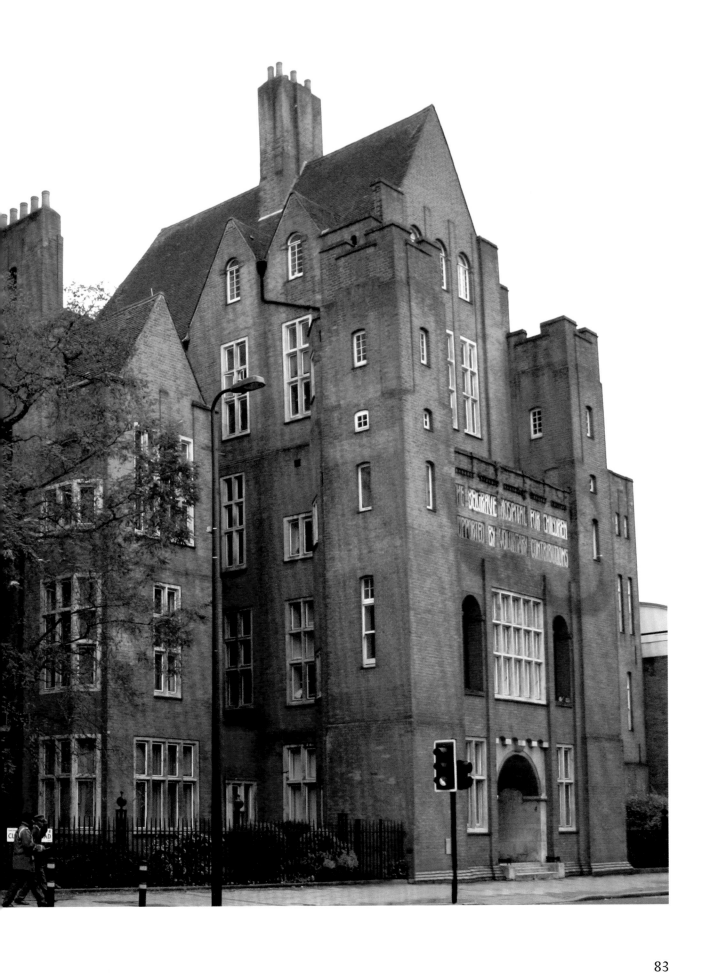

Facade signage,
Belgrave Hospital for
Children, 1900-1903,
1 Clapham Road,
Kennington,
London, UK.
Architect:
Charles Henry Holden.

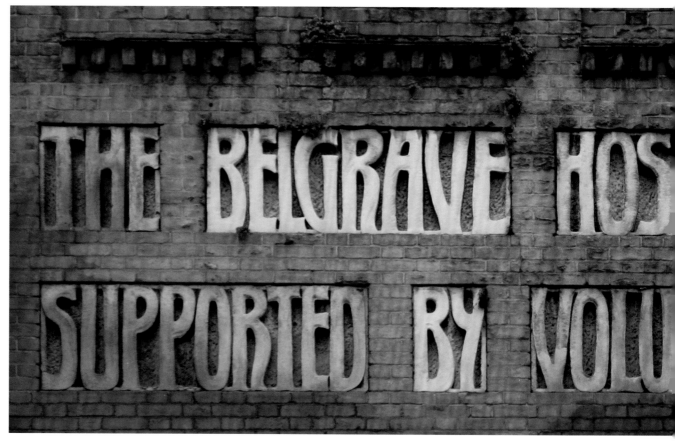

Hebrew Christian
Testimony to Israel, 1893,
180 Whitechapel Road,
London, UK.

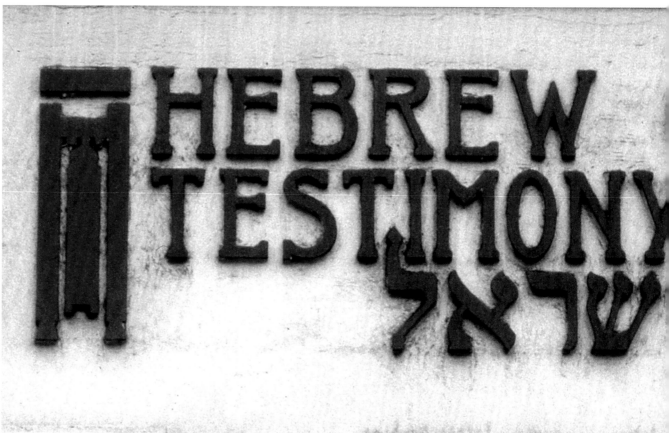

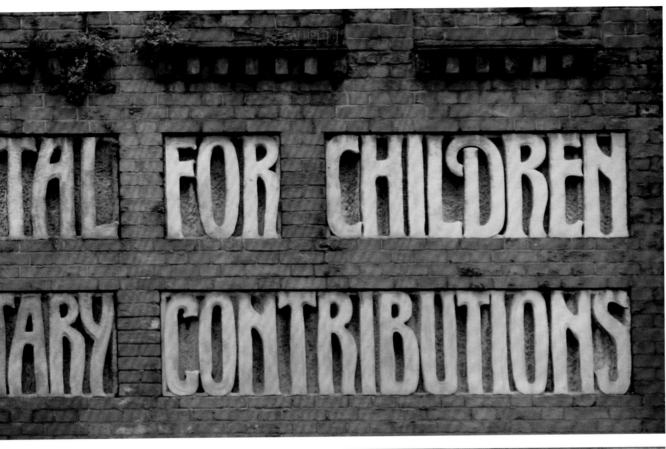

…TAL FOR CHILDREN
…TARY CONTRIBUTIONS

Above:
Belgrave Hospital
for Children, 1900-1903,
1 Clapham Road,
Kennington,
London, UK.
Architect:
Charles Holden.

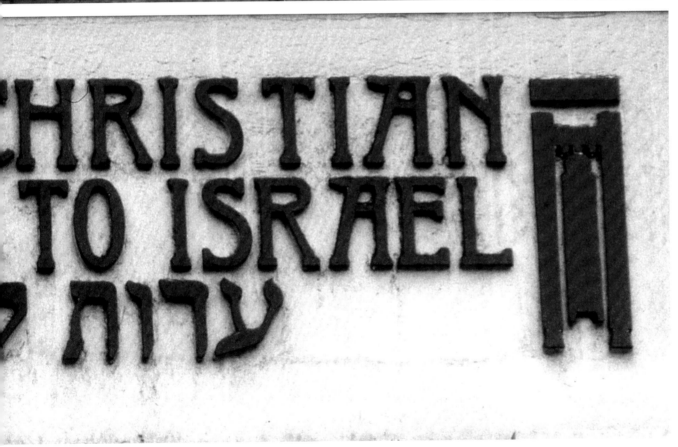

CHRISTIAN
TO ISRAEL
עירות

A selection of
metal door handles,
London, UK.

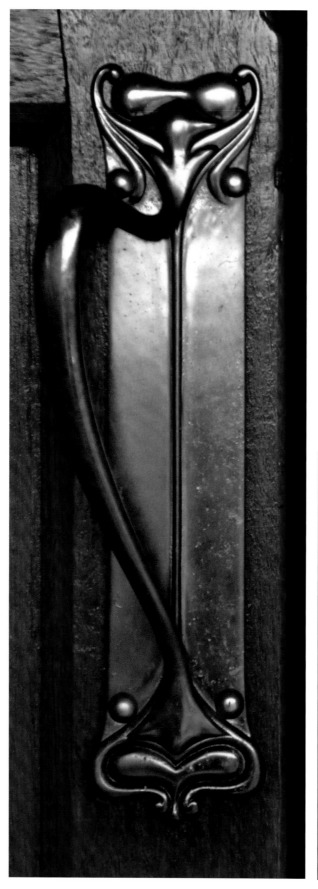

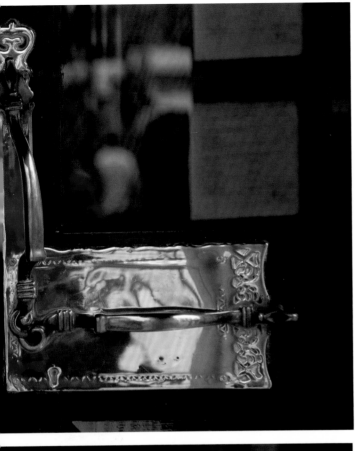

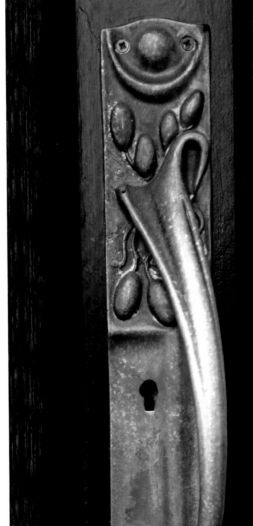

Above:
The Salisbury
public house, 1890s,
90 St Martin's Lane,
Covent Garden,
London, UK.
(The "Saloon" lettering
has since been polished
away.)

87

This page and opposite:
The Black Friar
public house, 1905,
174 Queen Victoria Street,
London, UK.
Architect:
Harold Herbert
Fuller-Clark.
Sculptures:
Nathaniel Hitch,
Frederick Callcott,
Henry Poole, and
Farmer and Brindley.

**Harold Herbert
Fuller-Clark,**
1869-1934.
British Arts and Crafts
architect.

Other notable work:
Boulting's Offices,
Riding House Street,
as well as residences
40 and 41a Foley Street,
London, UK.

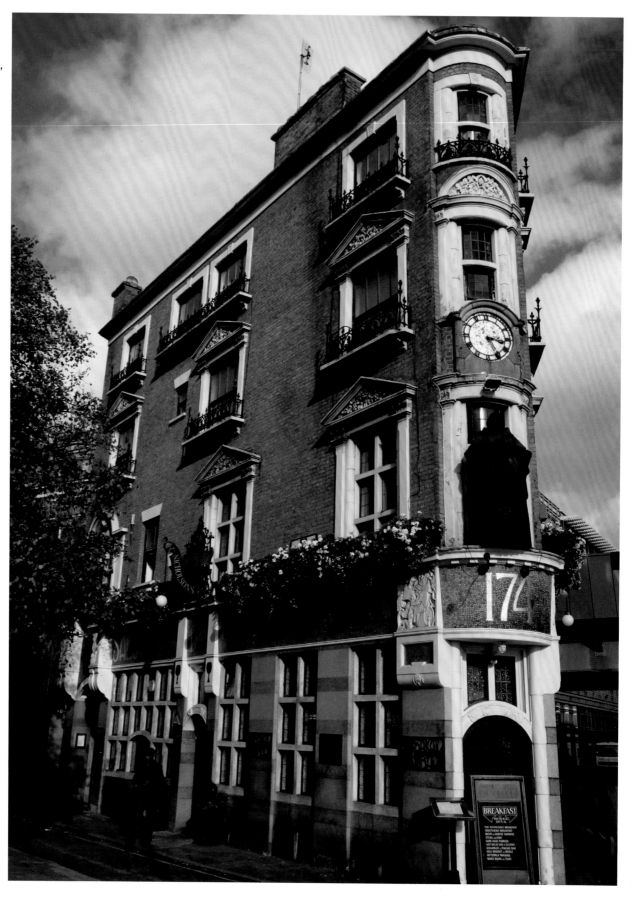

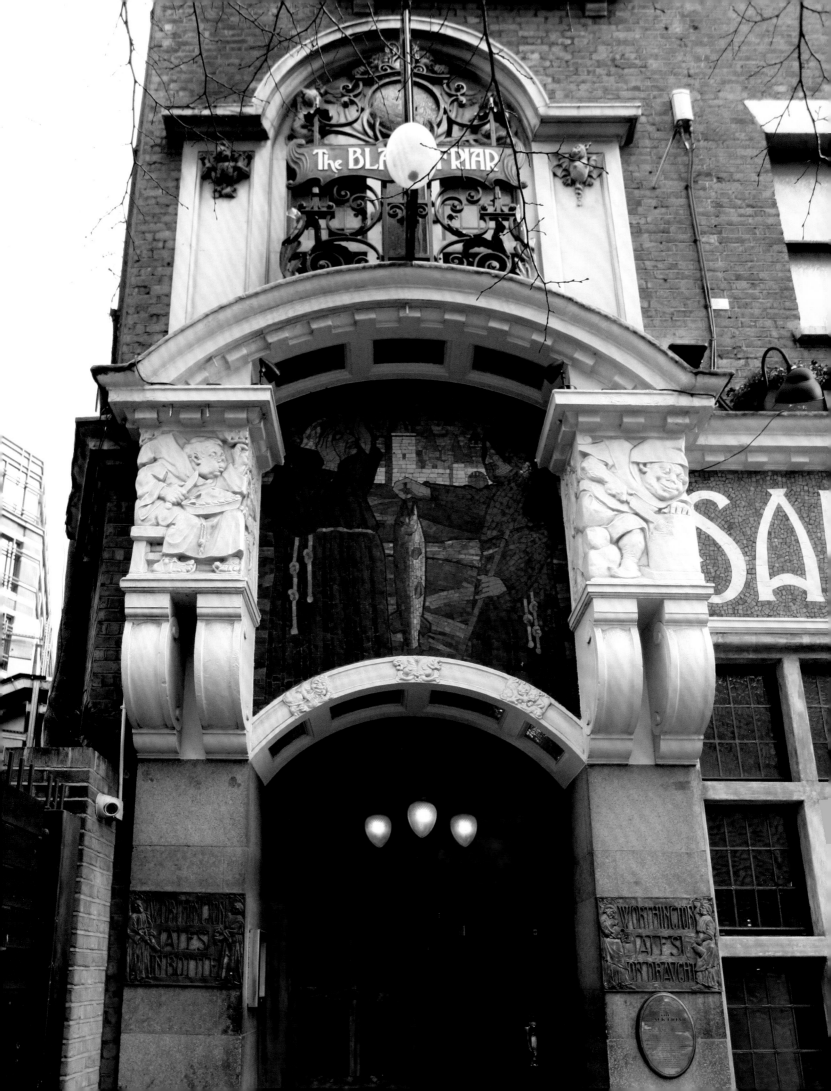

This page and opposite:
The Black Friar
public house, 1905,
174 Queen Victoria Street,
London, UK.
Architect:
Harold Herbert
Fuller-Clark.
Sculptor:
Henry Poole.
Exterior sculptures:
Nathaniel Hitch.

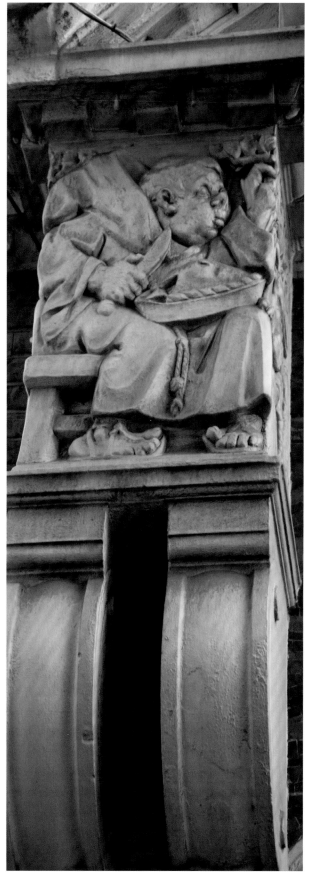

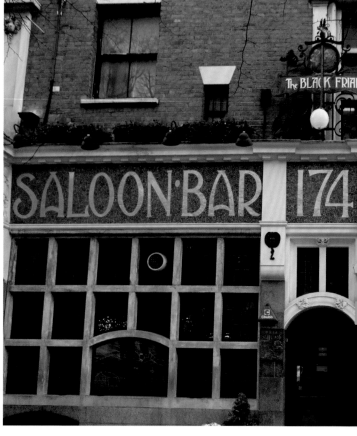

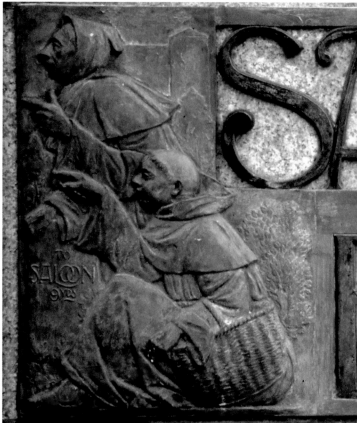

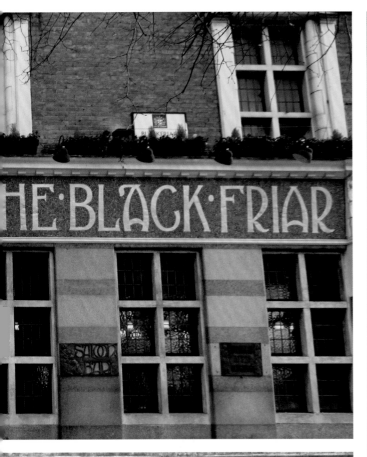

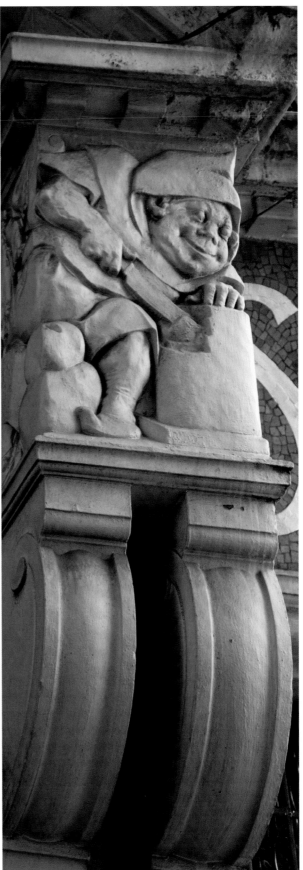

Nathaniel Hitch,
1845-1938.
British sculptor.

Noted sculptural work:
The Black Friar public
house exterior carvings
include a friar feeding pie to
an ass, and a friar cutting
into a cheese.
Hitch created sculptures
for Westminster Abbey,
London, and cathedrals in
Bristol, Canterbury,
Lincoln, Peterborough,
Truro, UK, also
Washington, USA,
Sydney, Australia
and Calcutta, India.

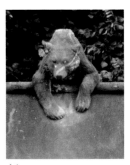

Above:
One of nine animal
sculptures built into
the Animal Wall
of Cardiff Castle,
Wales, UK.

This page and opposite:
Details,
The Black Friar
public house, 1905,
174 Queen Victoria Street,
London, UK.
Architect:
Harold Herbert
Fuller-Clark.
Sculptor:
Henry Poole.
Exterior sculptures:
Nathaniel Hitch.

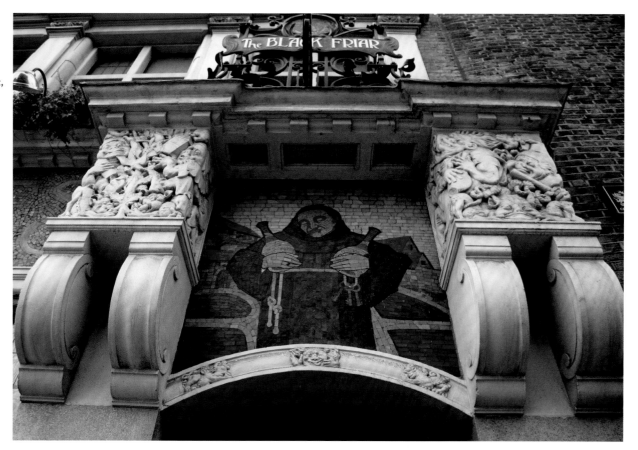

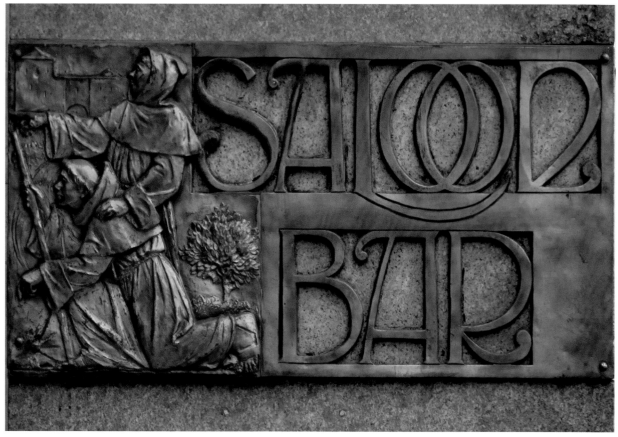

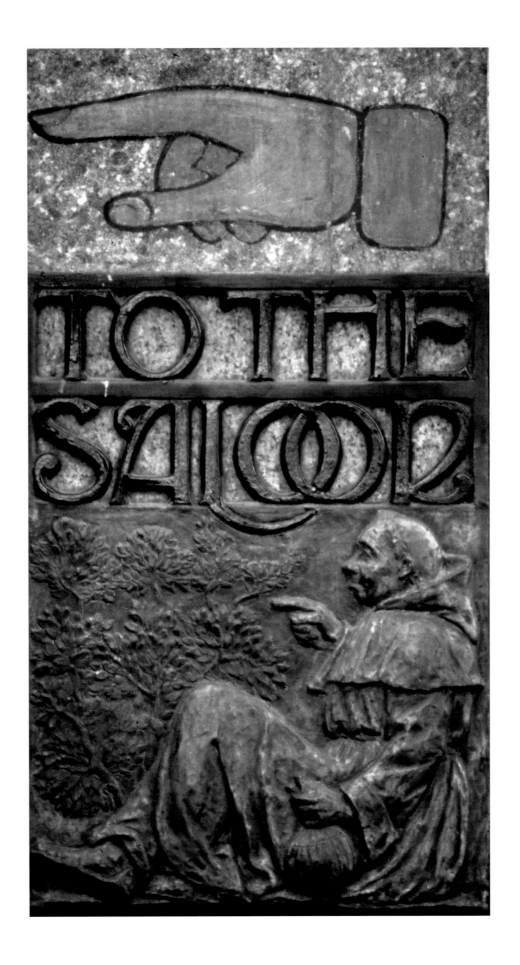

Stained-glass window,
The Black Friar
public house, 1905,
174 Queen Victoria Street,
London, UK.
Architect:
Harold Herbert
Fuller-Clark.

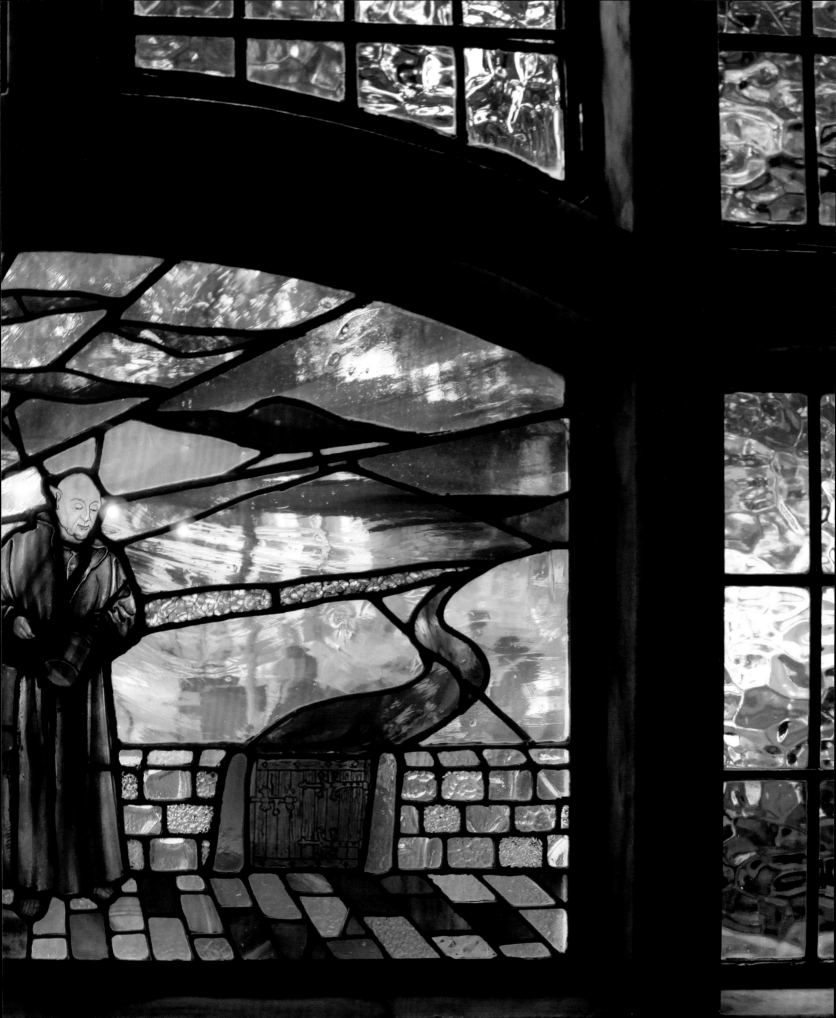

Interior,
The Black Friar
public house, 1905,
174 Queen Victoria Street,
London, UK.
Architect:
Harold Herbert
Fuller-Clark.

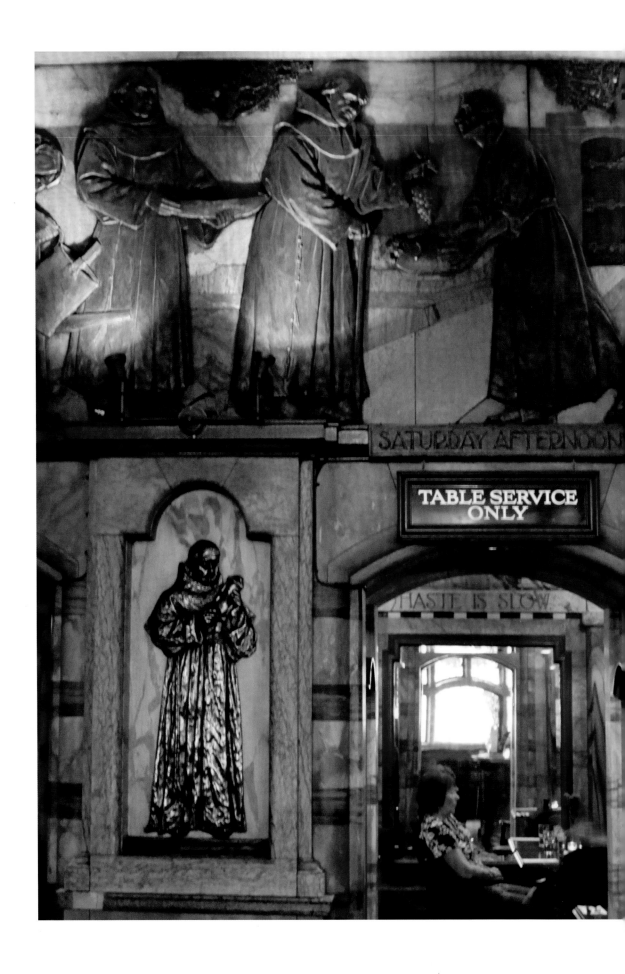

Interior, Dining area,
The Black Friar
public house, 1905,
174 Queen Victoria Street,
London, UK.
Architect:
Harold Herbert
Fuller-Clark.
Sculptor:
Henry Poole.

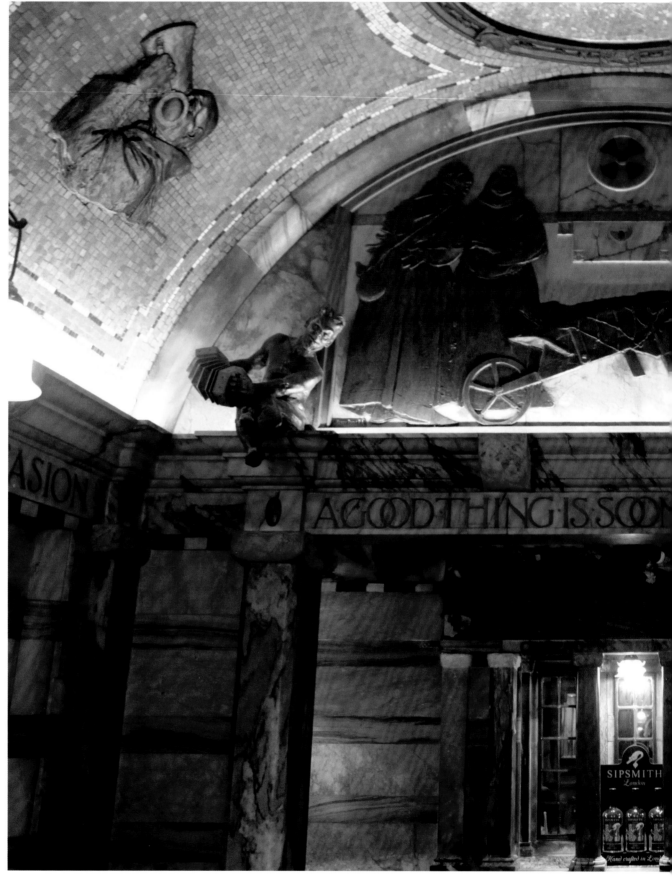

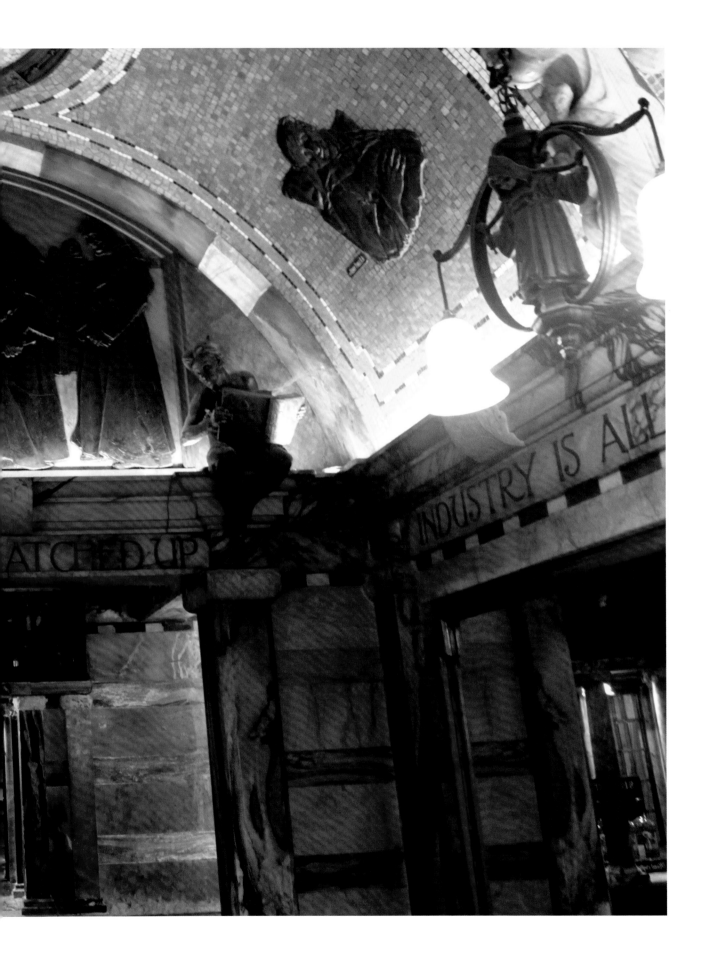

This page:
Belmont House, c.1903,
5-6 Candover Street,
London, UK.
Architect:
Harold Herbert
Fuller-Clark.

Opposite:
Tower House, 1903,
2 Candover Street,
London, UK.
Architect:
Harold Herbert
Fuller-Clark.

Harold Herbert
Fuller-Clark,
1869-1934,
British architect.

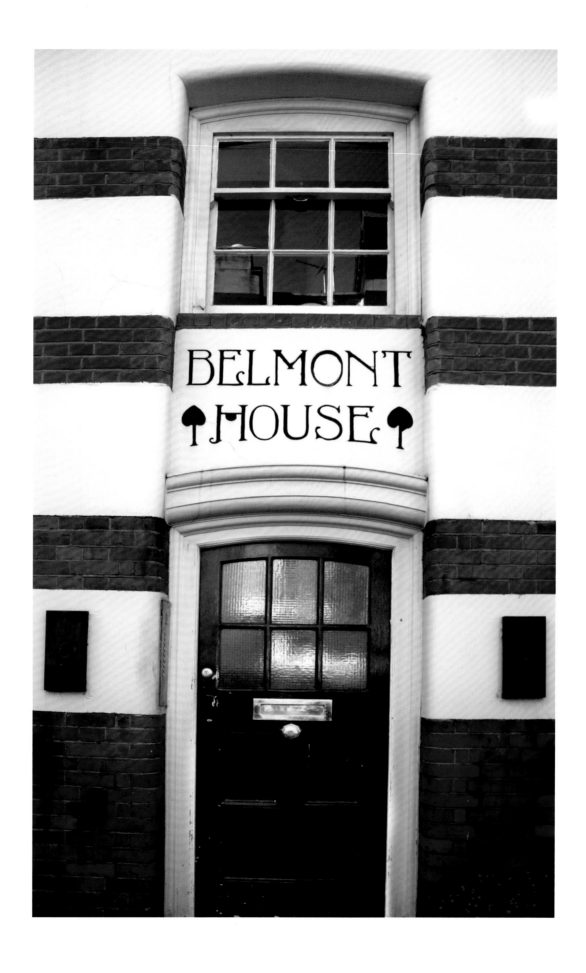

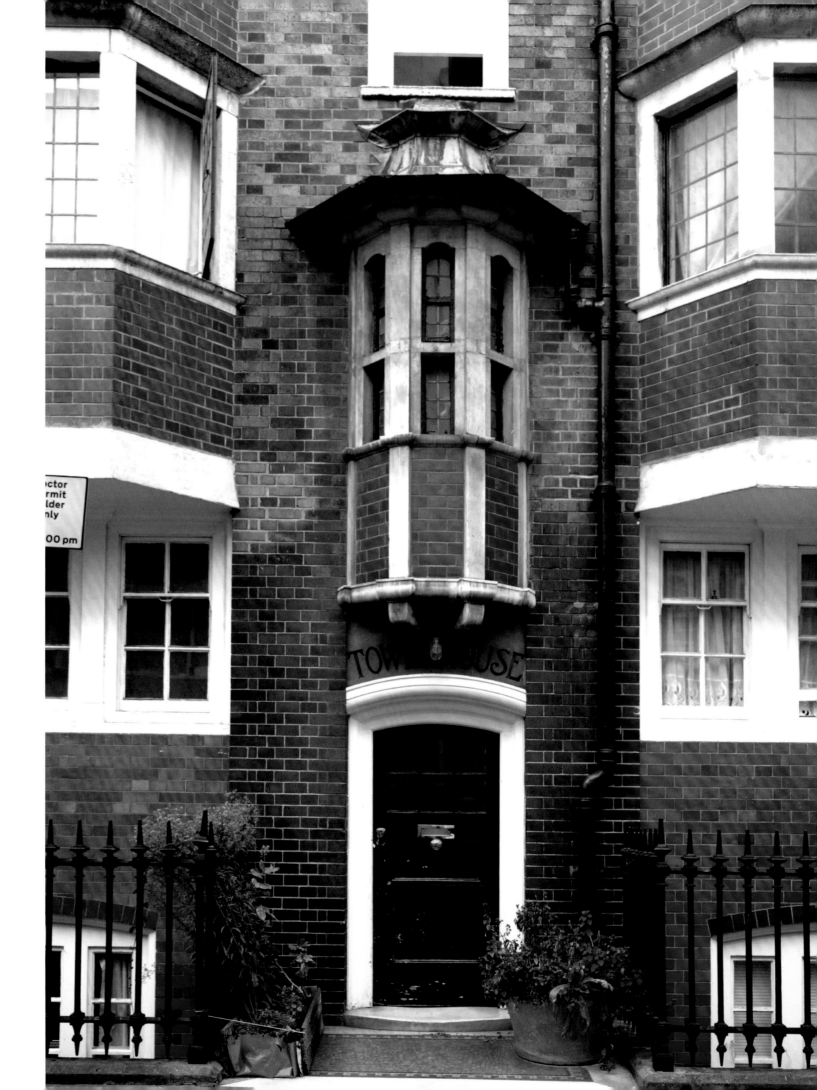

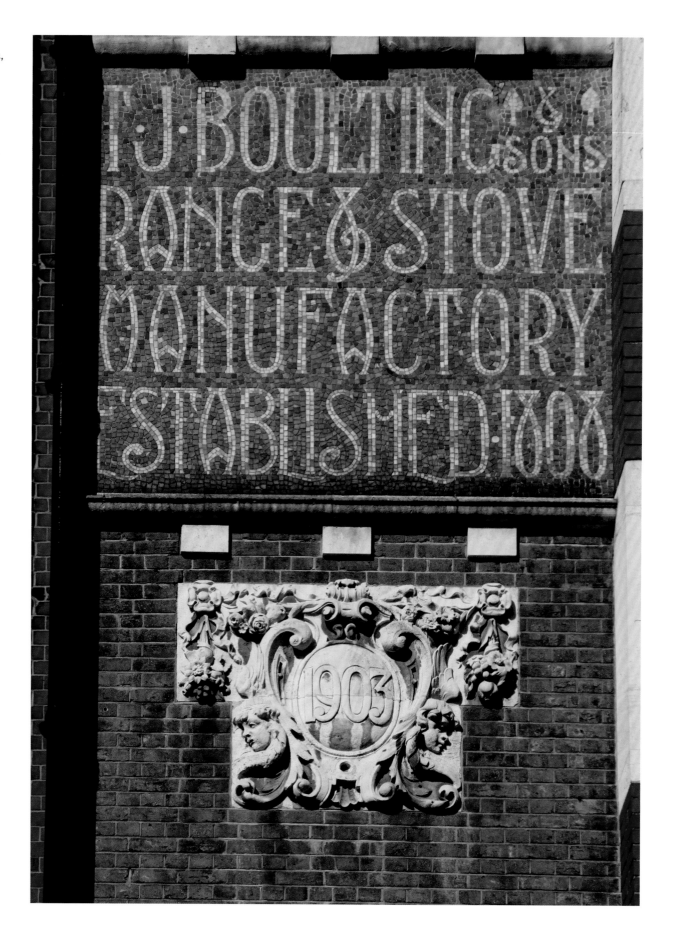

Mosaic signage,
T. J. Boulting & Sons,
1903,
59-61 Riding House
Street,
London, UK.
Architects:
Clark & Hutchinson.

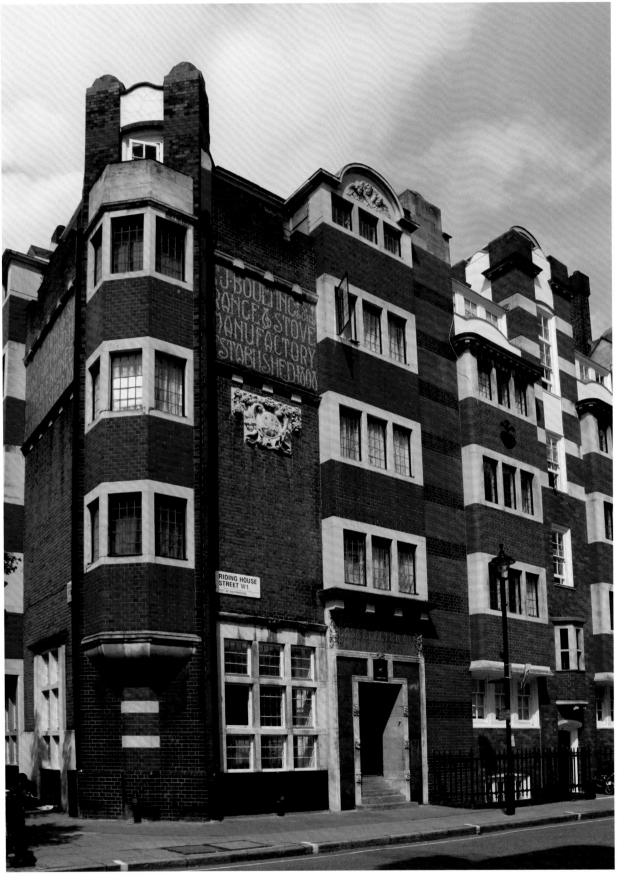

Facade,
T. J. Boulting & Sons,
1898,
59-61 Riding House Street,
London, UK.
Architects:
Clark & Hutchinson.

Above:
Relief sculpture, entrance, 16 Hans Road, **and right:** Brick-faced facade and Portland stone entry, 14-16 Hans Road, 1891-92, Knightsbridge, London, UK. Architect: Charles Francis Annesley Voysey.

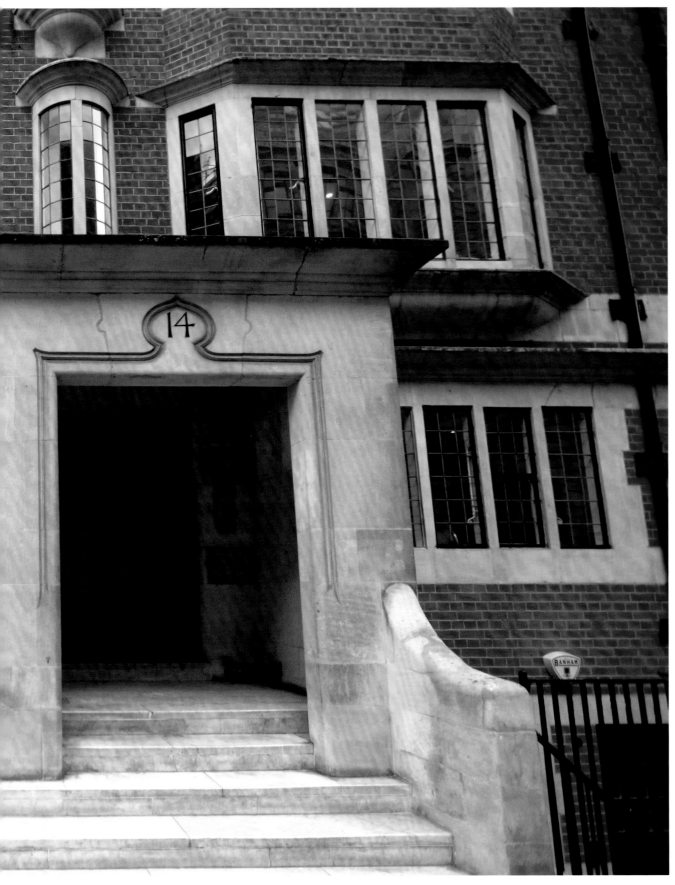

Above:
Relief sculpture,
entrance,
14 Hans Road,
1891-92.
Knightsbridge,
London, UK.
Sculptor:
Conrad Dressler.

**Charles Francis
Annesley Voysey,**
1857-1941.
British architect, and
furniture and textile
designer.

Other notable buildings:
Broad Leys Lodge,
Cumbria, UK.
Perrycroft, Malvern, UK.
Walnut Tree Farm,
Malvern, UK.

"Never look at an ugly
thing twice. It is fatally
easy to get accustomed to
corrupting influences."

105

Above:
Door number,
and right:
Facade,
"The Peacock House",
Debenham House,
1905-07,
8 Addison Road,
London, UK.
Architect:
Halsey Ricardo.
Tiles designed by:
William Frend
De Morgan.

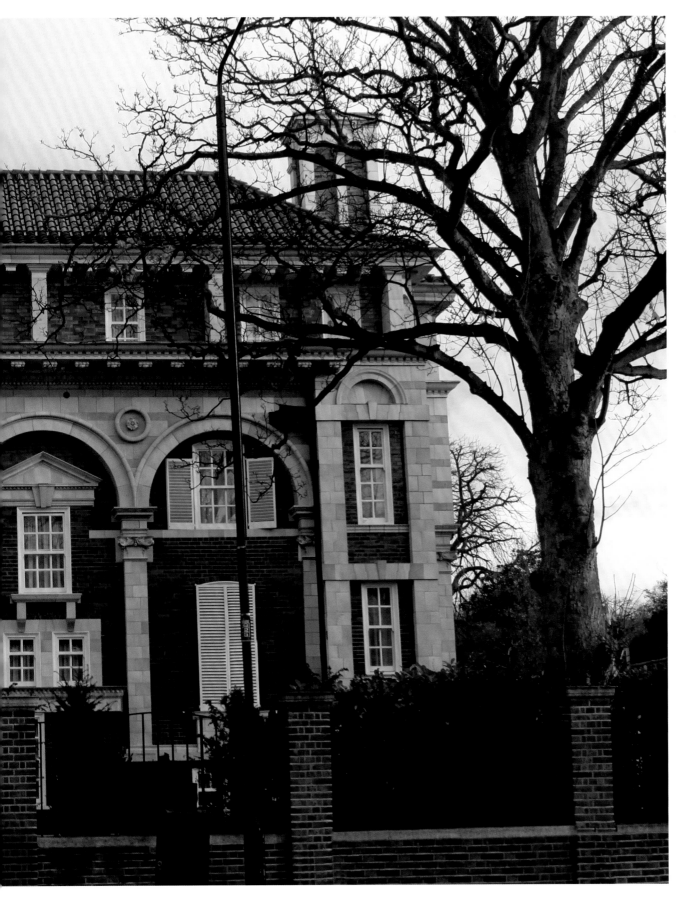

Halsey Ralph Ricardo, 1854-1928. British architect and designer. Ricardo worked in partnership with William Frend de Morgan, for whom he designed tiles, vases and other artifacts.

Other notable work: Ricardo's own house, "Woodside" (1905), Graffham, near Petworth, Sussex, UK.

"We have tried mass and form, and light and shade," he observed, "might we not now have an attempt at colour?"

Passageway,
"The Peacock House",
Debenham House,
1905-07,
8 Addison Road,
London, UK.
Architect:
Halsey Ricardo.
Tiles designed by:
William Frend
De Morgan.

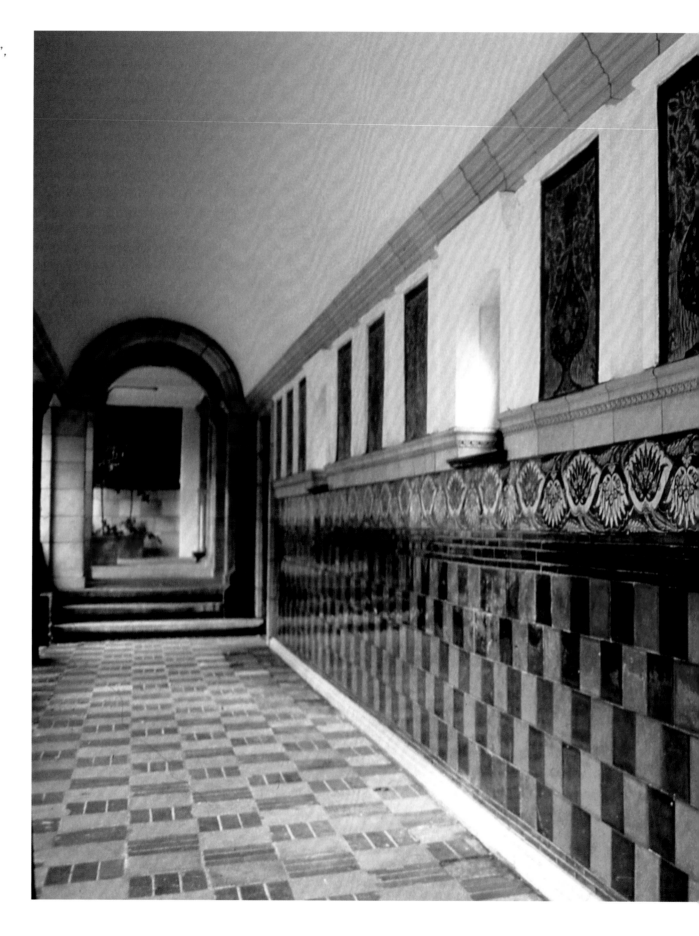

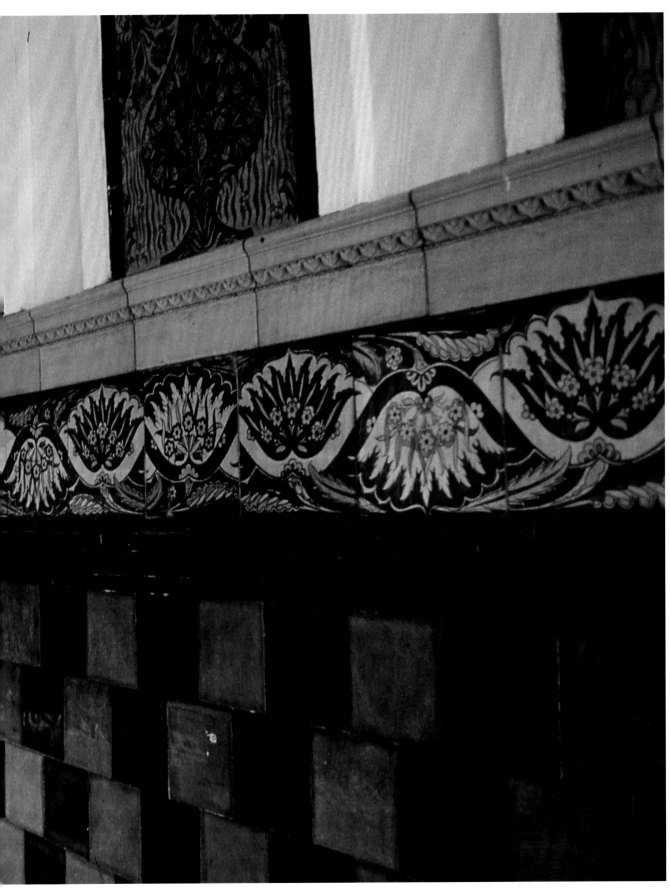

Above:
Royal Mail postal stamp.

William Frend De Morgan,
1839-1917.
British potter, tile designer
and novelist.
He designed tiles,
stained-glass and furniture
for Morris & Co.
His tiles were often based
on medieval designs.

Other notable work:
Leighton House,
Kensington, London, UK.
The Tabard,
Bedford Park,
Chiswick, London, UK.

Ceramic tiles,
Postman's Park,
The Memorial to Heroic
Self-Sacrifice, 1880,
Little Britain,
London, UK.
Tiles designed by
William Frend
De Morgan.

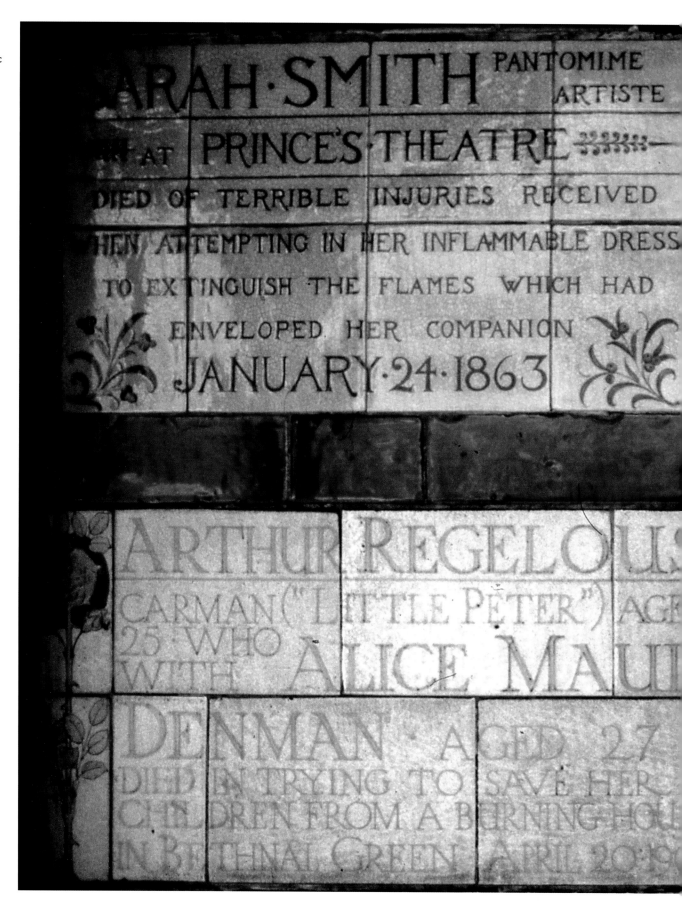

ROBERT·WRIGHT POLICE CONSTABLE

———·★★★∷∶ OF CROYDON ∷∶★★★★·———

ENTERED A BURNING HOUSE TO SAVE A WOMAN

KNOWING THAT THERE WAS PETROLEUM STORED

IN THE CELLAR - AN EXPLOSION TOOK PLACE

AND HE WAS KILLED

APRIL·30·1893

ARTHUR STRANGE

CARMAN OF LONDON·AND

MARK·TOMLINSON

ON A DESPERATE VENTURE
TO SAVE TWO GIRLS FROM A
QUICKSAND IN LINCOLNSHIRE
WERE THEMSELVES ENGULFED
AUG·25·1902

Above:
Tiles,
and right:
Facade,
The Tabard, 1880,
formerly the Tabard Hotel,
Bedford Park, Chiswick,
London, UK.
Architect:
Richard Norman Shaw RA.
Tiles:
William Frend De Morgan.

Richard Norman Shaw RA,
1831–1912, British architect.
Shaw was the leading architect
of his day.
His Queen Anne architecture
has been nicknamed
'Wrenaissance'.

Other notable work:
The planning and designing
of buildings for Bedford Park,
including St Michael and
All Angels Church.

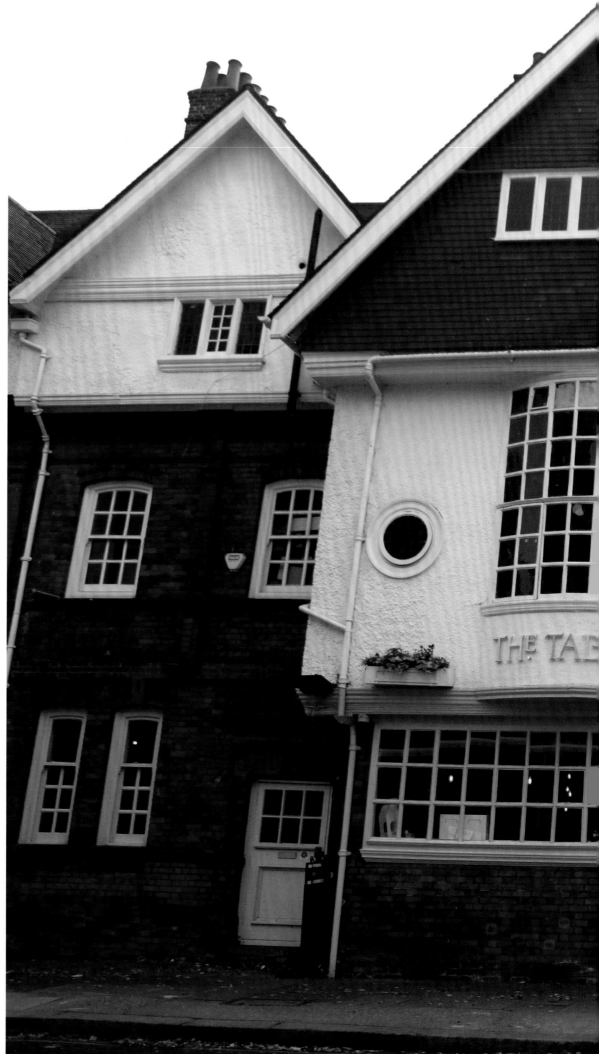

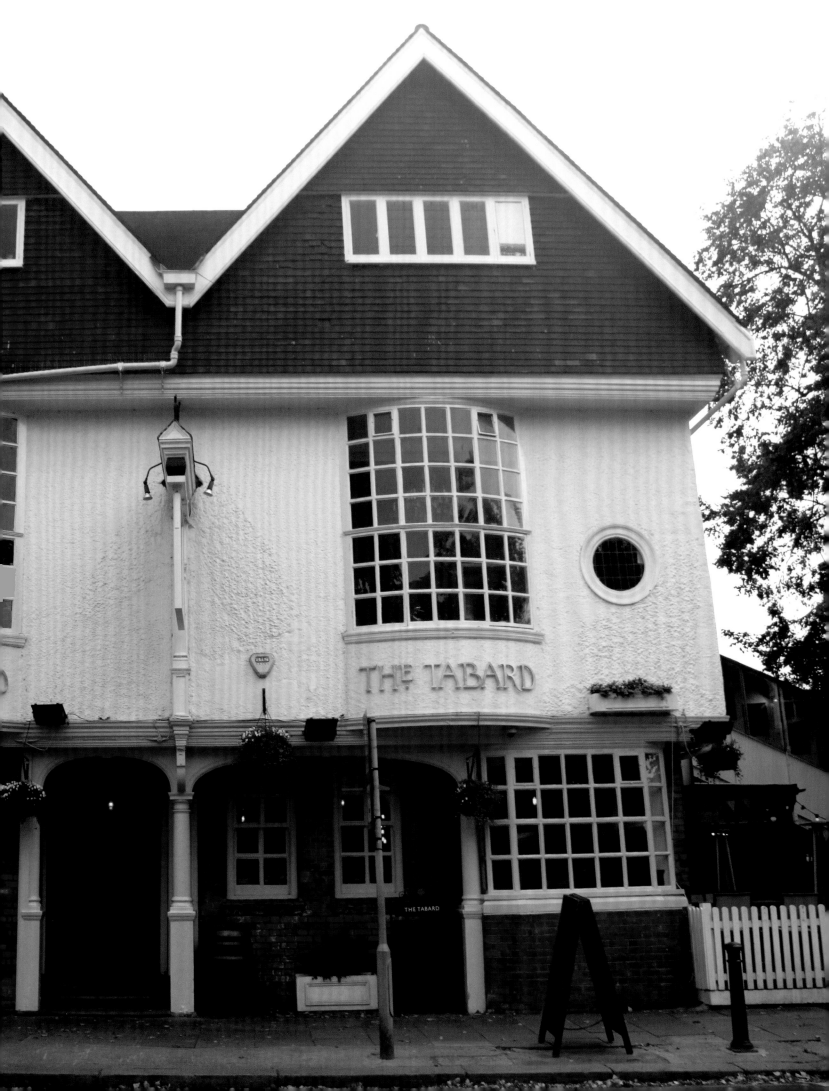

Queen Anne's Gardens,
1890s,
1 Rupert Road,
Bedford Park,
London, UK.
Architect:
Richard Norman Shaw RA.

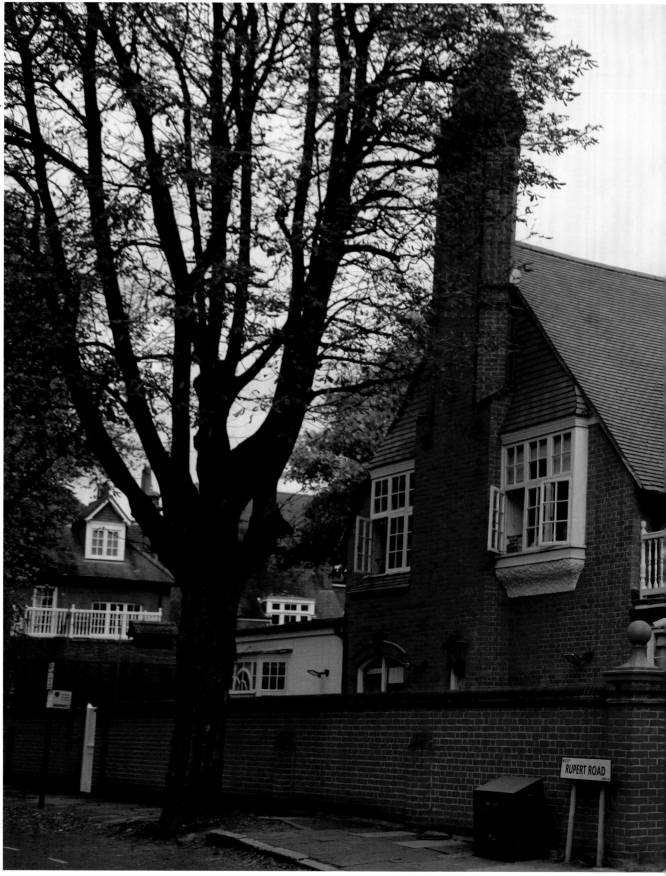

114

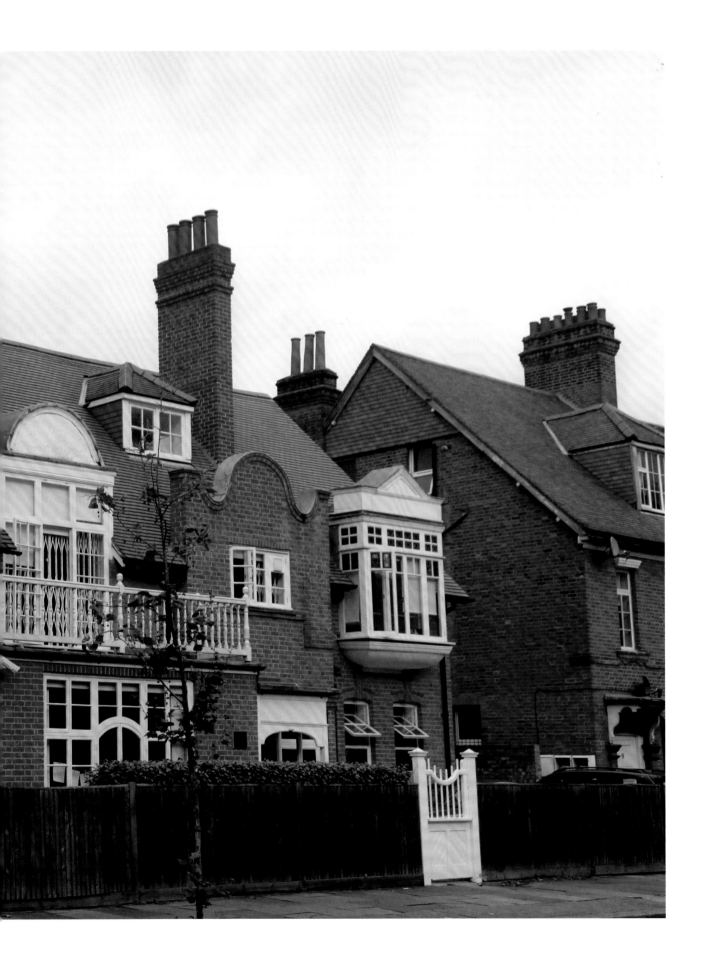

Facade,
Swan House, 1876,
17 Chelsea Embankment,
London, UK.
Architect:
Richard Norman Shaw RA.

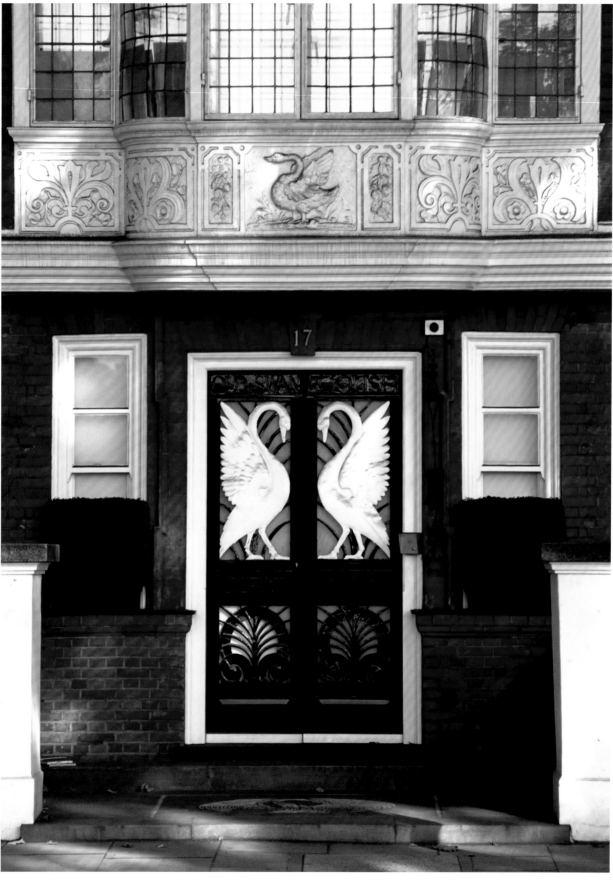

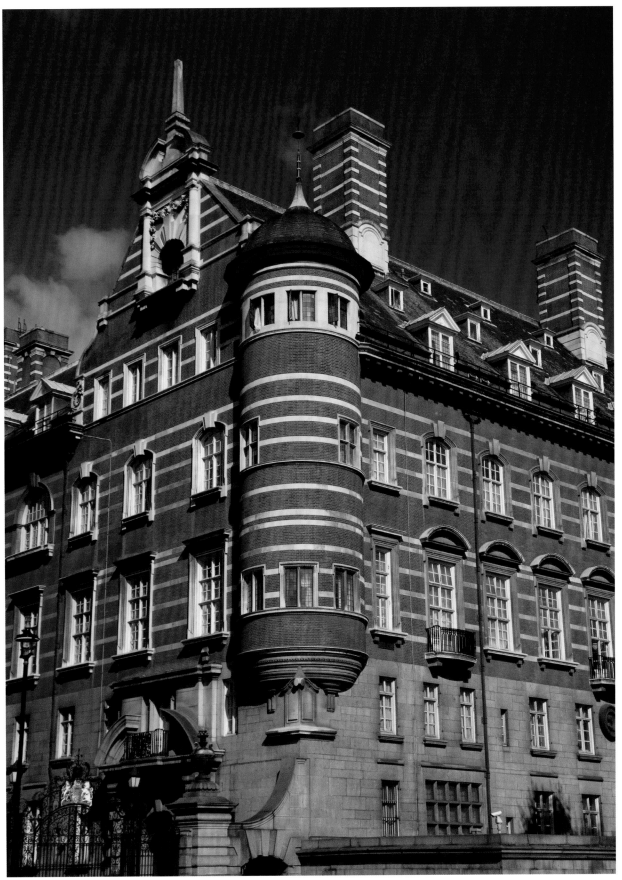

Facade,
New Scotland Yard, 1887,
(now the
Norman Shaw Buildings),
Victoria Embankment,
Westminster,
London, UK.
Architect:
Richard Norman Shaw RA.

St Paul's Studios, 1891,
Talgarth Road,
London, UK.
Architect:
Frederick Wheeler.

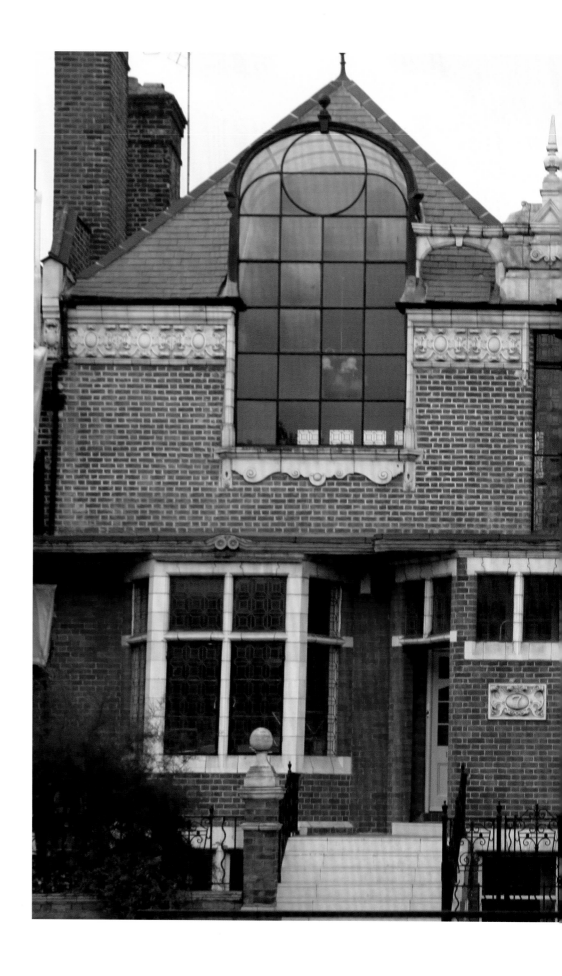

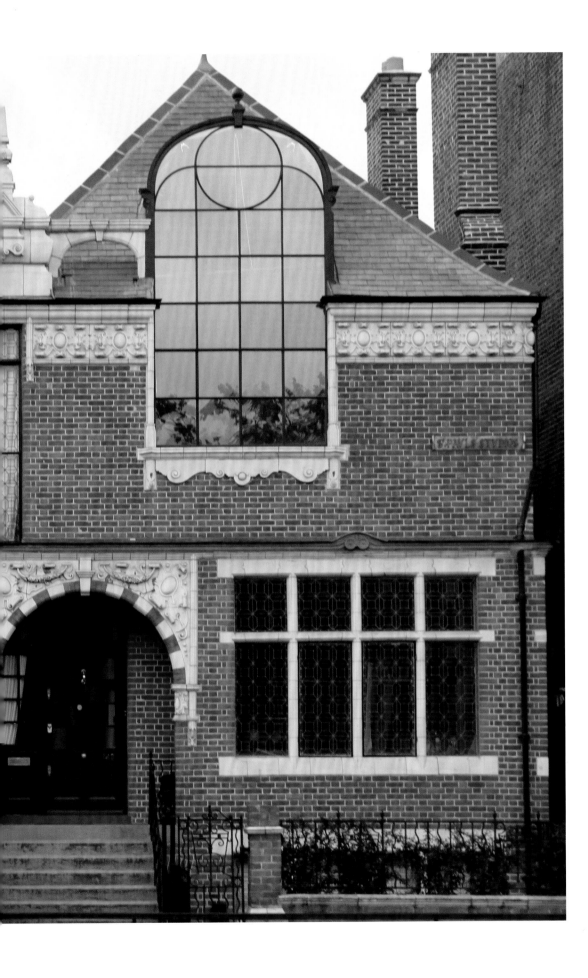

Frederick Wheeler, RIBA,
1853-1931,
British architect.

Other notable structures:
The Victoria
Embankment,
London, UK.
Mount Vernon Hospital,
Northwood, UK.

Red brick and
Portland stone facade,
Westminster
Fire Brigade Station,
1906,
Greycoat Place,
London, UK.
Architects:
William Edward,
H.F.T. Cooper and
London County Council
Architects Department.

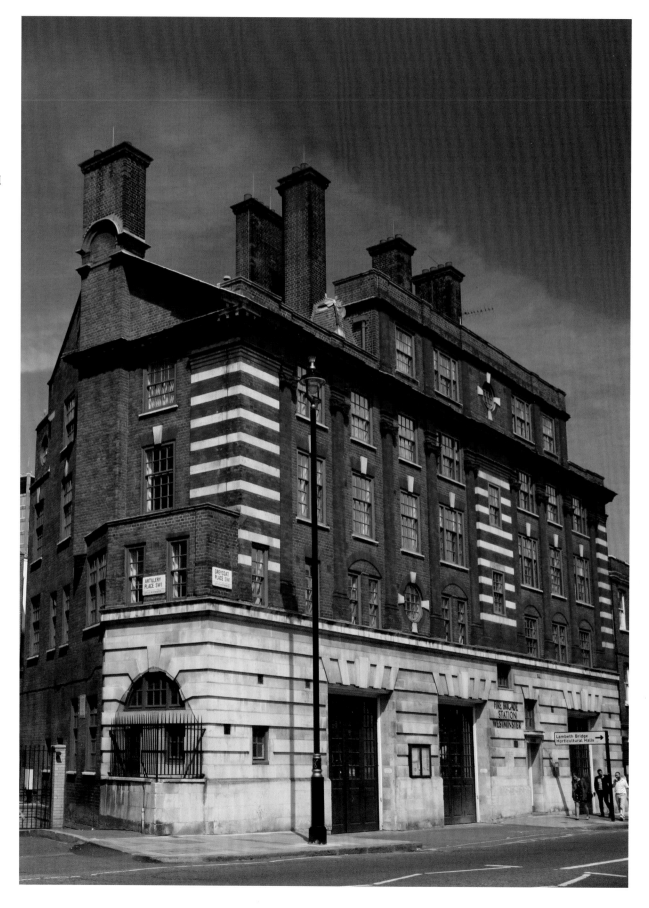

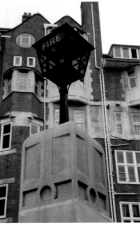

Above:
Fire station lantern,
and left:
Red brick and
Portland stone facade,
Euston Fire Station, 1902,
Euston Road,
London, UK.
Architects:
William Edward Riley,
H.F.T. Cooper and
London County Council
Architects Department.

William Edward Riley,
1852–1937,
British architect.
Architect to the
London County Council.

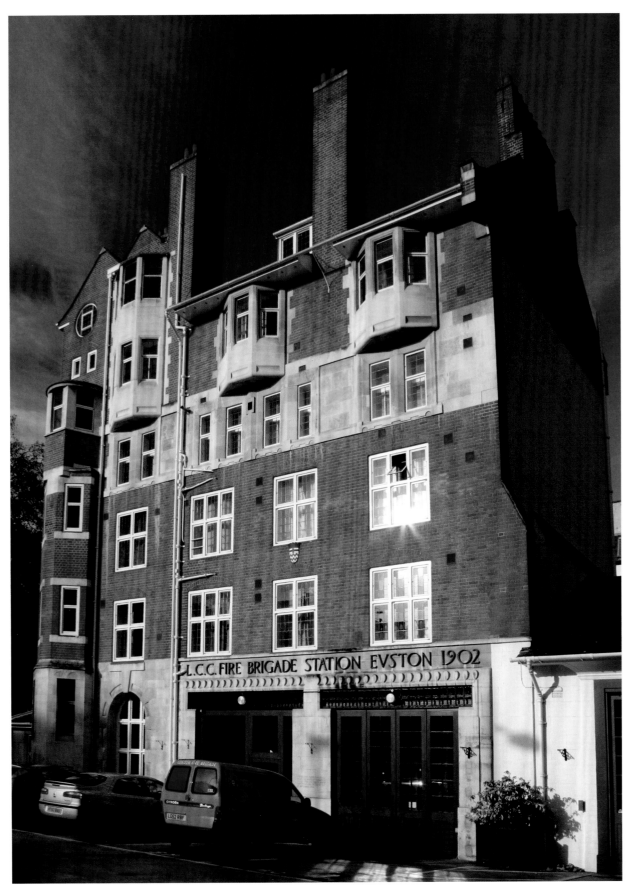

L.C.C. FIRE BRIGADE STATION EVSTON 1902

Mosaic sign,
Freeman, Hardy
and Willis, 1890s,
Market Place,
Hitchin,
Hertfordshire, UK.

Opposite:
The Prince Edward
public house, 1870s,
38 Parkhurst Road,
London, UK.

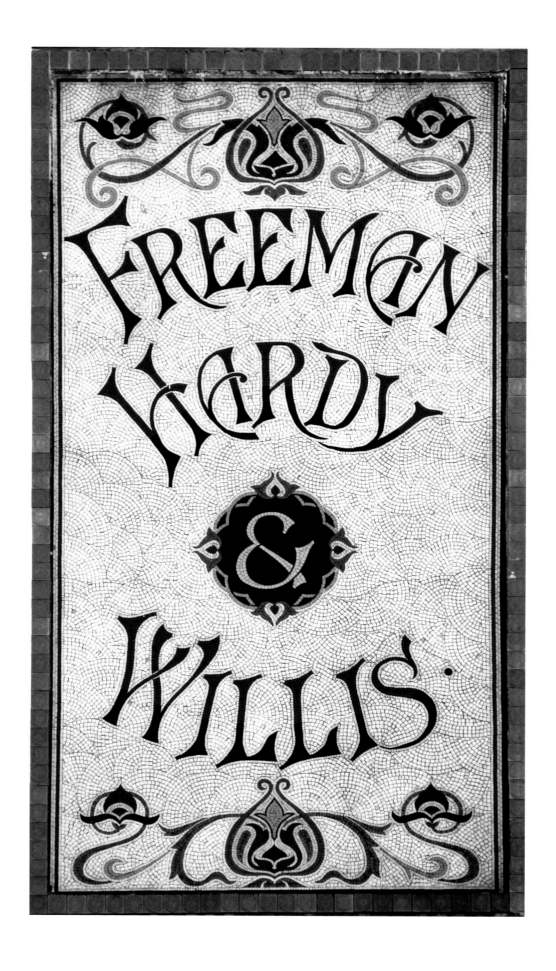

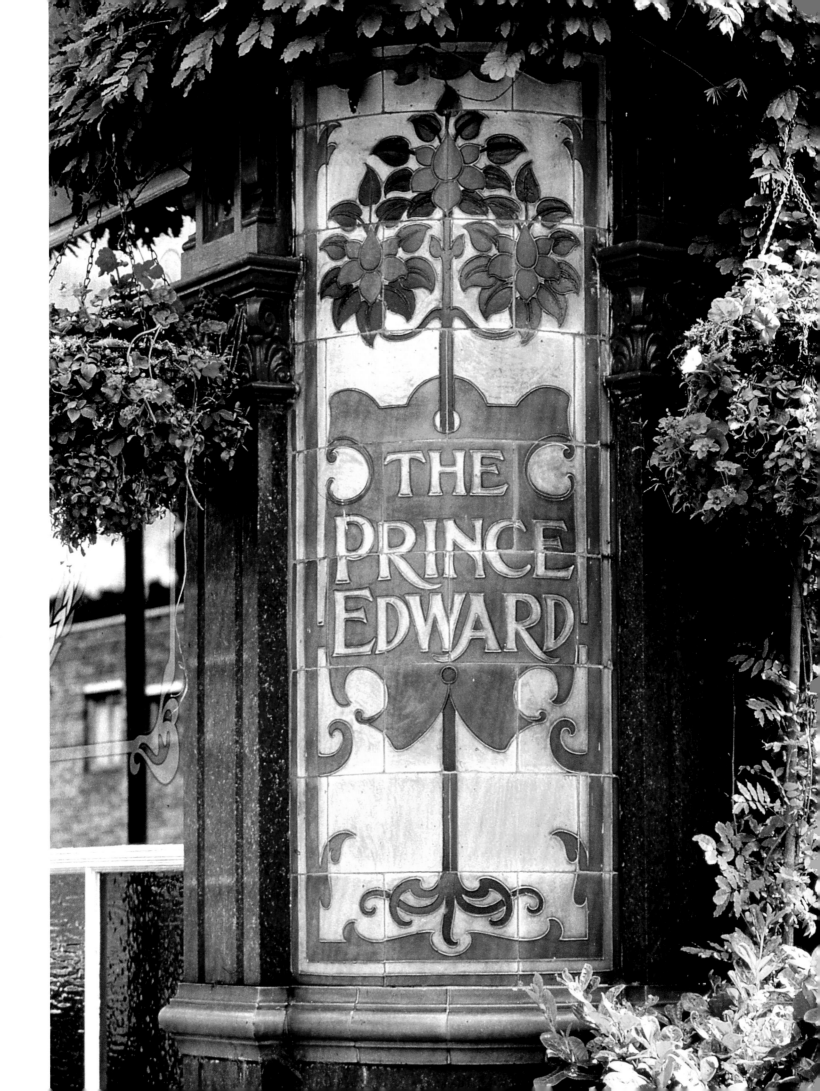

Former Temperance
Billiard Hall, 1912-1914,
134-141 King's Road,
Chelsea,
London, UK.
Architect:
Thomas Retford
Somerford.

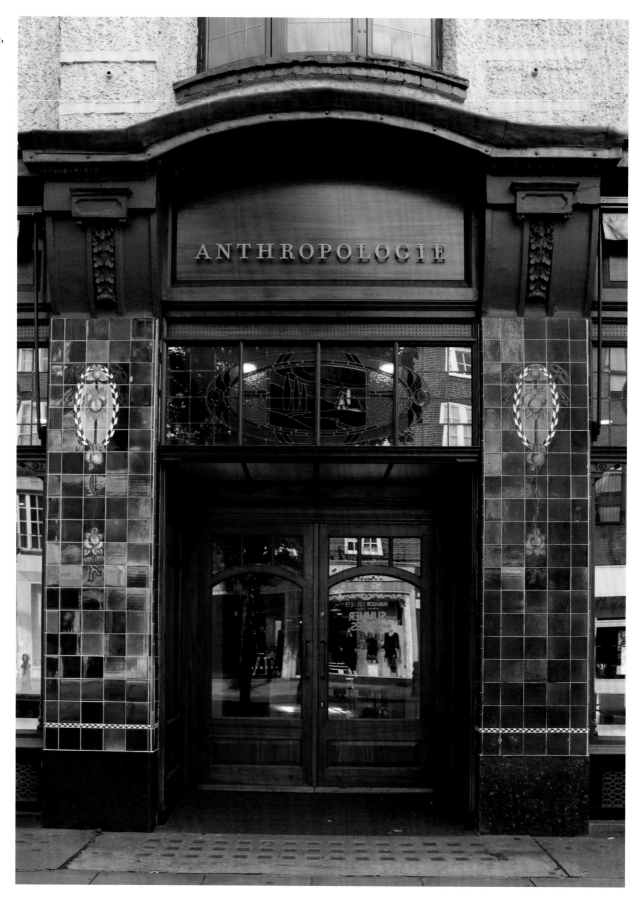

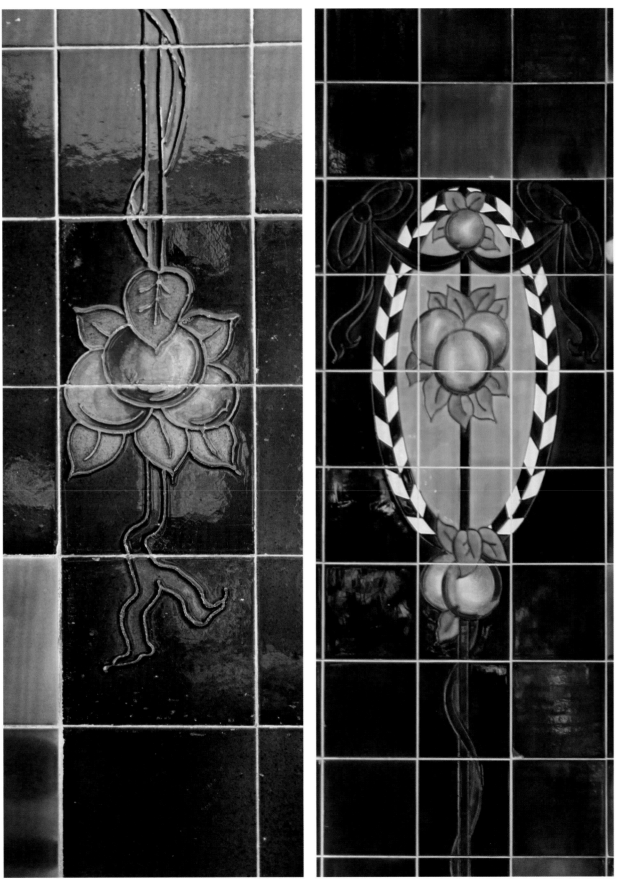

Details, tiled facade,
Former Temperance
Billiard Hall, 1912-1914,
134-141 King's Road,
Chelsea,
London, UK.
Architect:
Thomas Retford
Somerford.

**Thomas Retford
Somerford,**
1881-1948,
British architect.

Other notable work:
Somerford's Hall,
Brixton, London, UK.
The Astoria,
with E. A. Stone,
Brixton, London, UK.

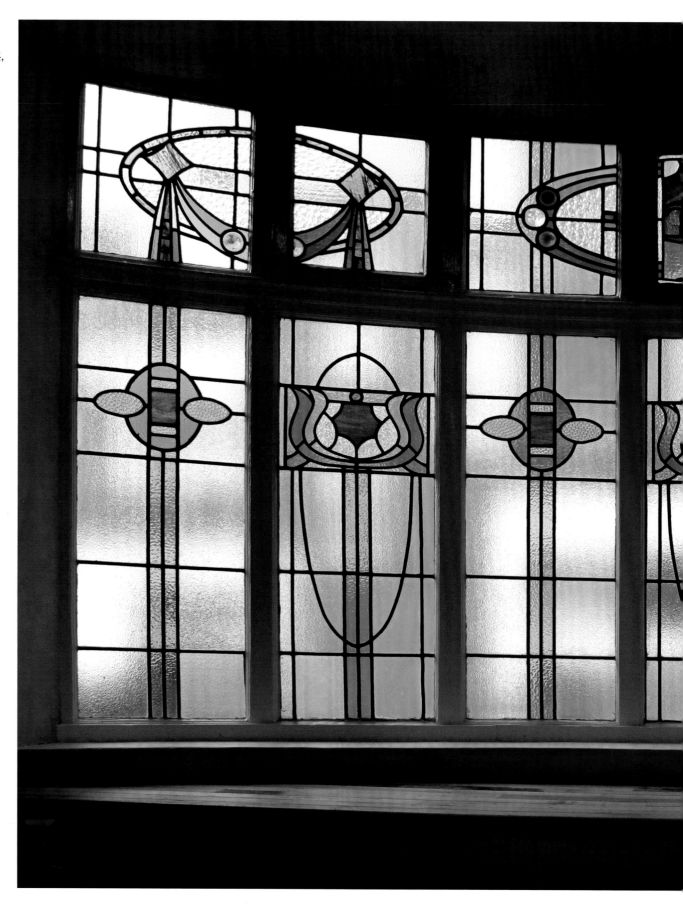

Stained-glass window,
former Temperance
Billiard Hall, 1912-1914,
134-141 King's Road,
Chelsea,
London, UK.
Architect:
Thomas Retford
Somerford.

126

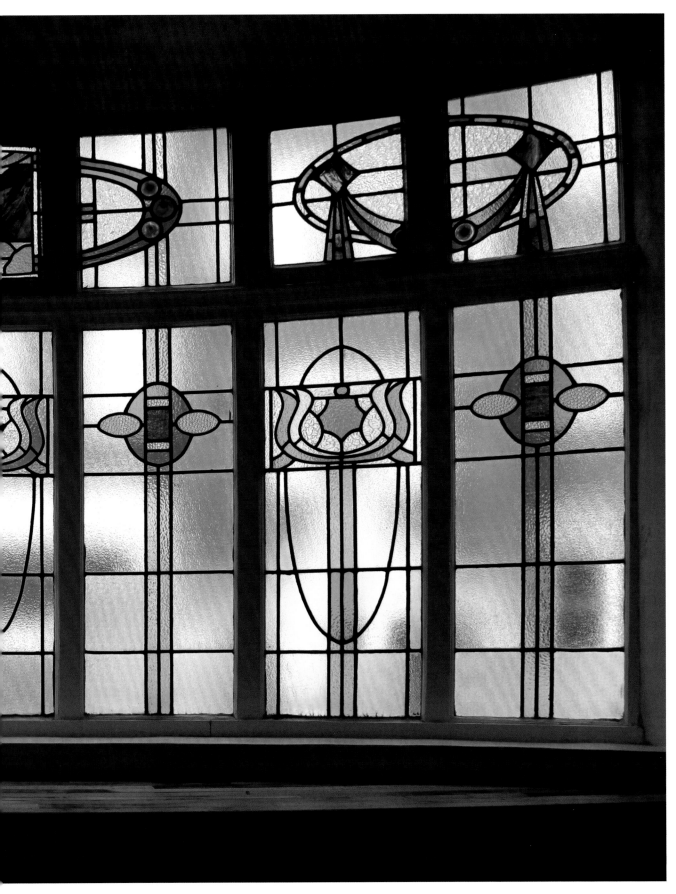

Overleaf:
Stained-glass window,
Former Temperance
Billiard Hall, 1912-1914,
134-141 King's Road,
Chelsea,
London, UK.
Architect:
Thomas Retford
Somerford.

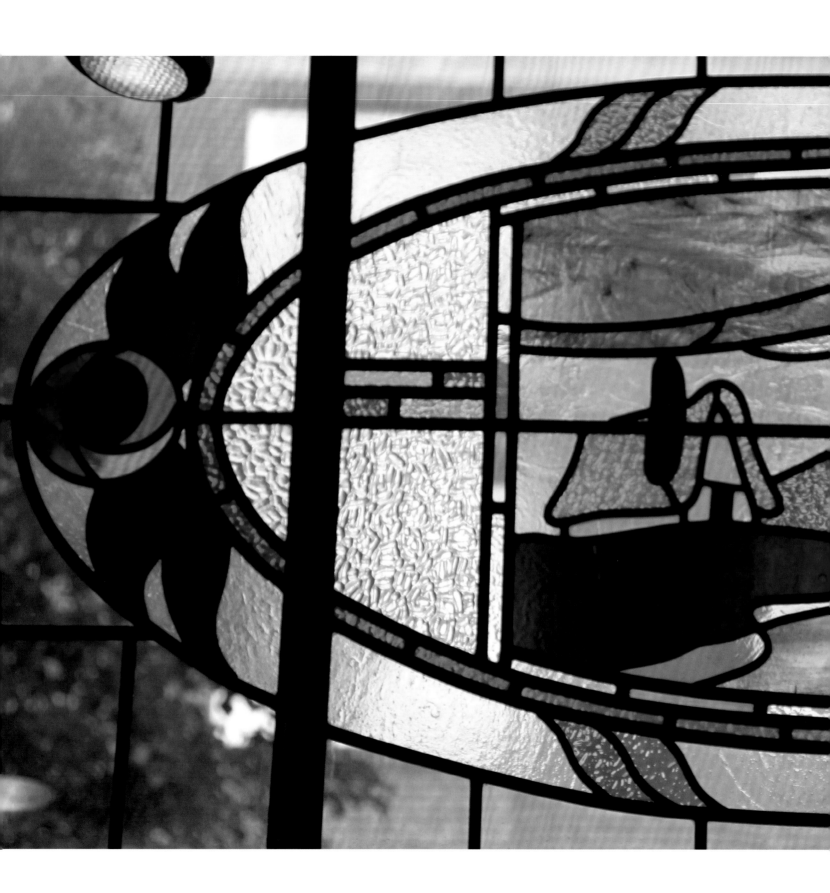

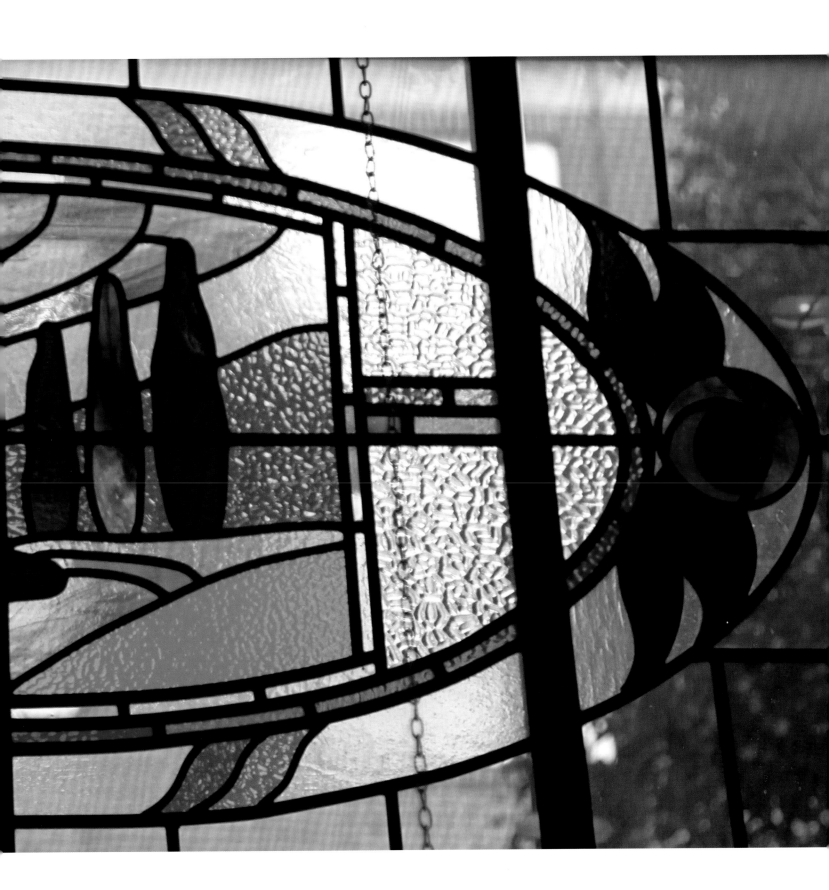

Bronze memorial,
Queen Alexandra
Memorial, 1926-1932,
Marlborough Road,
London, UK.
Sculptor:
Sir Alfred Gilbert.

Sir Alfred Gilbert RA,
1854-1934.
British sculptor
and goldsmith.

Other notable structures:
The Shaftesbury
Memorial Fountain,
Piccadilly Circus,
popularly referred to as
"Eros". One of the
first statues to be cast
in aluminium.

Above:
Detail,
The Shaftesbury
Memorial Fountain,
1885-93,
Piccadilly Circus,
London, UK.
Sculptor:
Sir Alfred Gilbert.

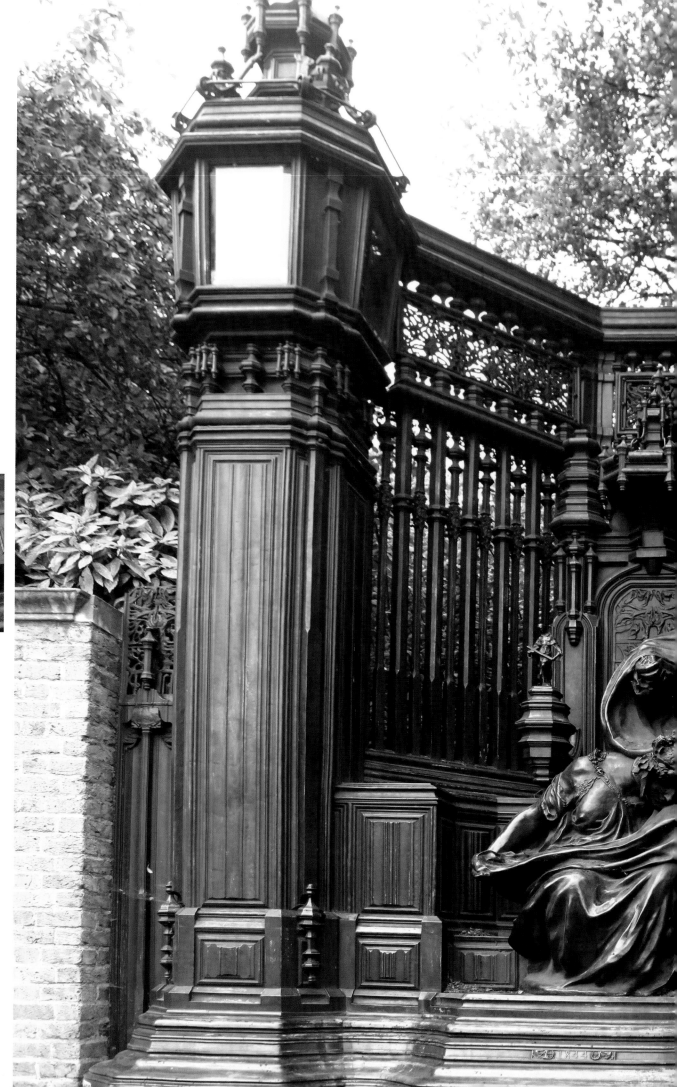

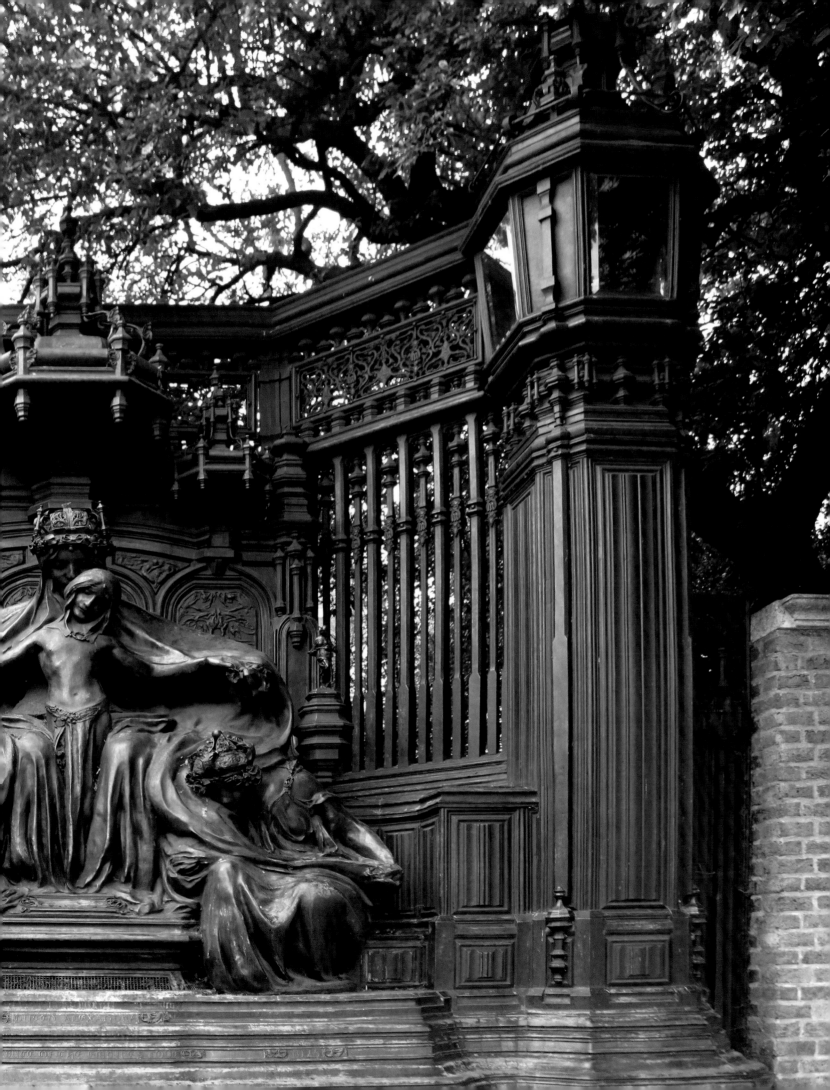

Detail, railing,
Holy Trinity Church,
1888-90,
Sloane Street,
London, UK.
Architect:
John Dando Sedding.

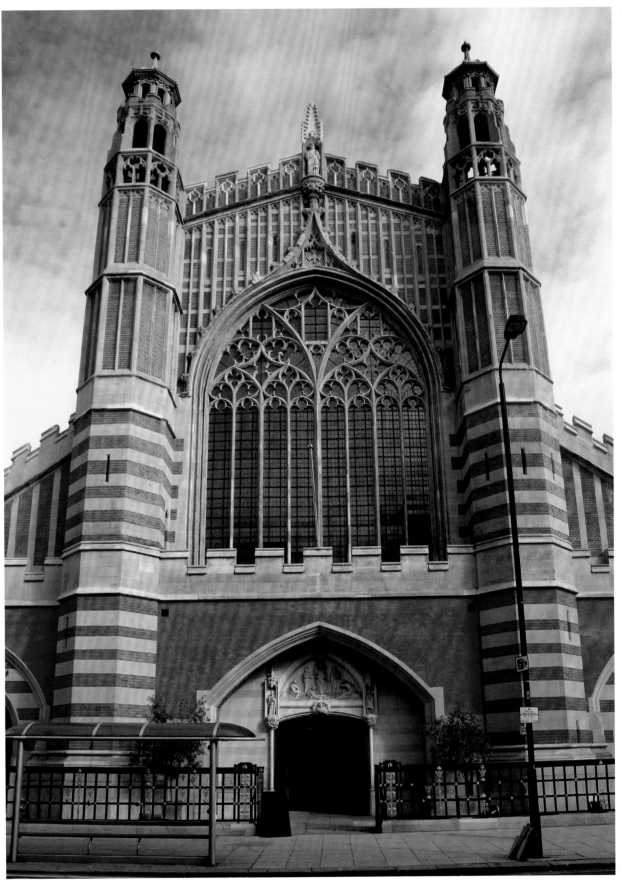

Above:
Memorial plaque to
architect John D. Sedding,
Holy Trinity Church.
and left:
Facade,
Holy Trinity Church,
1888-90,
Sloane Street,
London, UK.
Architect:
John Dando Sedding.

John Dando Sedding,
1838-1891. British
architect, an influential
figure in the Arts and
Crafts movement.

In 1876, Sedding met
Ruskin under whose
influence he developed
a Gothic Revival style,
introducing natural
ornament into his designs.

Other notable structures:
Church of St Martin,
Marple and St Mary's
Church, Potsgrove, UK.

"I need not print a line,
nor conjure with the
painter's tools to prove
myself an artist ... Whilst
in other spheres of labor
the greater part of our
life's toil and moil will of
a surety end, as the wise
man predicted, in vanity
and vexation of spirit,
here is instant physical
refreshment in the work the
garden entails, and, in
the end, our labor will be
crowned with flowers."

This page and opposite:
Interior,
Holy Trinity Church,
1888-90.
Sloane Street,
London, UK.
Architect:
John Dando Sedding.
Stained-glass window
designed by
Edward Burne-Jones.

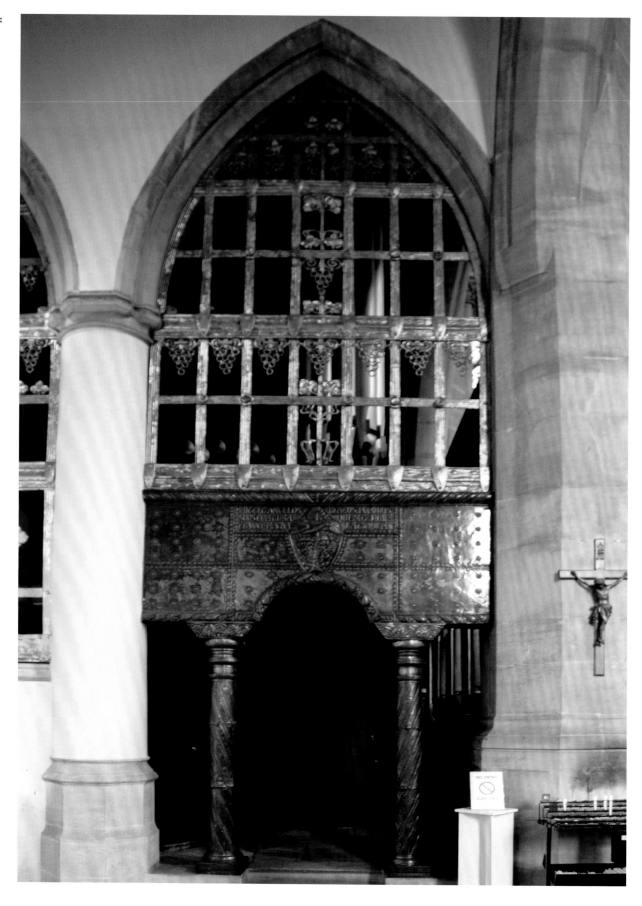

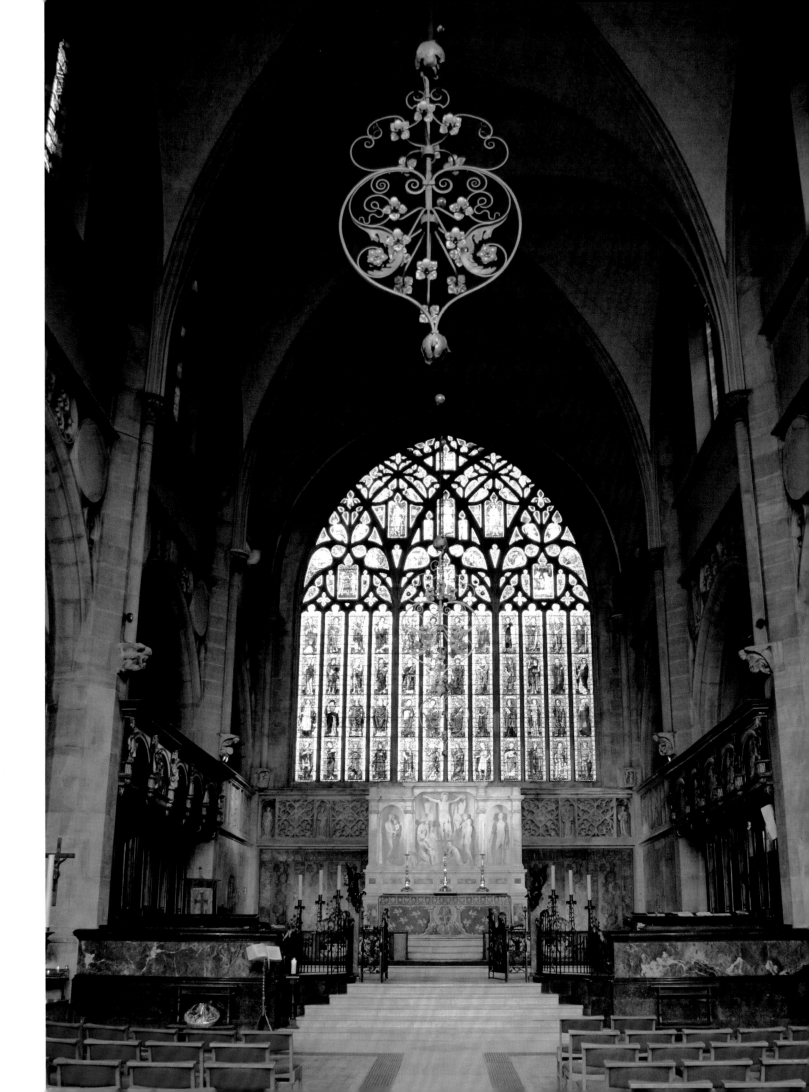

The Horniman Museum,
1898-1901,
100 London Road,
Forest Hill,
London, UK.
Architect:
Charles Harrison
Townsend.

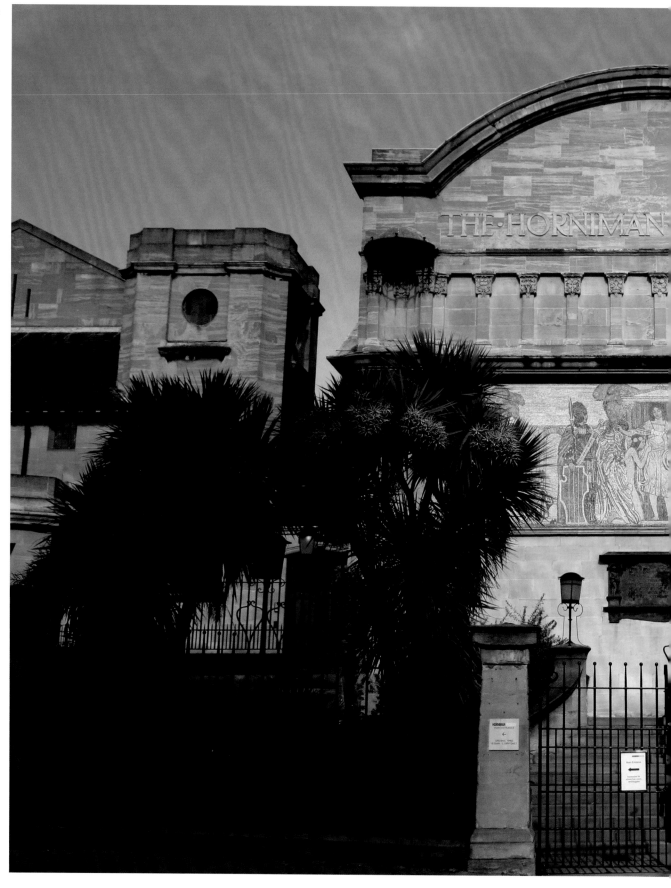

136

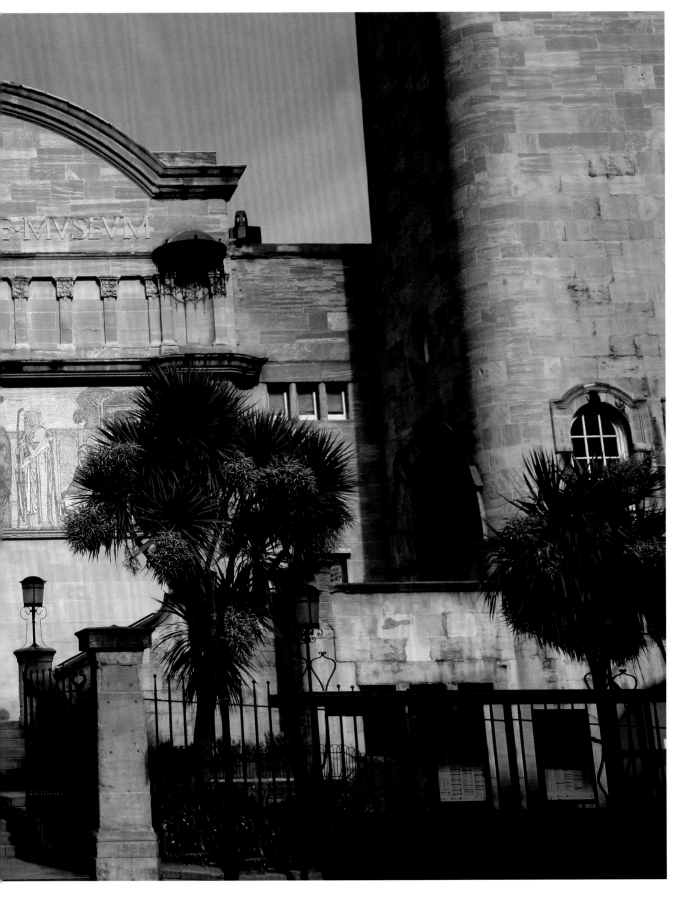

Charles Harrison Townsend,
1851-1928, British architect.

Other notable structures:
Whitechapel Gallery and
Bishopsgate Institute,
London, UK.

"The history of modern
art in England...is to a
large extent a history of
delayed and mediated
responses."

"Vividness in
representation must
entail the reconciliation
of technical concerns
for expressive form and
surface on the one hand
with the requirements
of realistic description
on the other...the more
the activity of art tends
toward the pursuit of
the one at the expense
of the other, the smaller
the value is to be
attached to either."

137

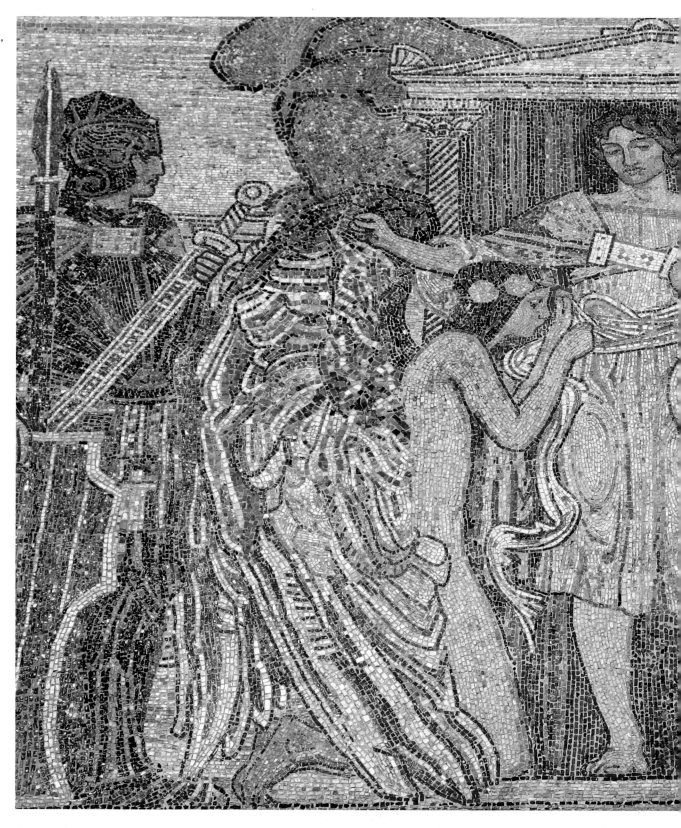

Mosaic mural,
The Horniman Museum,
1898-1901,
100 London Road,
Forest Hill,
London, UK.
Architect:
Charles Harrison
Townsend.
Mosaic:
Robert Anning Bell.

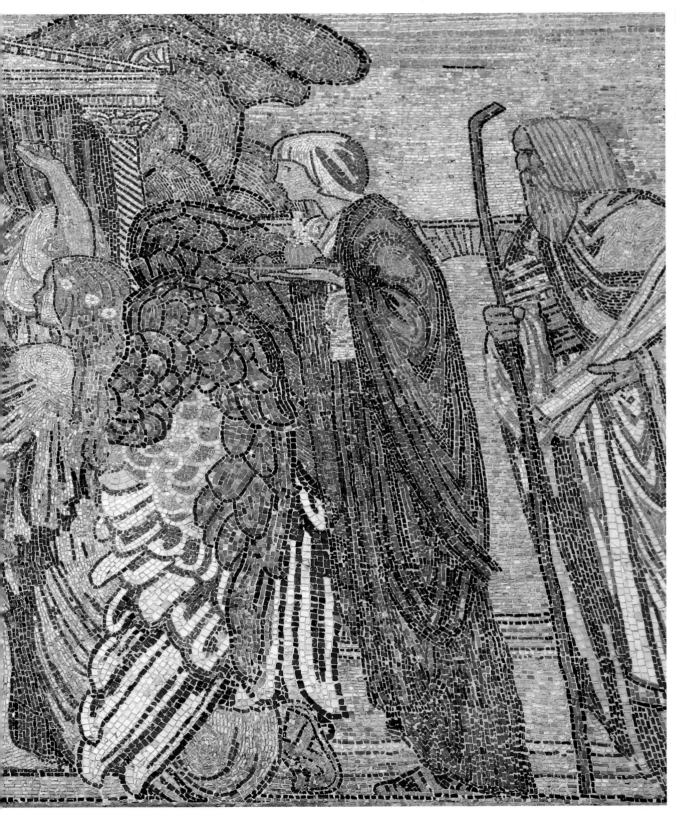

Robert Anning Bell RA
1863-1933, British
artist and designer.

Other notable work:
Mosaic in the tympanum
at Westminster Cathedral,
and mosaics for the
Palace of Westminster,
London, UK.

Clock tower,
The Horniman Museum,
1898-1901,
100 London Road,
Forest Hill,
London, UK.
Architect:
Charles Harrison
Townsend.

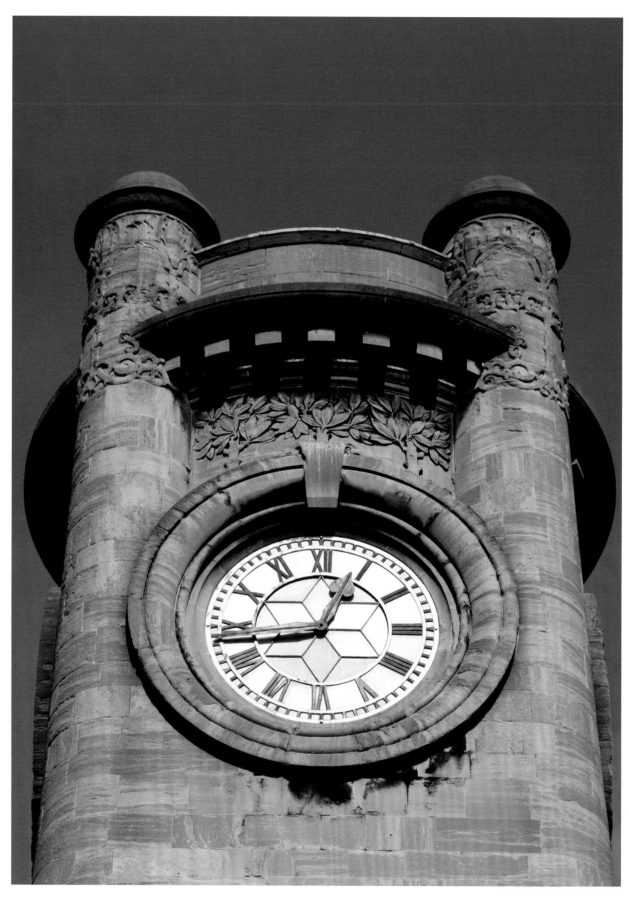

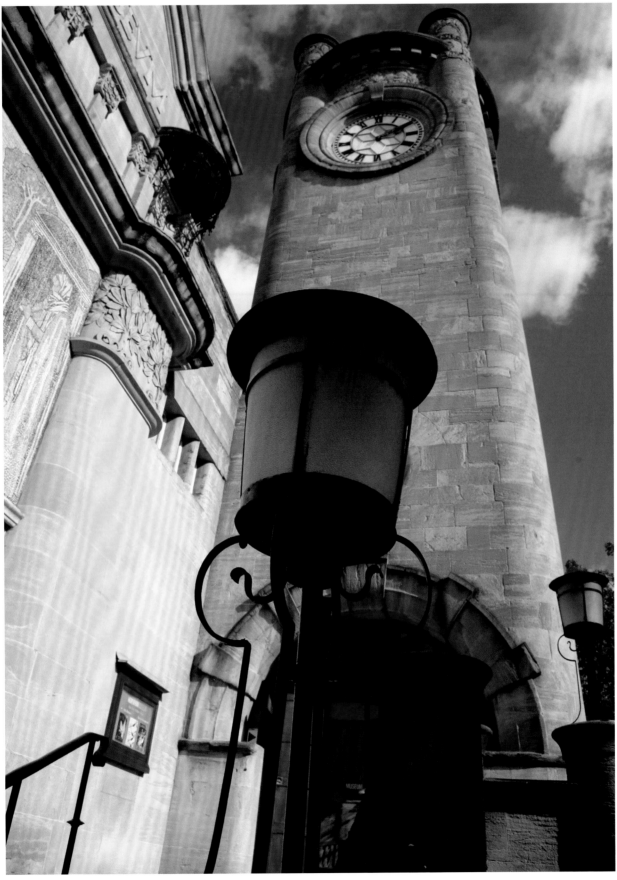

The Horniman Museum,
1898-1901,
100 London Road,
Forest Hill,
London, UK.
Architect:
Charles Harrison
Townsend.

United Free Church,
1904.
4 High Elms,
Woodford Green,
Essex, UK.
Architect:
Charles Harrison
Townsend.

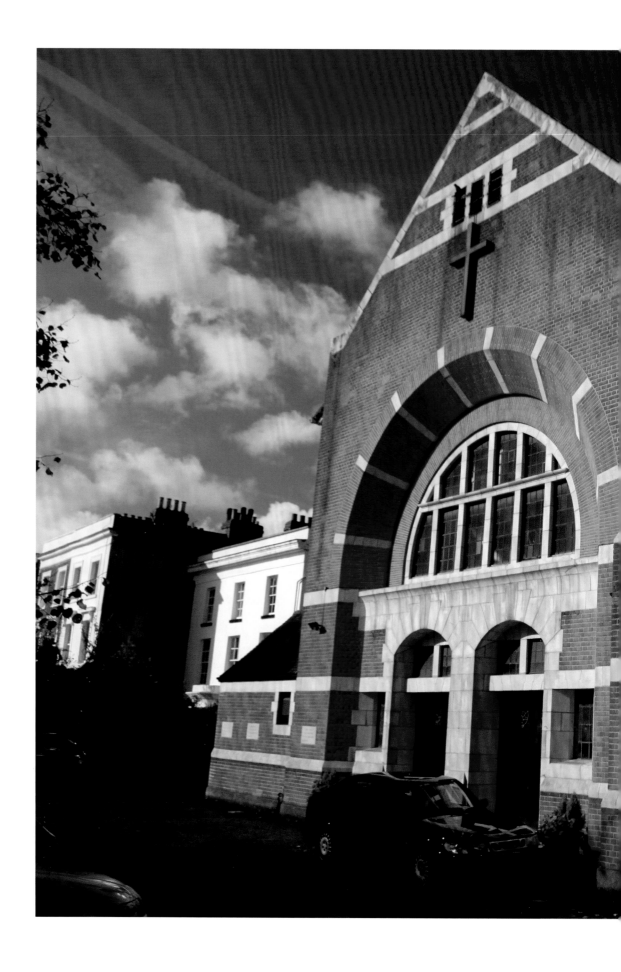

Facade,
Whitechapel Gallery,
1901,
Whitechapel High Street,
London, UK.
Architect:
Charles Harrison
Townsend.

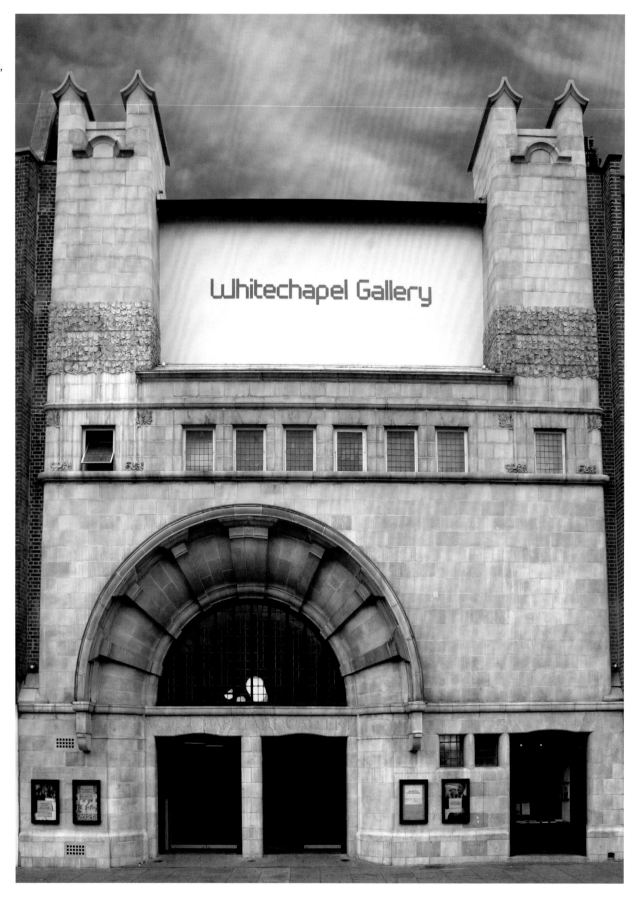

144

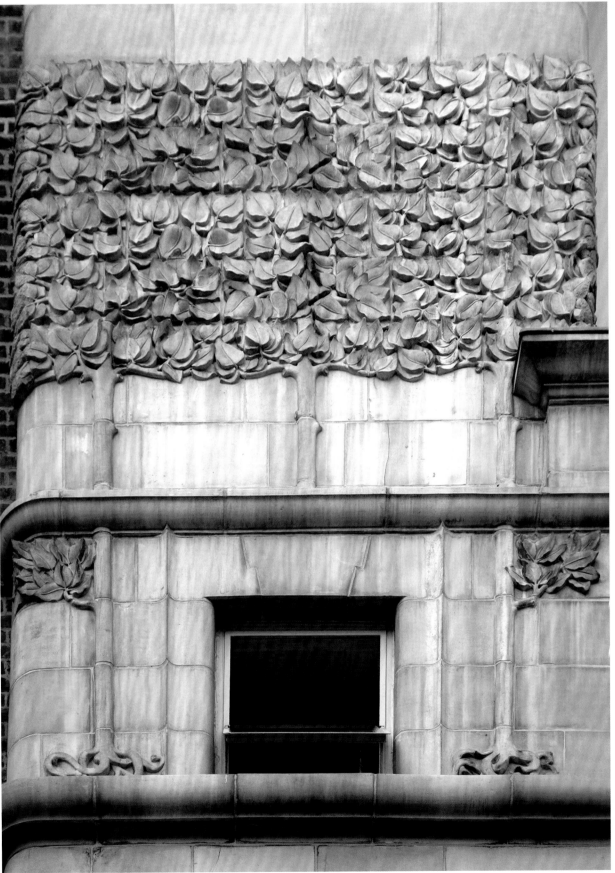

Detail, decoration,
Whitechapel Gallery,
1901,
Whitechapel High Street,
London, UK.
Architect:
Charles Harrison
Townsend.

Bishopsgate Institute,
1895,
230 Bishopsgate,
London, UK.
Architect:
Charles Harrison
Townsend.

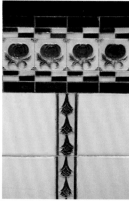

Above:
Ceramic tiles,
Bishopsgate Institute,
1895,
230 Bishopsgate,
London, UK.
Architect:
Charles Harrison
Townsend.

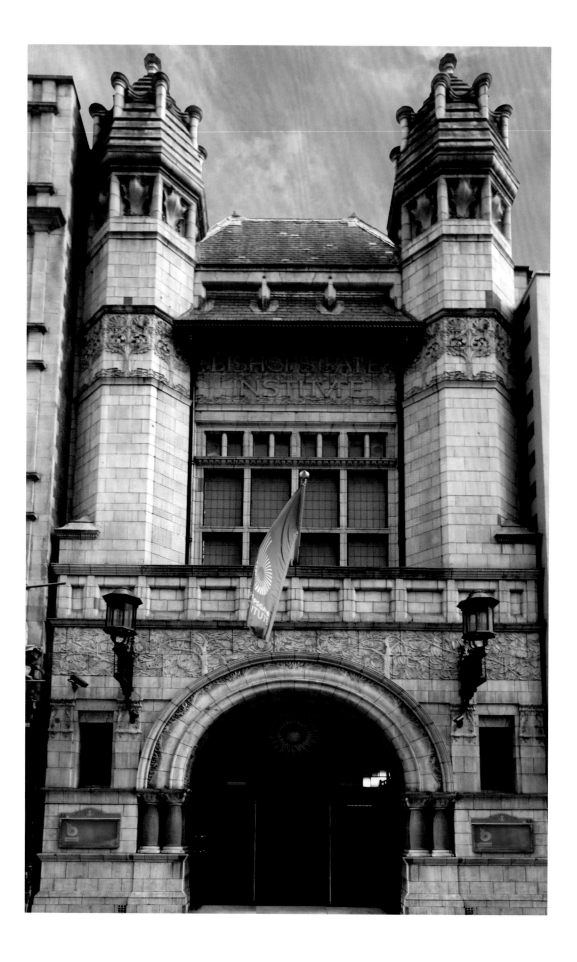

146

Above:
"Peacock"
fanlight window,
Left:
Facade, 1899,
39 Cheyne Walk,
Chelsea,
London, UK.
Architect:
Charles Robert Ashbee.

Charles Robert Ashbee,
1863-1942,
British architect and
designer of silver and
other metals, jewellery,
cutlery, tableware
and type.
He was a prime mover
in the Arts & Crafts
movement.

Other notable work:
Villa San Giorgio,
Taormina, Sicily, Italy.

Entrance, Clifton House,
Boundary Street Estates,
1893-1900,
Bethnal Green,
London, UK.
Architects:
LCC Architects
Department.

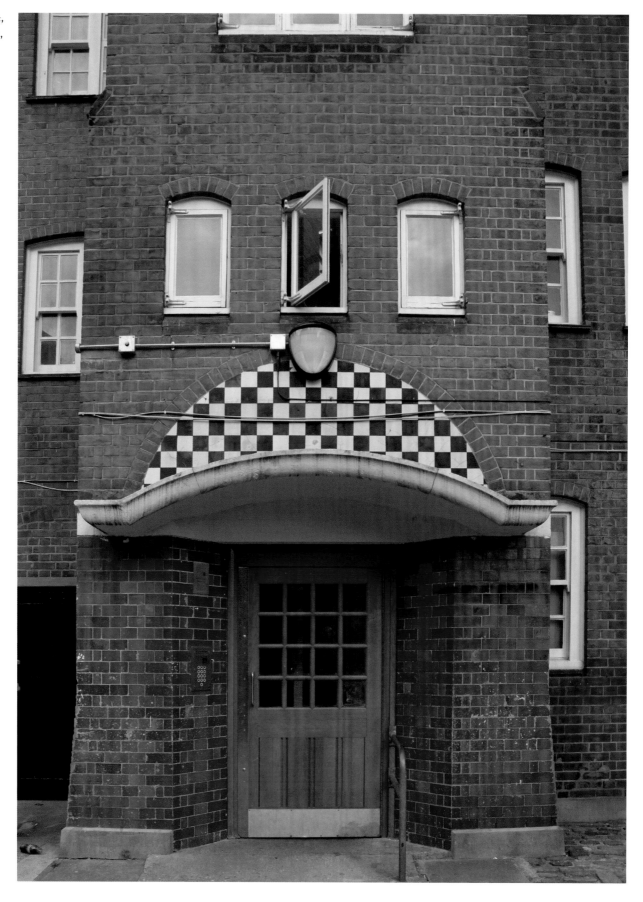

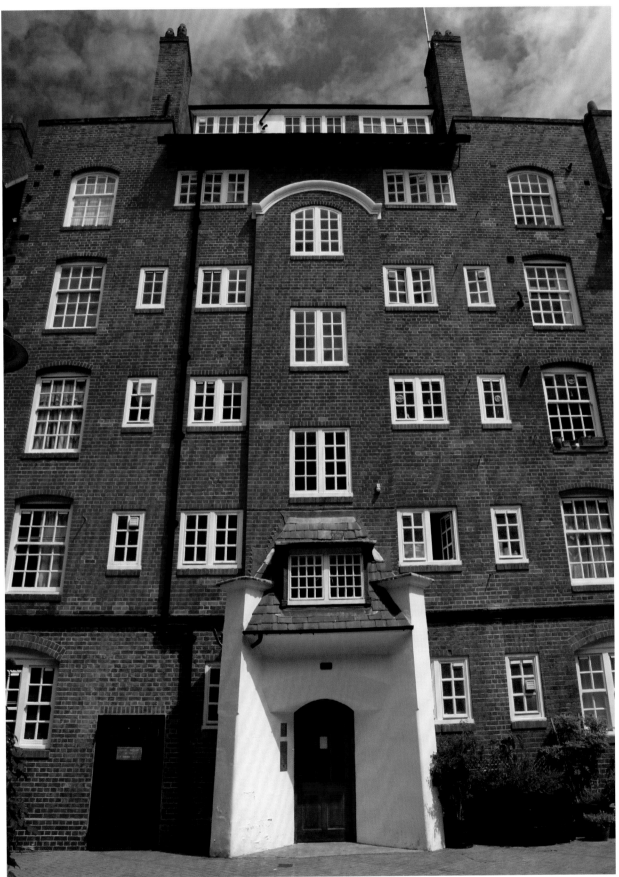

Entrance,
Millbank Estate,
1897-1902,
Westminster,
London, UK.
Architect:
R. Minton Taylor,
London County Council.

Above:
"The Princess and
the Swineherd",
Doulton glazed ceramic
lunette, 1926.
Sidney Street Estate,
Somerstown, London, UK.
Sculptor:
Gilbert Bayes.

Gilbert William Bayes,
1872-1953, British
sculptor. Bayes worked
in association with the
Royal Doulton Company,
and worked in
polychrome ceramics
and enamelled bronze.

Other notable works:
Ceramic frieze,
Doulton Headquarters,
London, UK.
"The Queen of Time"
bronze group,
Selfridges department store,
Oxford Street entrance,
London, UK.

Mary Ward House,
1890s,
5-7 Tavistock Place,
Bloomsbury,
London, UK.
Architects:
Arnold Dunbar Smith
and Cecil Brewer.

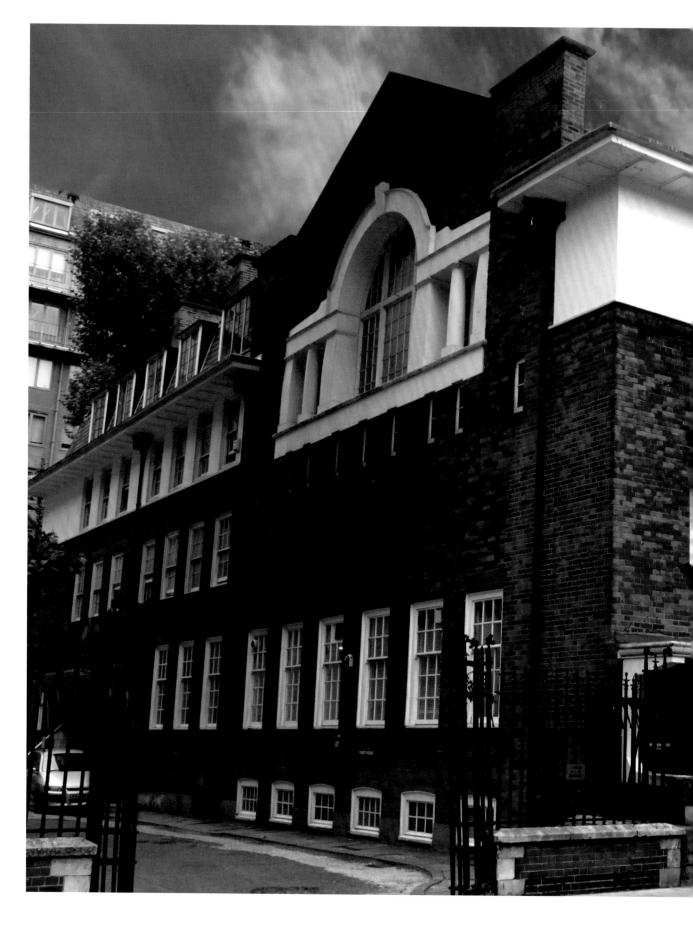

150

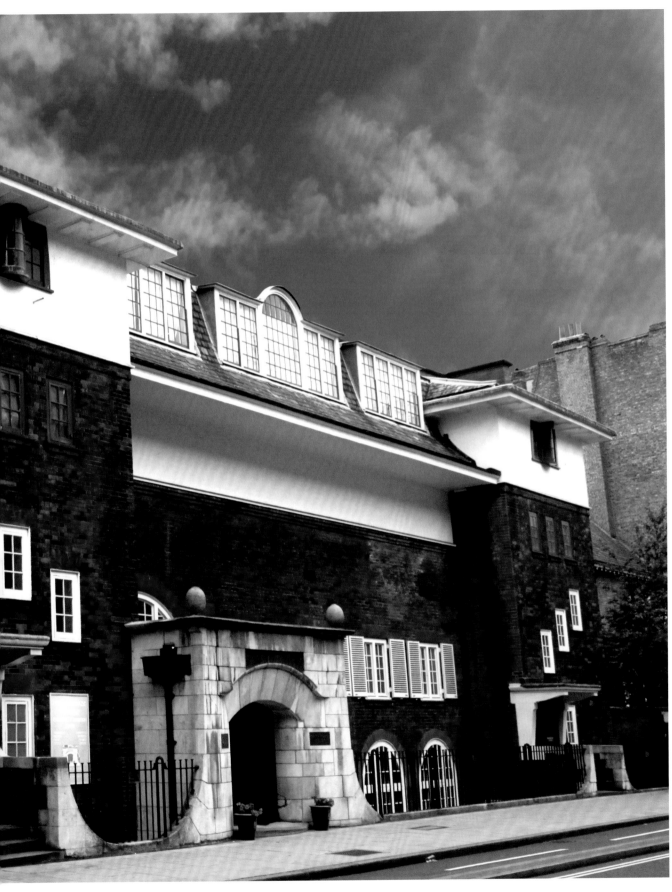

Arnold Dunbar Smith,
1866-1933, and
Cecil Claude Brewer,
1871-1918.
British architects, both were
members of the
Art Workers' Guild.

Other notable structures:
The National Museum
of Wales, UK, 1910,
Heal's Furniture Store,
1916, London, UK.

Brewer was a cousin
of Ambrose Heal.

Portland Stone entrance,
Mary Ward House,
1890s,
5 Tavistock Place,
Bloomsbury,
London, UK.
Architects:
Arnold Dunbar Smith
and Cecil Brewer.

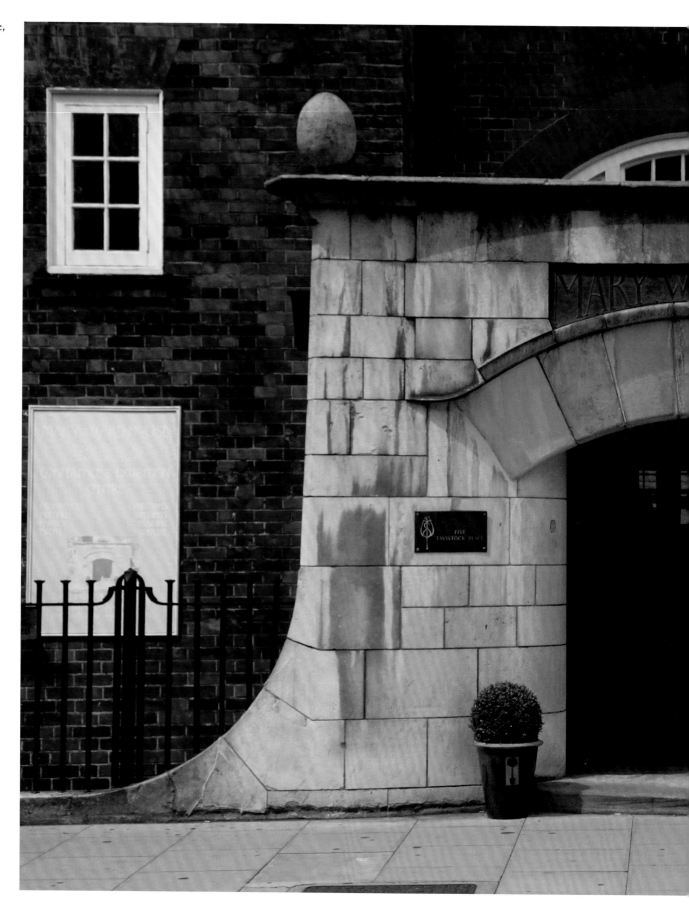

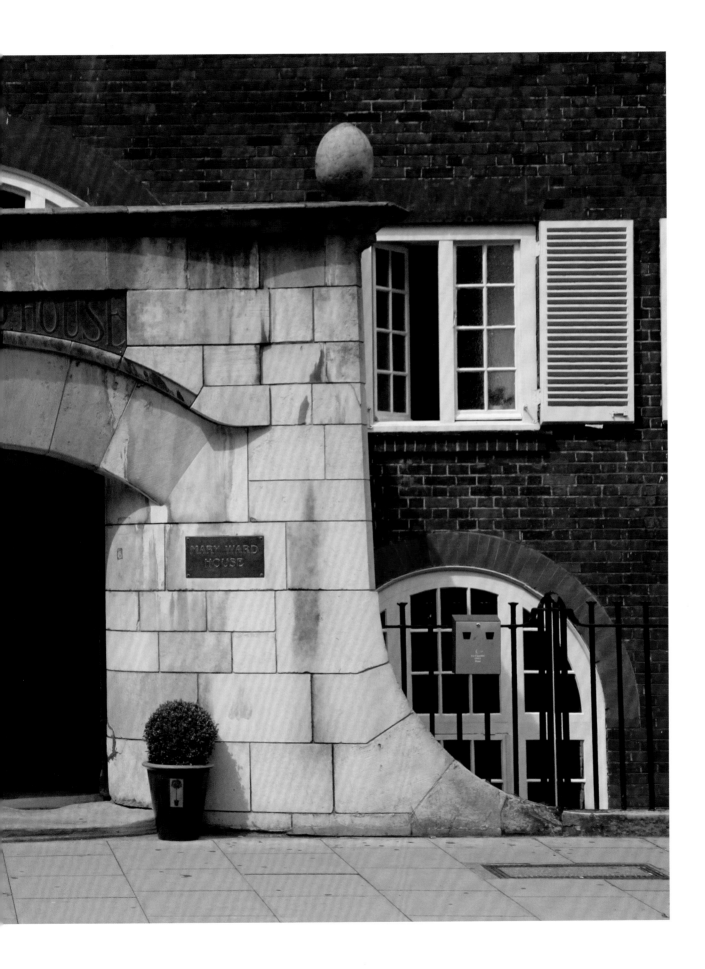

Wong Kei Restaurant,
1904-05,
former costumier
and wig maker,
41-43 Wardour Street,
London, UK.
Architect:
H.M. Wakeley.

154

This page and opposite:
B. Davies & Sons, 1900,
14-16 New Cavendish St,
London, UK.
Architects:
H. Saul and G. Harvey.

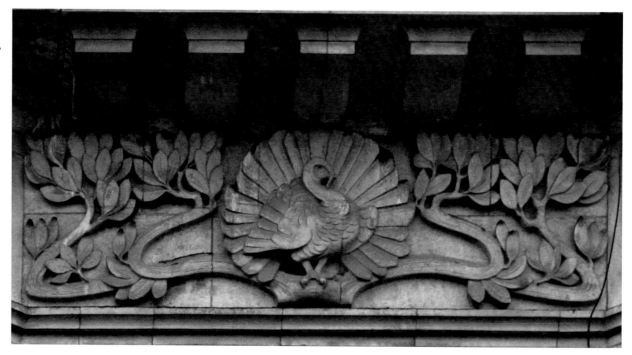

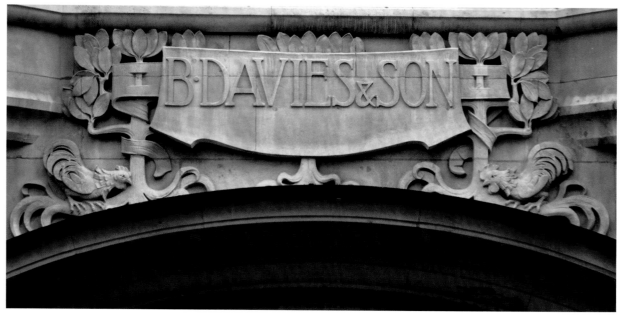

Relief quotation,
facade,
Francis Holland School,
1915,
Ivor Place, Marylebone,
London, UK.
Architect:
Henry Thomas Hare.

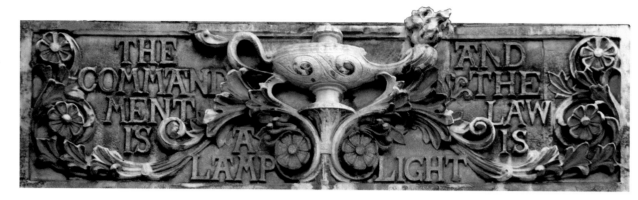

Wrought-iron and
copper gates,
Francis Holland School,
1915,
Ivor Place, Marylebone,
London, UK.
Architect:
Henry Thomas Hare.

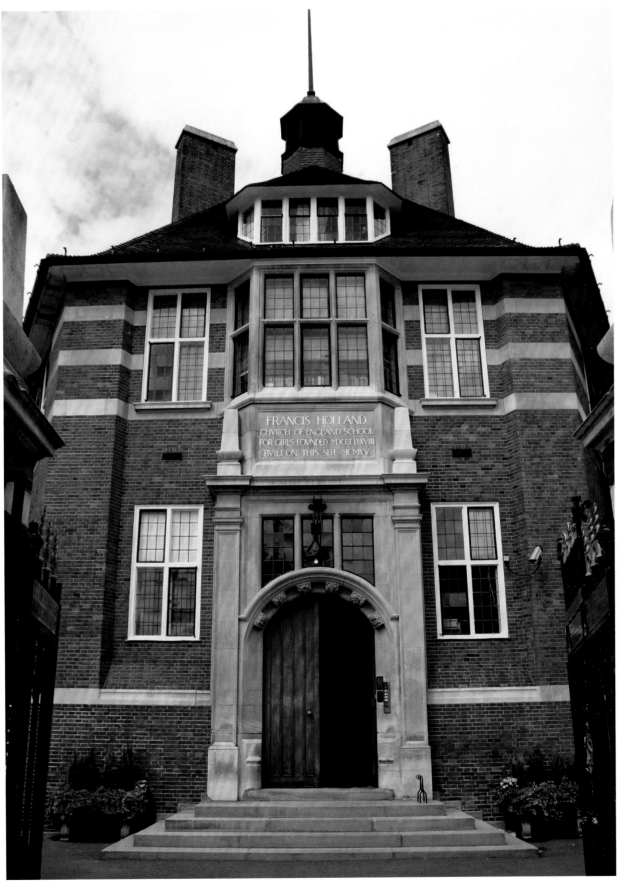

Francis Holland School,
1915,
Ivor Place, Marylebone,
London, UK.
Architect:
Henry Thomas Hare.

Henry Thomas Hare,
1861-1921,
British architect.

Other notable buildings:
Passmore Edwards
Free Library,
Hackney, London, UK,
Westminster College,
Cambridge, UK.

"Every building should be
a worthy landmark to the
district where it is built,
and should impress itself on
the passer-by as a dignified
expression of the public
spirit which has promoted
its erection."

3 Soho Square, 1903,
London, UK.
Architect:
Charles H. Worley.

Charles H. Worley,
1853-1906,
British architect.

Other notable work
in London, UK:
28–30 Wigmore Street,
42 Harley Street,
28–29 Wimpole Street,
51, 55–56 Welbeck Street,
84 Wimpole Street,
37 New Bond Street,
6–7 St George Street,
1–3 Old Compton Street,
99A Charing Cross Road,
3 Soho Square,
12 Moor Street.

Terracota relief,
1896-97,
22 Albermarle Street,
London, UK.
Architect: R. J. Worley.

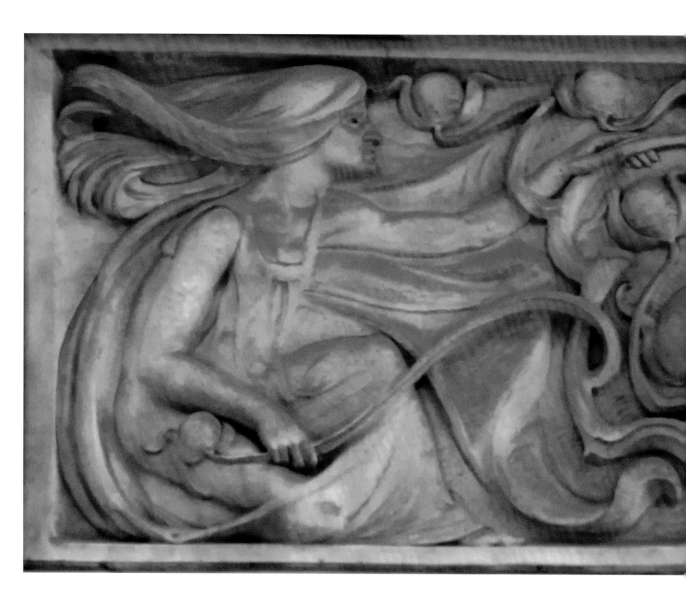

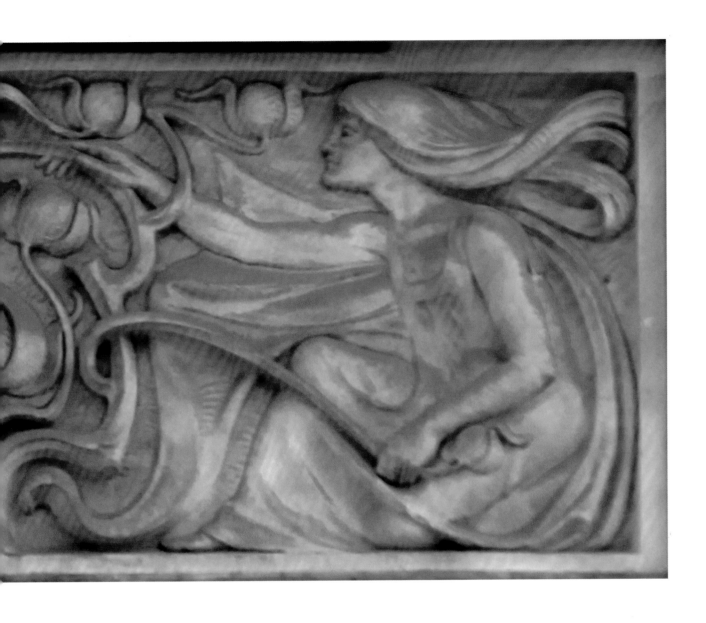

Bolton House, 1907,
14-16 Cullum Street,
London, UK.
Architect: A.I. Selby.

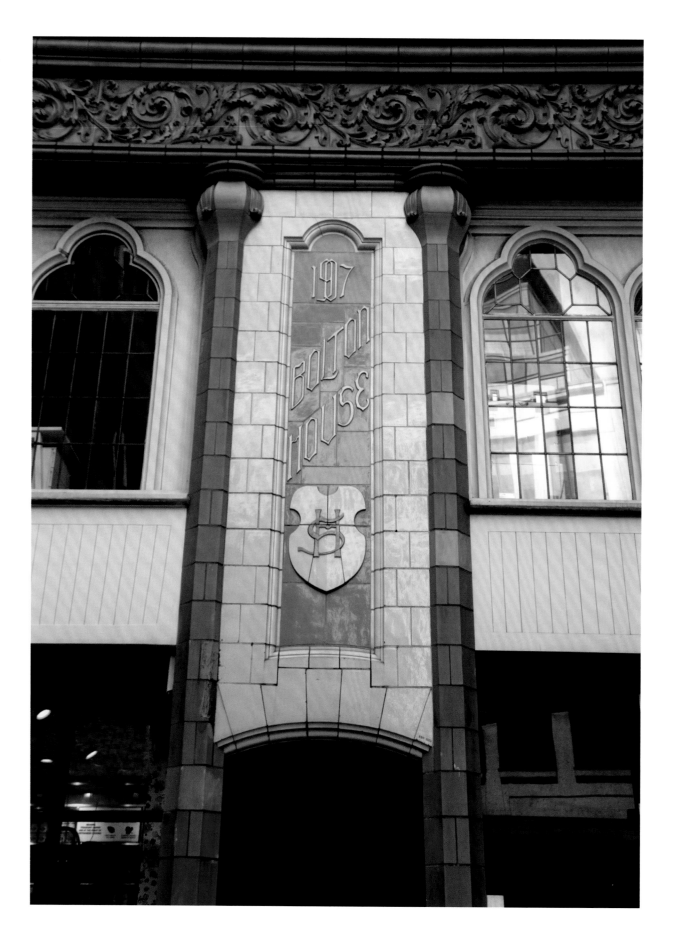

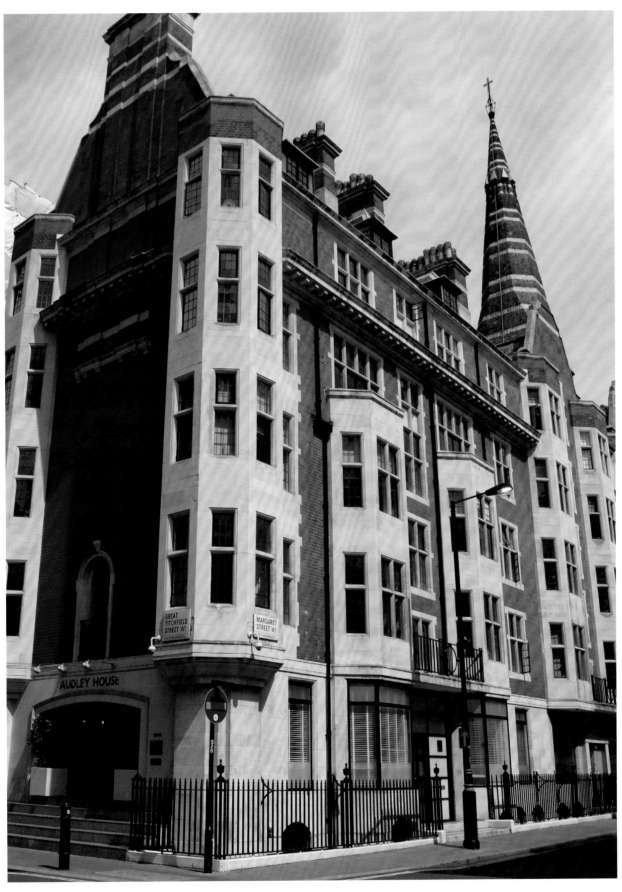

Audley House, 1900s,
Great Titchfield Street,
London, UK.
Architects:
Simpson & Ayrton.

**Sir John William
Simpson** KBE FRIBA,
1858-1933. British
architect and President
of the Royal Institute of
British Architects.

Other notable structures:
Kelvingrove Art
Gallery and Museum
and Wembley Stadium,
London, UK.

Maxwell Ayrton FRIBA,
1874-1960. Scottish
architect, partnered
with Sir John
William Simpson.

Other notable work:
The new chapel for
Gresham's School, Holt,
the National Institute
for Medical Research
at Mill Hill, and with
Simpson, the old
Wembley Stadium.

165

Hanging sign,
"Ye Civet Cat",
former public house,
High Street Kensington,
London, UK.

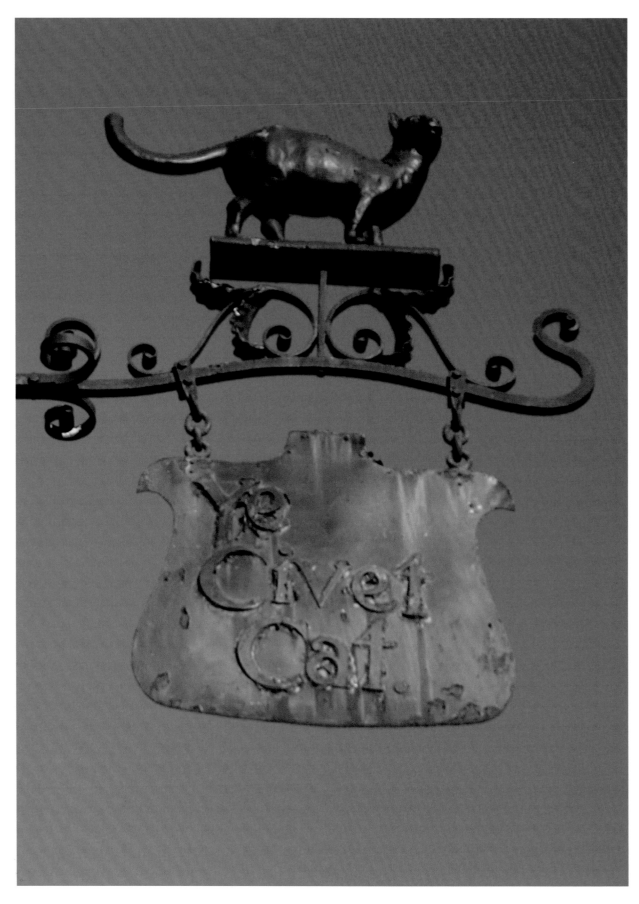

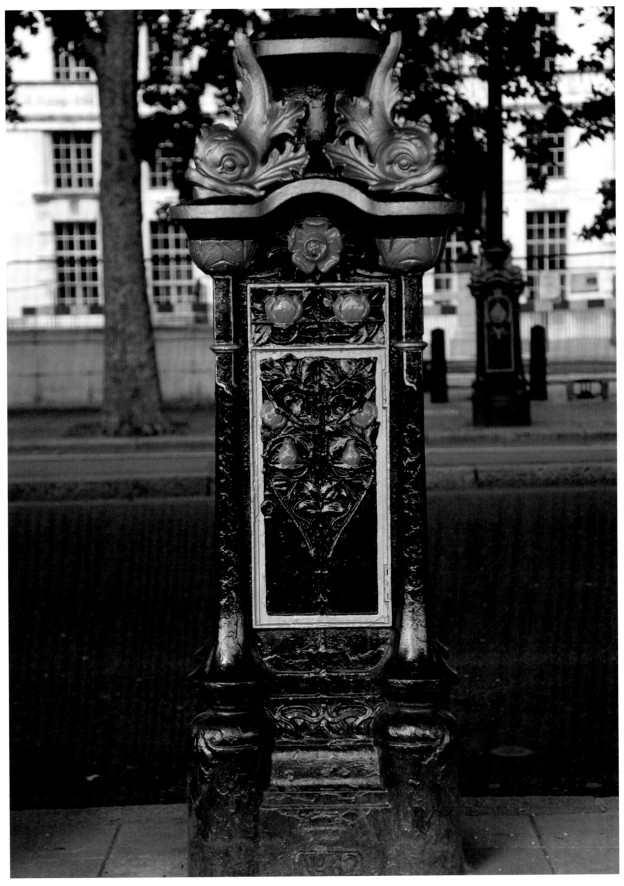

Lamp post,
Victoria Embankment,
Westminster,
London, UK.
Designer:
George John Vulliamy.

George John Vulliamy,
1817–1886.
British architect who
designed the "dolphin
lamp posts" that line
the Embankment.

Other notable work:
Several fire stations,
and the pedestal
and sphinxes for
Cleopatra's Needle on the
Thames Embankment.

Detail,
wrought-iron railings,
1897-99,
37 Harley Street,
London, UK.
Architect:
Arthur Beresford Pite.

Detail,
wrought-iron railings,
1895,
15 Stratton Street,
London, UK.
Architect:
C. J. Harold Cooper.

Above:
Mosaic doorstep,
80 Mortimer Street,
London, UK.

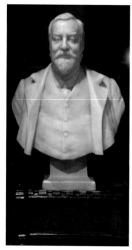

Above:
Marble bust,
Sir Arthur
Lasenby Liberty,
founder of Liberty & Co.
Great Marlborough
Street,
London, UK.

Right:
Liberty's clock.
Motto: "No minute gone
comes ever back again,
take heed and see ye
nothing do in vain."

Liberty,
Mock Tudor-style
department store,
1924,
Great Marlborough
Street,
London, UK.
Architects:
Edwin T. Hall and
Edwin S. Hall.

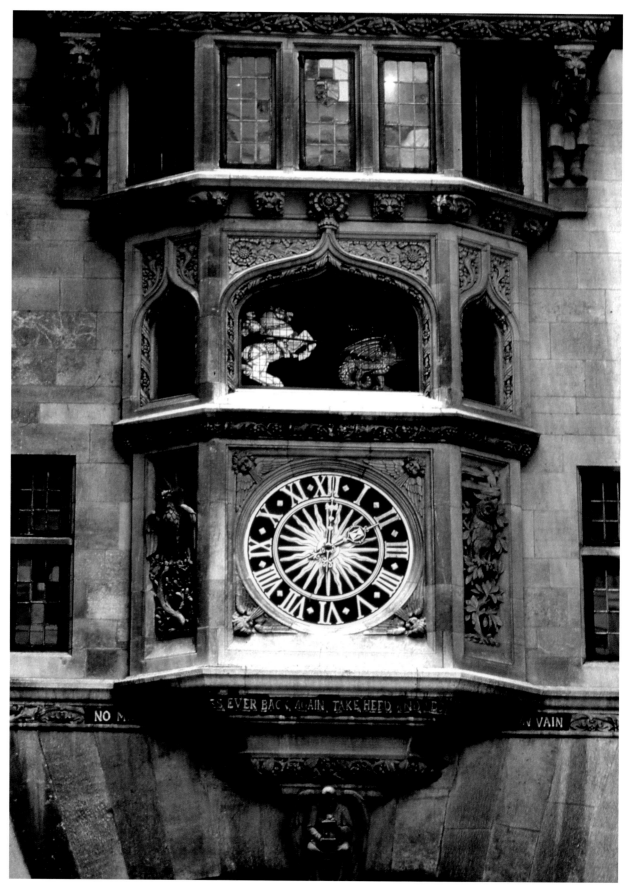

Entrance and lantern,
Shottendane House,
circa 1910,
Shottendane Road,
Margate, Kent, UK.
Architect:
Hugh Thackeray Turner.

Hugh Thackeray Turner,
1853-1937,
British architect.

Other notable work:
Lygon Place Buildings,
Ebury Street,
London, UK.
Wycliffe Buildings,
The Court, and
Mead Cottage in
Guildford, Surrey, UK.

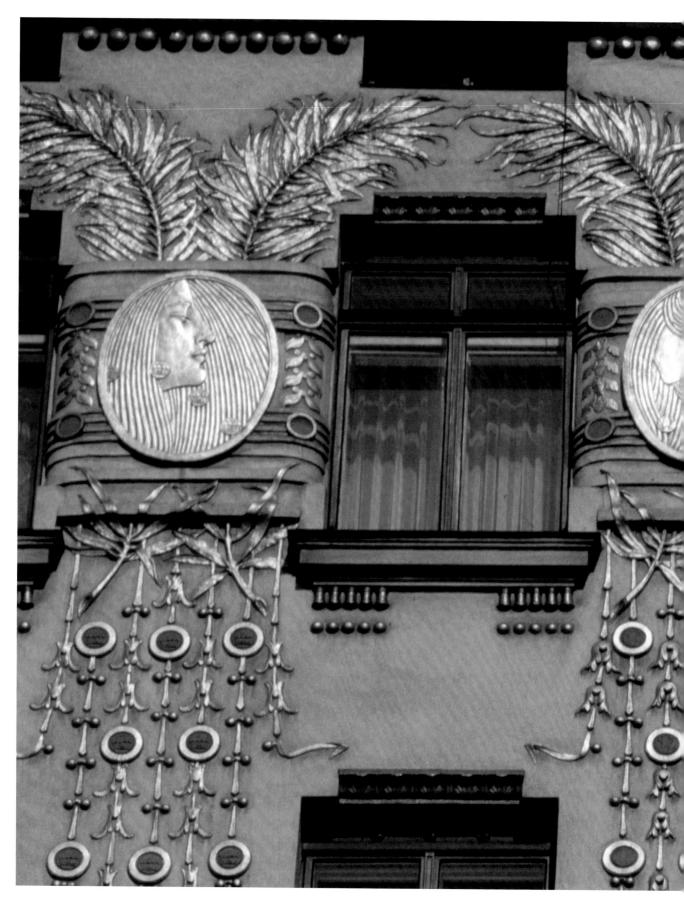

Gilded stucco
medallions,
The Medallion House,
1898-1899.
Linke Wienzeile 38,
Vienna, Austria.
Architect: Otto Wagner.
Artist: Koloman Moser.

CENTRAL EUROPE

172

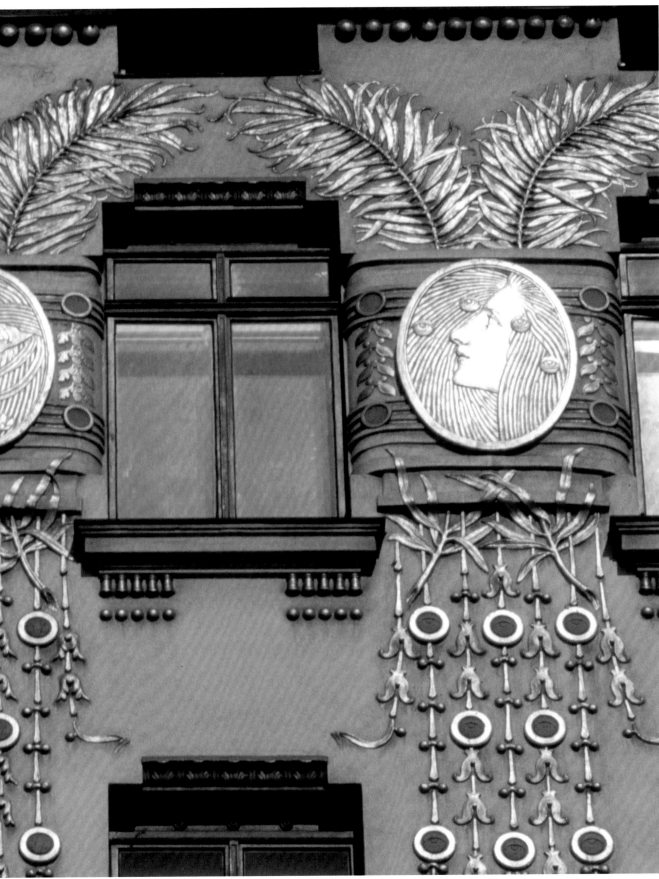

Above:
Austrian postal stamp.

Koloman Moser,
1868-1918, Austrian.
In 1903, Moser and his
colleague Josef Hoffmann
founded the
Wiener Werkstätte.
Moser also designed a
wide range of art works,
including books and
graphic works from
postage stamps to
pottery and glass.

"Simplicity lies not in
omission, but in synthesis."

Detail, ceramic tiles,
"Majolikahaus",
1898–99.
Linke Wienzeile 40,
Vienna, Austria.
Architect:
Otto Wagner.

Otto Wagner,
1841–1918, Austrian.
Designed several buildings
in what became known
as the Vienna Secession
style.
Beginning in 1898,
with his designs of
Vienna's metro stations,
his style became floral
and Art Nouveau.

Other notable work:
Austrian Postal Savings
Bank, 1903–1912.
"Something impractical
cannot be beautiful."

Detail, wall mural
mosaic,
"The Five Continents",
1894–1896.
Kärntner Strasse 16,
Vienna, Austria.
Artist:
Eduard Veith.

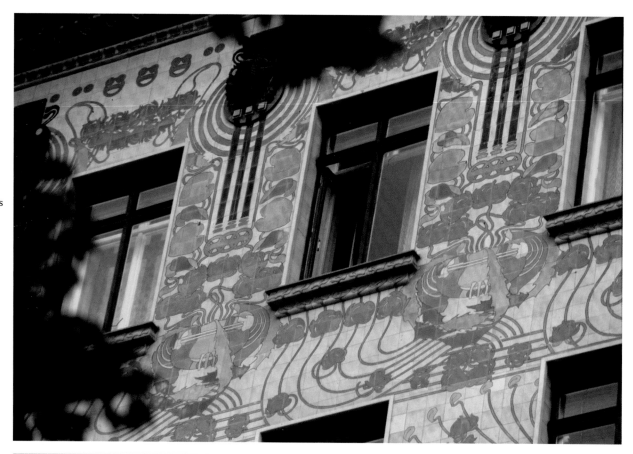

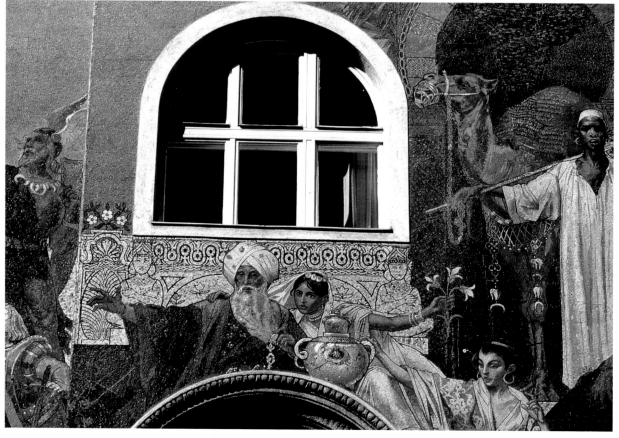

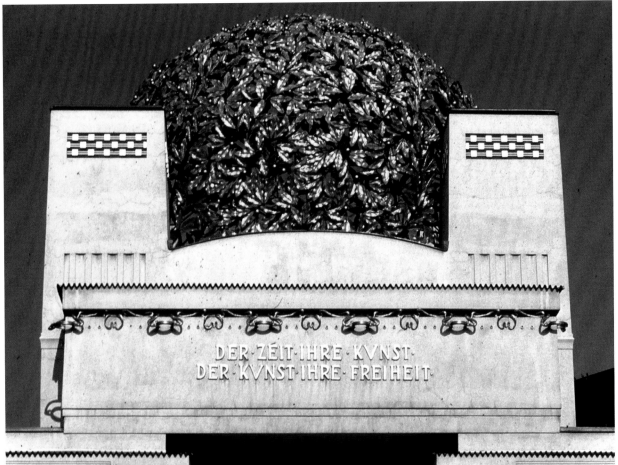

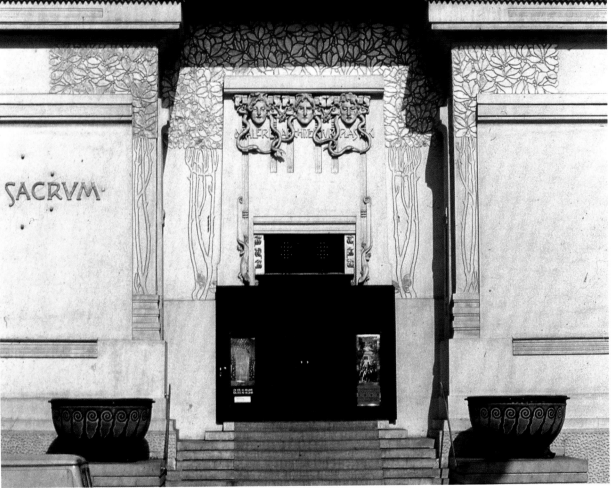

DER·ZEIT·IHRE·KVNST·
DER·KVNST·IHRE·FREIHEIT·

SACRVM·

Above:
Illustration,
Secession building,
and left:
Facade,
Secession building, 1897.
Friedrichstrasse 12,
Vienna, Austria.
Architect:
Joseph Maria Olbrich.
Designers:
Koloman Moser
and Gustav Klimt.

Joseph Maria Olbrich,
1867-1908, Austrian
architect.

Other notable work:
Residence for
Hermann Bahr,
Vienna, Austria.
Hochzeitsturm and other
buildings at Darmstadt
Artists' Colony,
Mathildenhöhe,
Darmstadt, Germany.
Department store for
Leonhard Tietz,
Düsseldorf, Germany.
Villa for Josef Feinhals,
Cologne, Germany, built
1908 and destroyed in
World War II.

175

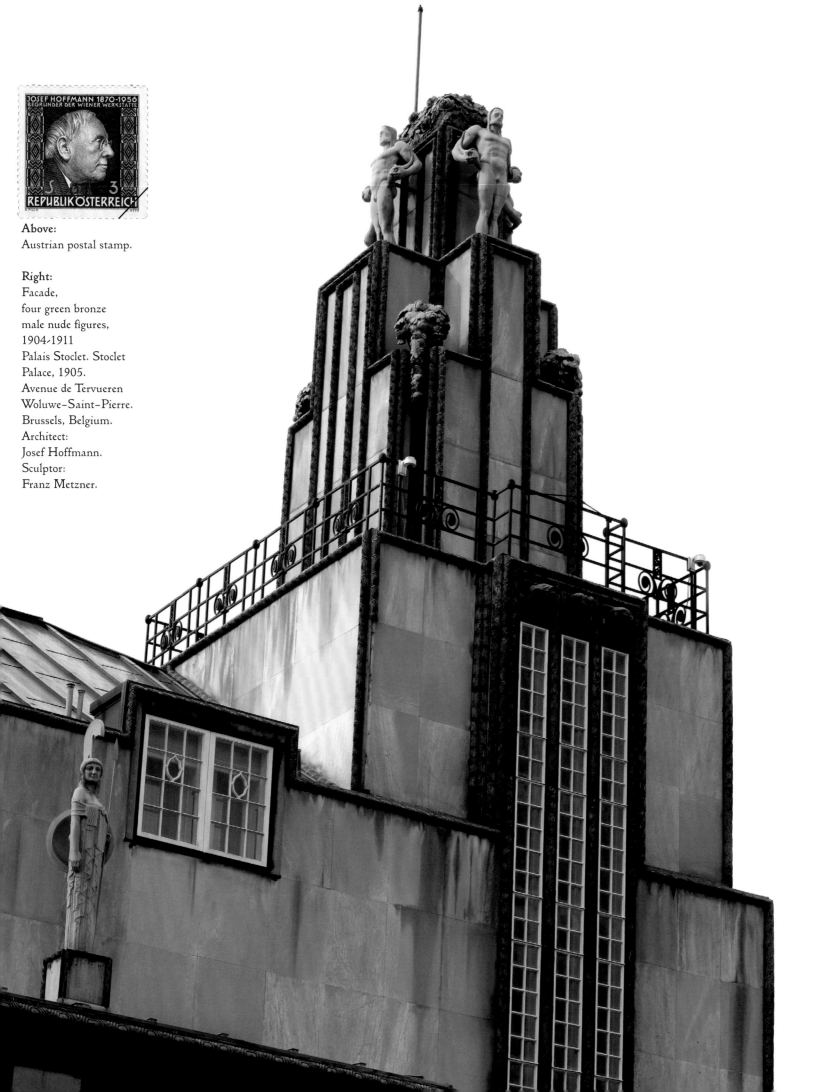

Above:
Austrian postal stamp.

Right:
Facade,
four green bronze
male nude figures,
1904-1911
Palais Stoclet. Stoclet
Palace, 1905.
Avenue de Tervueren
Woluwe-Saint-Pierre.
Brussels, Belgium.
Architect:
Josef Hoffmann.
Sculptor:
Franz Metzner.

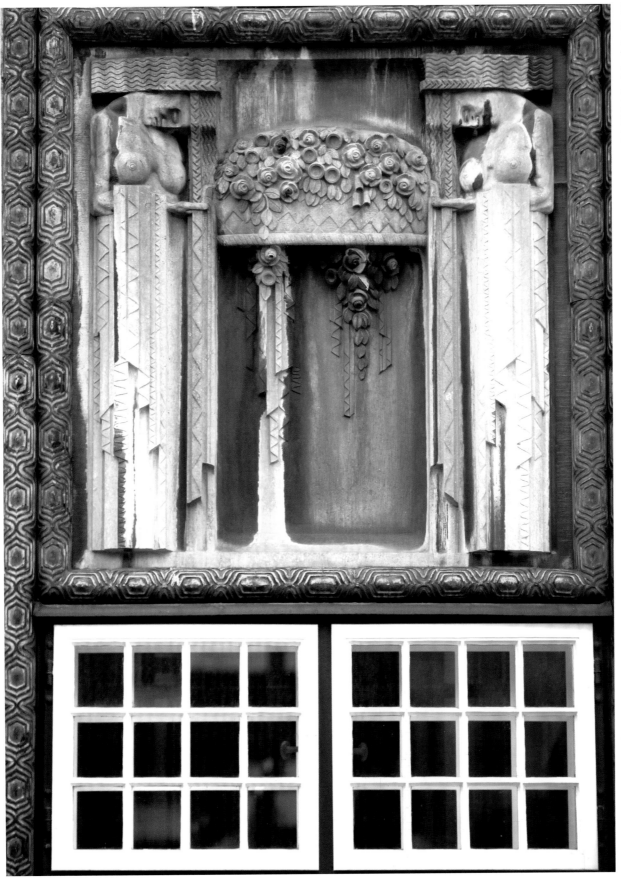

Relief sculpture,
Stoclet Palace, 1905.
Avenue de Tervueren
Woluwe-Saint-Pierre.
Brussels, Belgium.
Architect:
Josef Hoffmann.
Sculptor:
Franz Metzner.

Franz Metzner,
1870-1919,
German sculptor.

Other notable work:
Monument to the
Battle of the Nations,
Leipzig, Germany.

Josef Hoffmann,
1870-1956, Austrian
architect and designer.
Studied under Otto Wagner.
A founder of the Vienna
Secession and
co-establisher of the
Wiener Werkstätte, 1899.

Other notable work:
Purkersdorf Sanatorium,
1903,
Purkersdorf, Austria.

"Our aim is to create an
island of tranquility in our
own country which, amid
the joyful hum of arts and
crafts, would be welcome to
anyone who professes faith
in Ruskin and Morris."

Above:
Detail, copper grille,
Kazinczy Street
Synagogue, 1912–13,
Kazinczy u. 29–31,
Budapest, Hungary.
Architects:
Sandor Loffler and
Bela Loffler.

Right and opposite:
Sepulchre
mosaic interiors,
Jewish Cemetery,
Kozma u. 6,
Budapest, Hungary.
Designed by
Bela Lajta and
Odon Lechner.

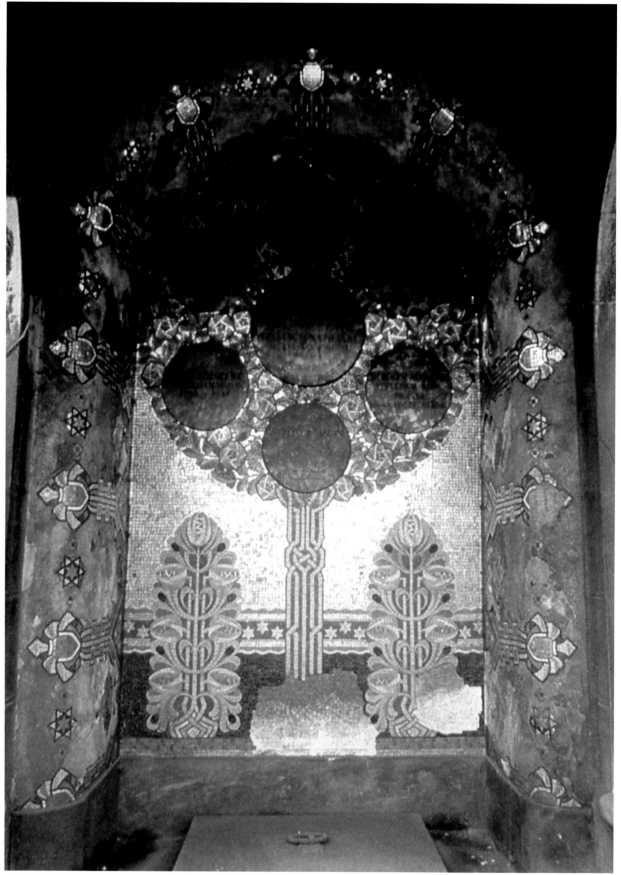

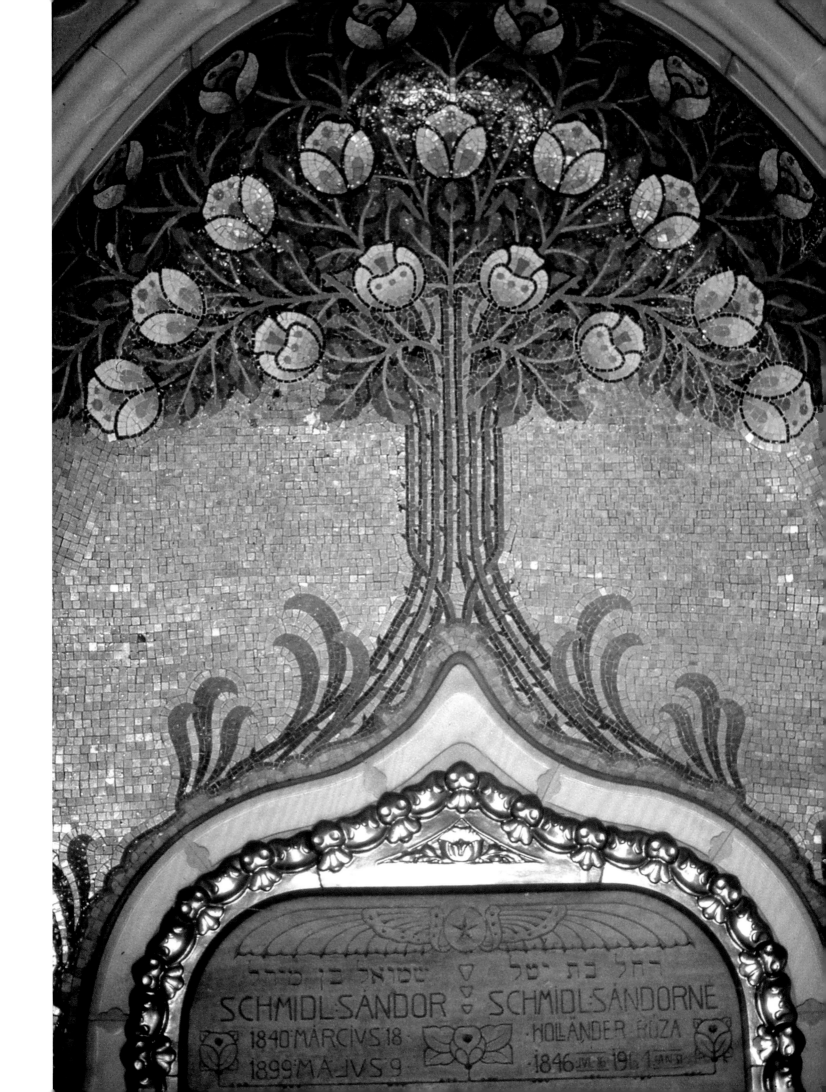

Notre-Dame Basilica,
1829,
110 rue Notre-Dame
Ouest,
Montreal, Quebec,
Canada.
Architect:
James O'Donnell.

NORTH AMERICA

James O'Donnell,
1774–1830. Irish-born
American architect.
O'Donnell moved from
New York to Montreal
to build the Notre-Dame
Basilica, designed in the
Neo-Gothic Revival style.
Other notable structures:
Bloomingdale
Insane Asylum,
the Fulton Market
and Christ Church,
all in New York City.

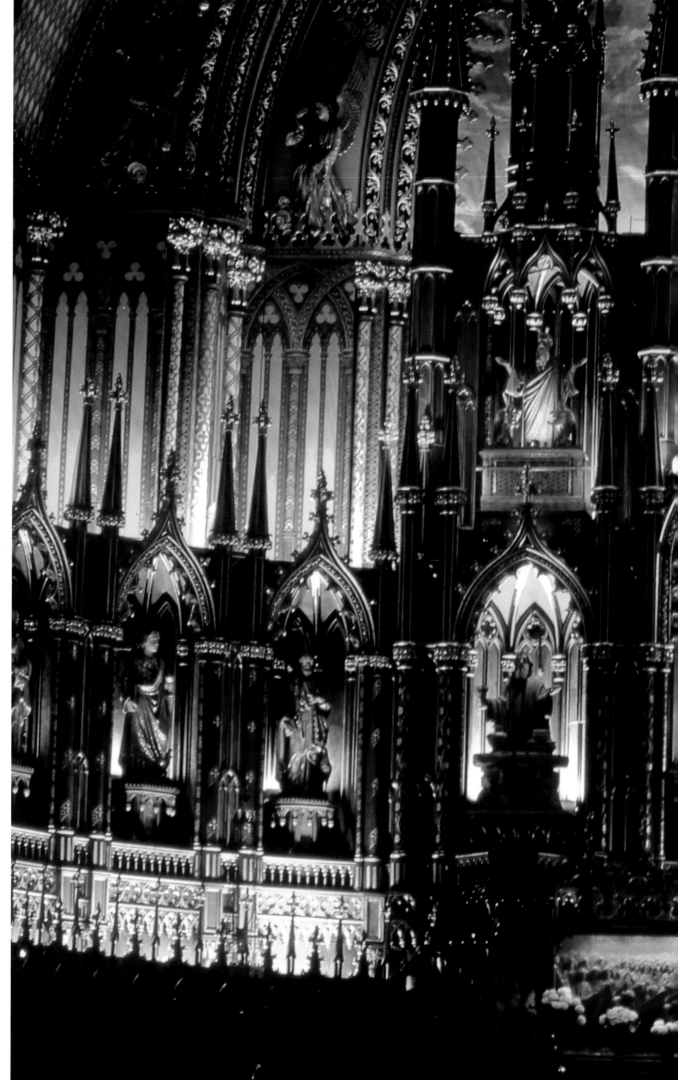

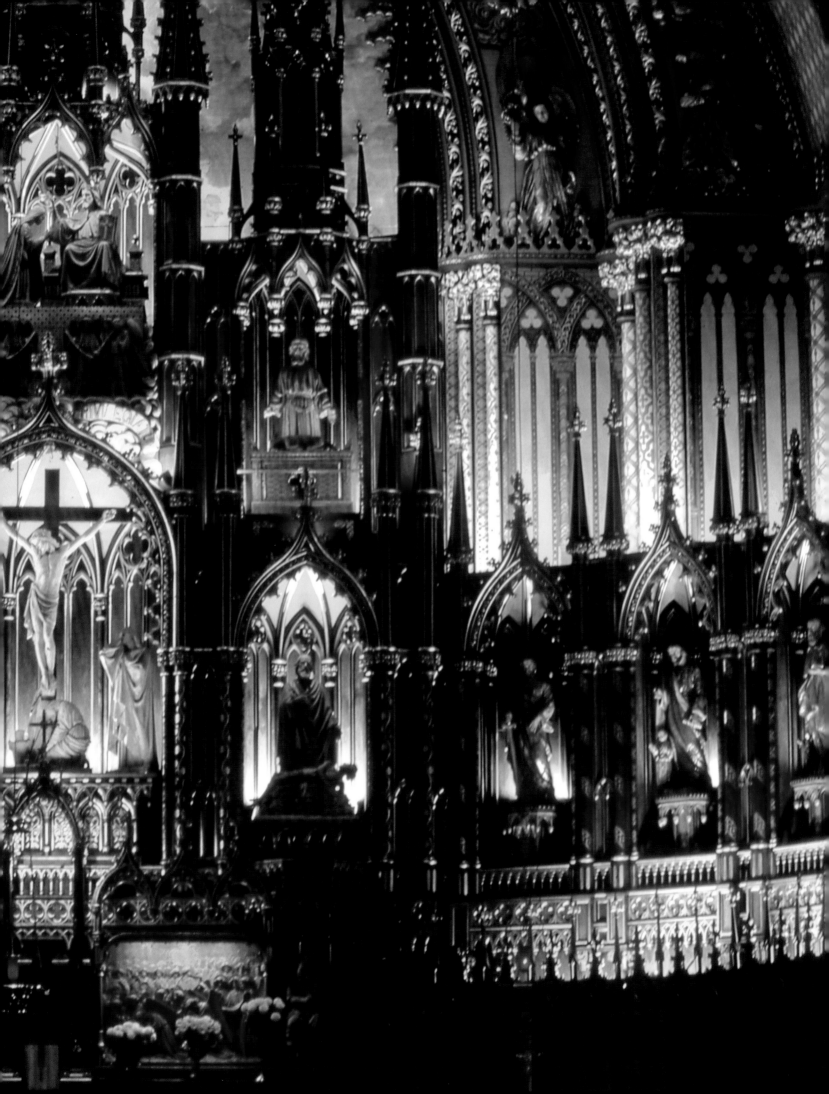

The California Building,
1915,
Panama-California
Exposition, Balboa Park,
San Diego, California,
USA.
Architect:
Bertram Goodhue.

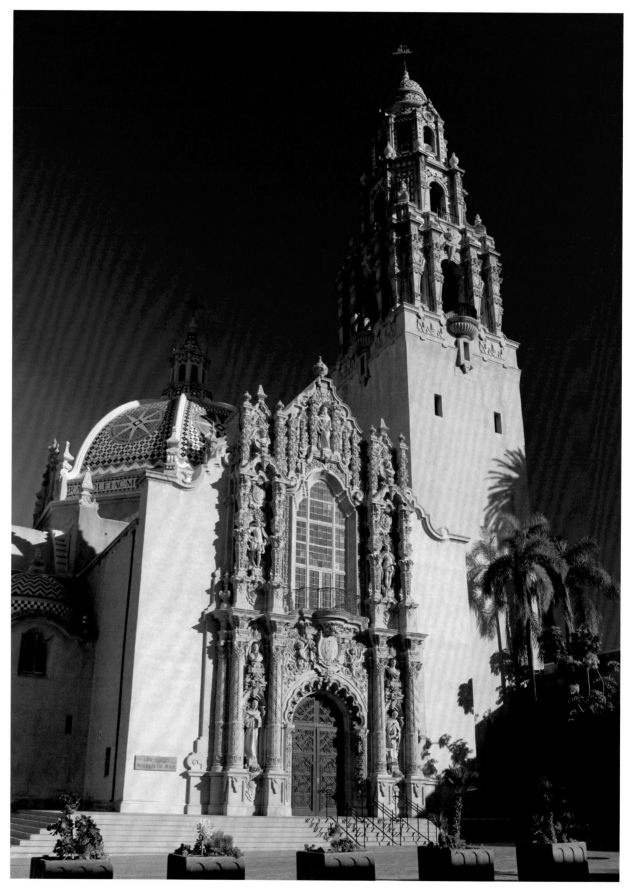

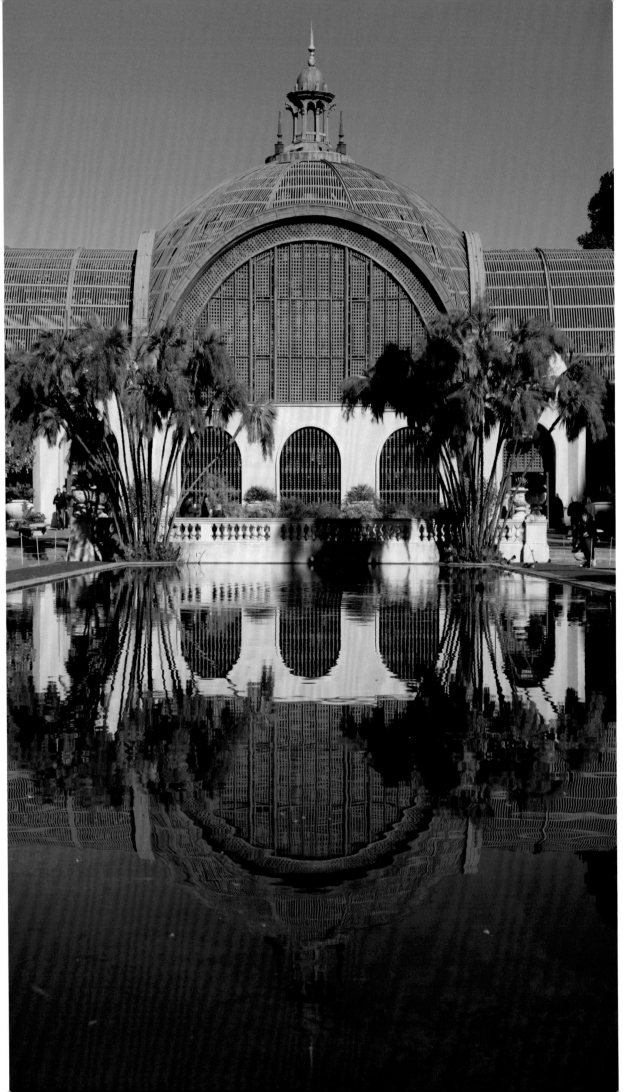

Left:
Botanical Building
and Reflective Pool,
Panama-California
Exposition,
Balboa Park,
San Diego,
California, USA.
Architect:
Bertram Goodhue.

Above:
Bertram Goodhue.

Bertram Grosvenor
Goodhue, 1869-1924.
American architect
celebrated for his work
in Gothic Revival and
Spanish Colonial Revival
design. He also designed
notable typefaces,
including Cheltenham
and Merrymount for the
Merrymount Press.

Other notable structures:
The Rockefeller Chapel,
Chicago, Illinois, USA, and
Los Angeles Central Library,
California, USA.

This page and opposite:
Stairwell and exteriors,
Mission Inn, 1902–1932,
3649 Mission Inn
Avenue, Riverside,
California, USA.
Architects:
Arthur Benton,
Myron Hubbard Hunt,
and G. Stanley Wilson.

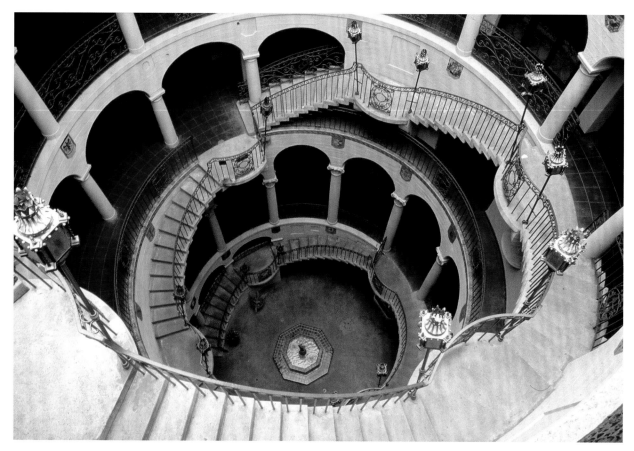

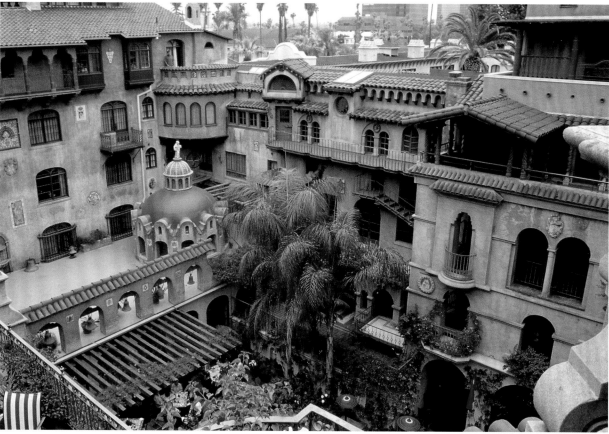

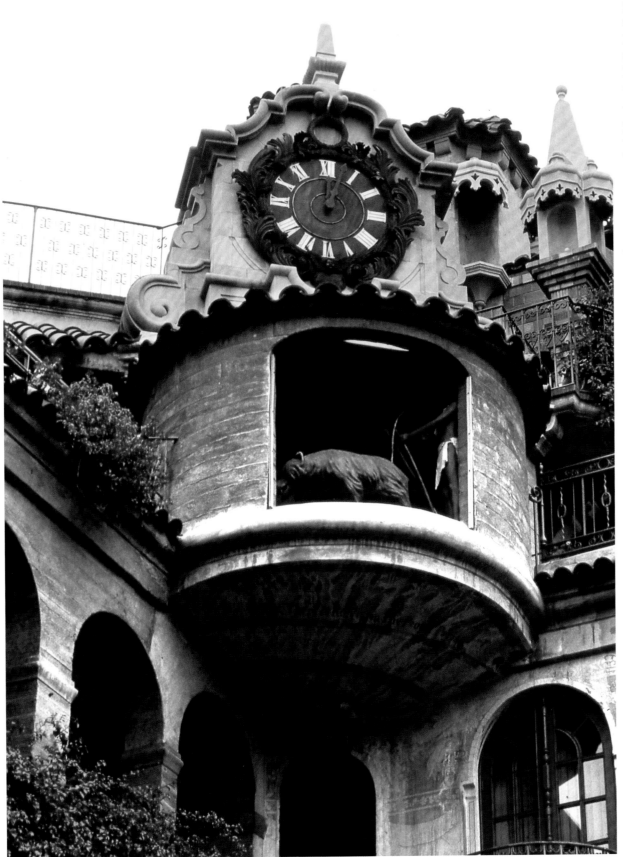

Left:
Detail,
Clock Tower,
Mission Inn, 1902-1932,
3649 Mission Inn Avenue,
Riverside,
California, USA.
Architects:
Arthur Benton,
Myron Hubbard Hunt,
and G. Stanley Wilson.

Myron Hubbard Hunt,
1868-1952,
American architect.

Other notable projects:
Huntington Art Gallery,
Ambassador Hotel,
Rose Bowl, Pasadena,
California, USA.

G. Stanley Wilson,
1879-1958, American
architect born in
Bournemouth, England.

Other notable work:
United States Post Office,
Redlands, California, USA.
Riverside Municipal
Auditorium and Soldiers'
Memorial Building,
Riverside,
California, USA.
Fruit Exchange,
Riverside, California, USA.
Corona High School,
Corona, California, USA.
Fullerton City Hall,
Fullerton, California, USA.

185

Front and side elevations,
Duncan-Irwin House,
1908,
240 N. Grand Avenue,
Pasadena,
California, USA.
Greene & Greene.

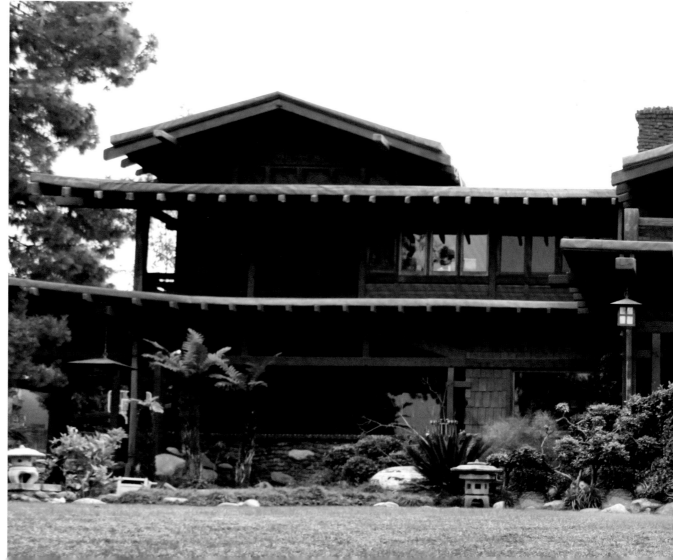

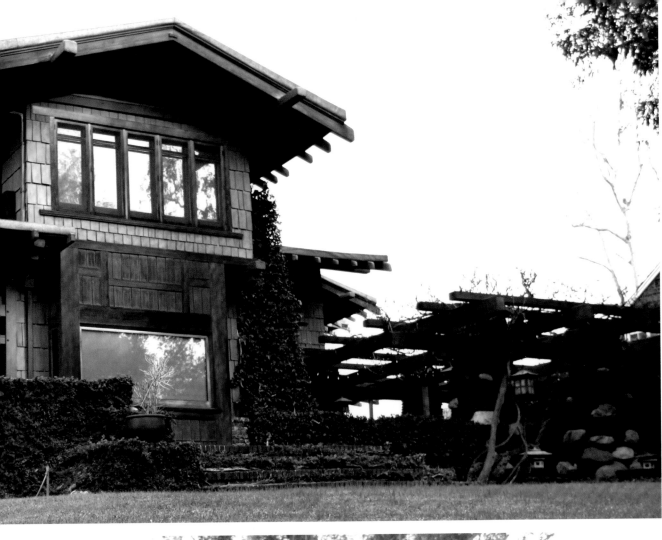

Greene & Greene,
the architectural firm
established by brothers
Charles Sumner Greene,
1868-1957, and
Henry Mather Greene,
1870-1954.
American architects,
their houses personified
the American Arts and
Crafts movement.

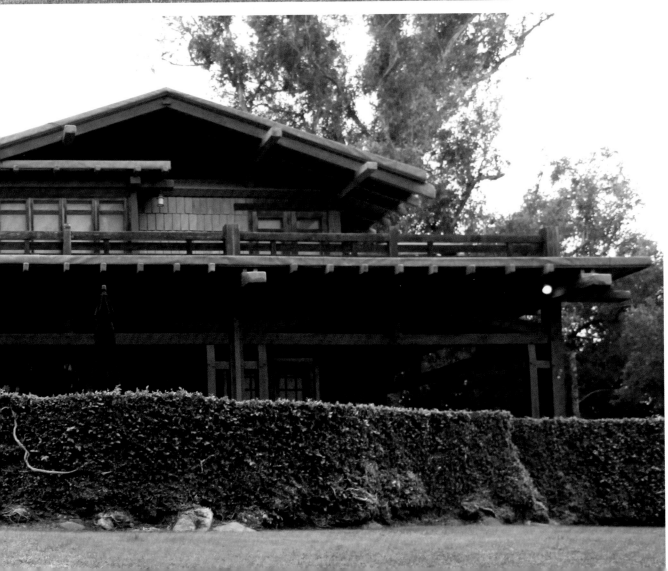

Robert Blacker House,
1907,
1177 Hillcrest Avenue,
Pasadena,
California, USA.
Architects:
Greene & Greene.

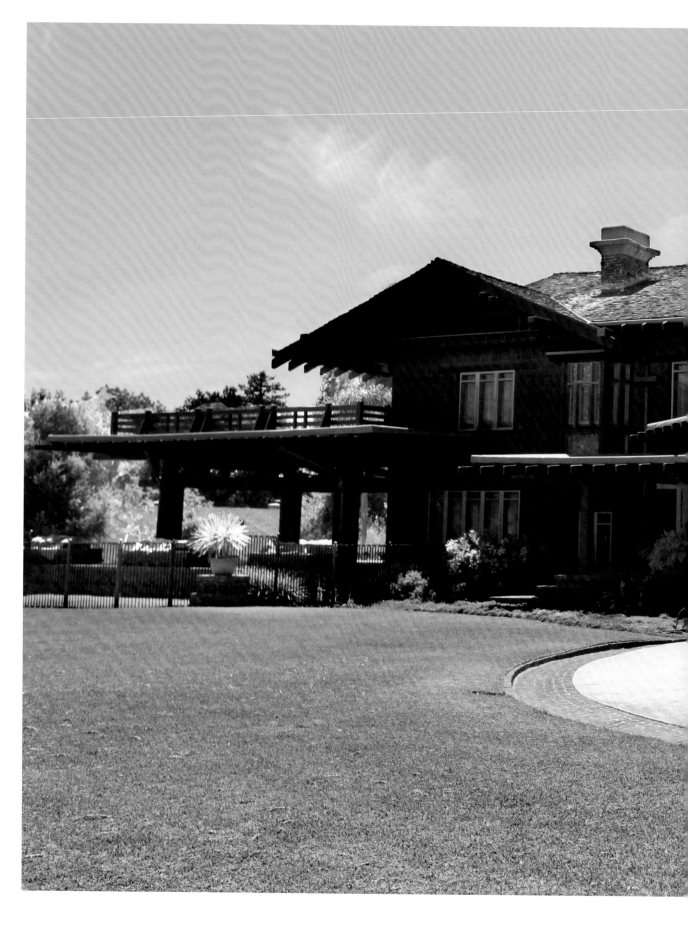

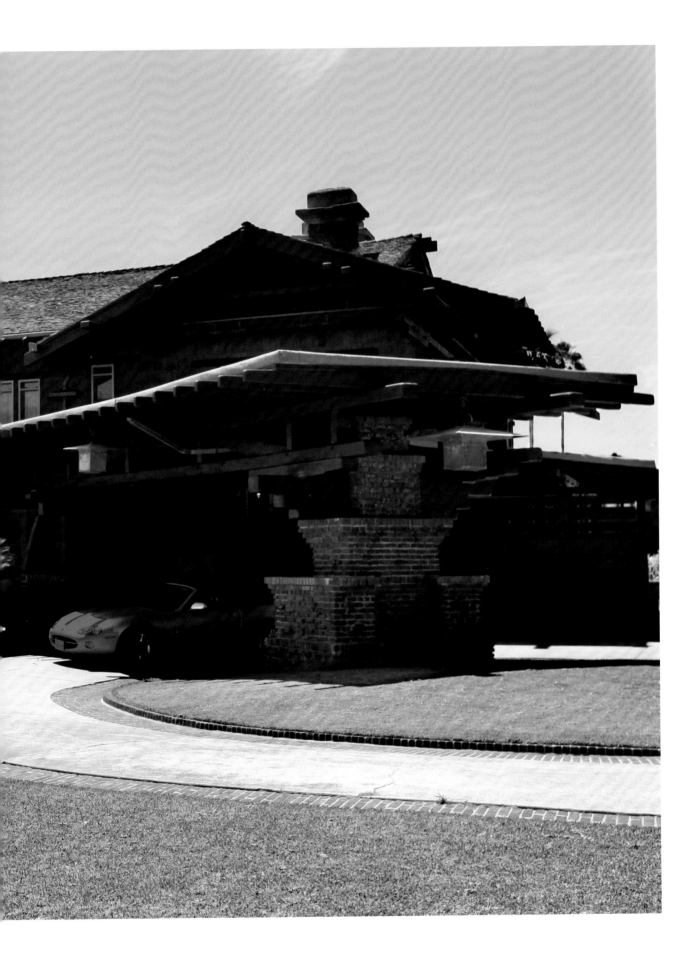

368 Arroyo Terrace,
1902,
Pasadena,
California, USA.
Architect:
Charles Summer Greene.

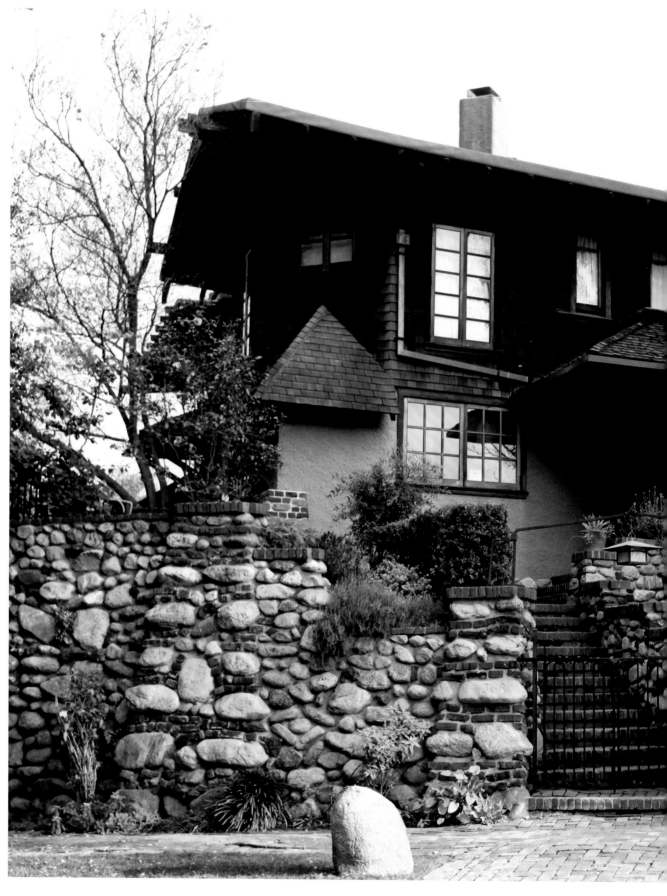

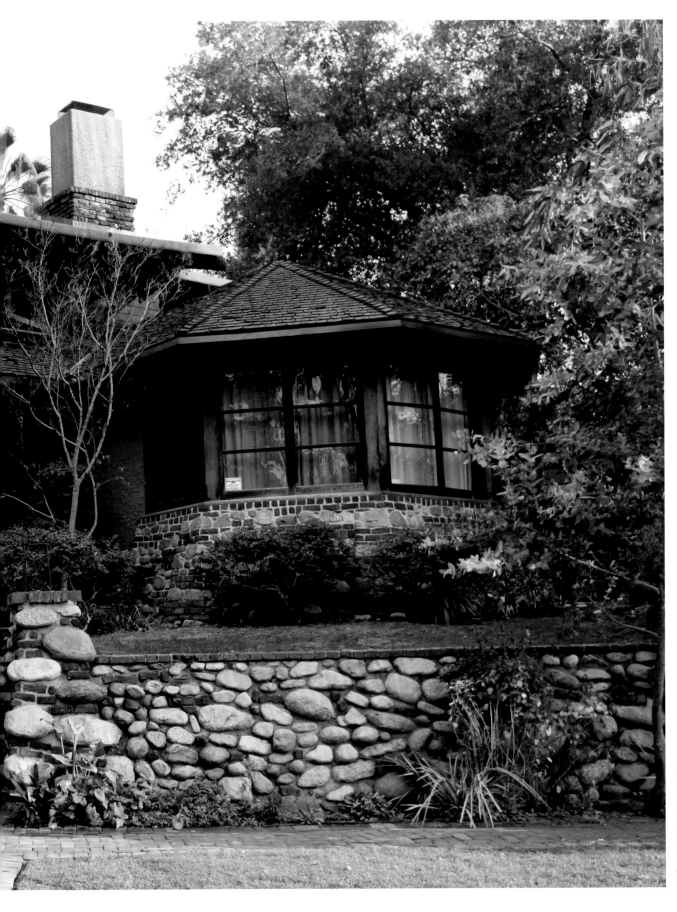

Overleaf:
Dr W. T. Bolton House,
1929,
370 W. Del Mar Blvd,
Pasadena,
California, USA.
Architects:
Greene & Greene.

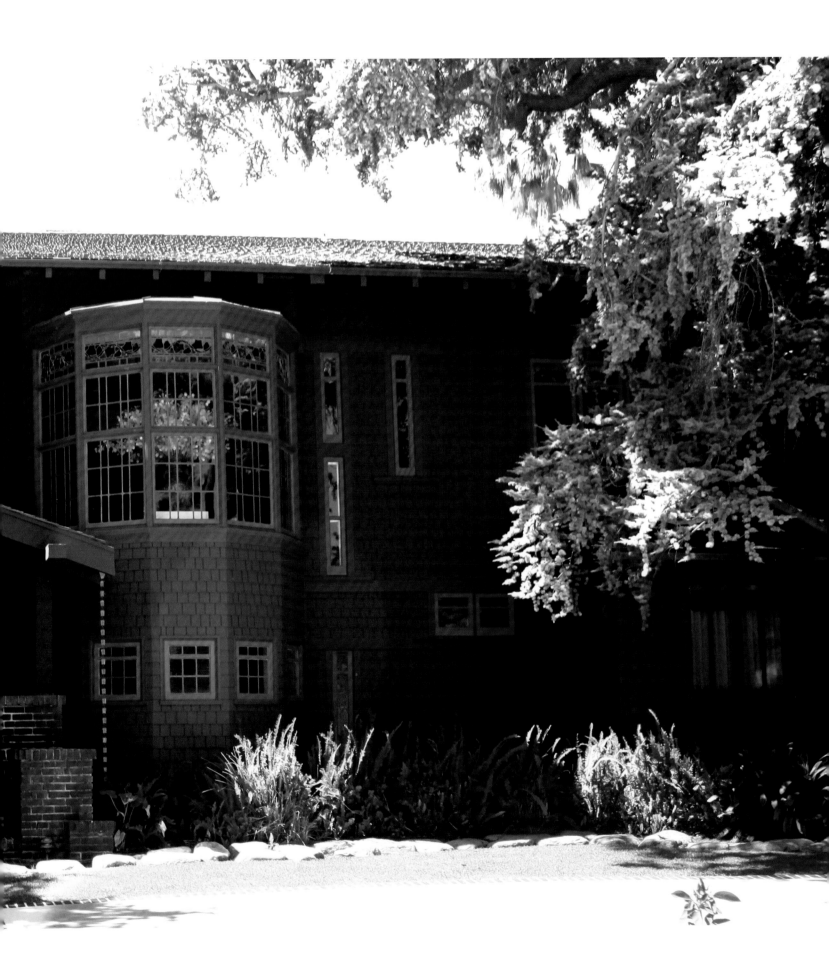

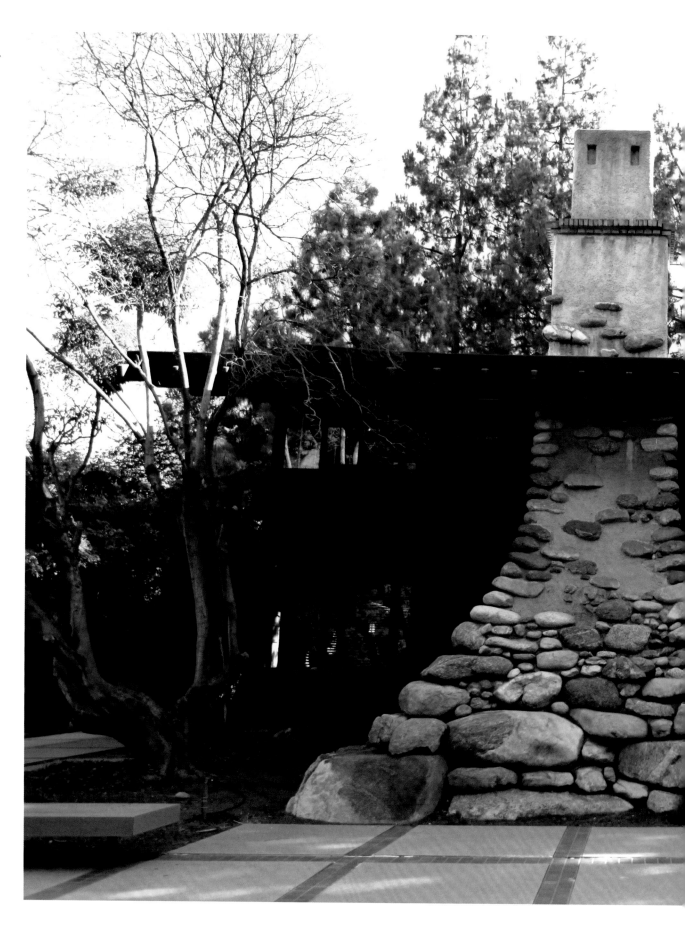

Cole House, 1906,
2 Westmoreland Place,
Pasadena,
California, USA.
Architects:
Greene & Greene.

194

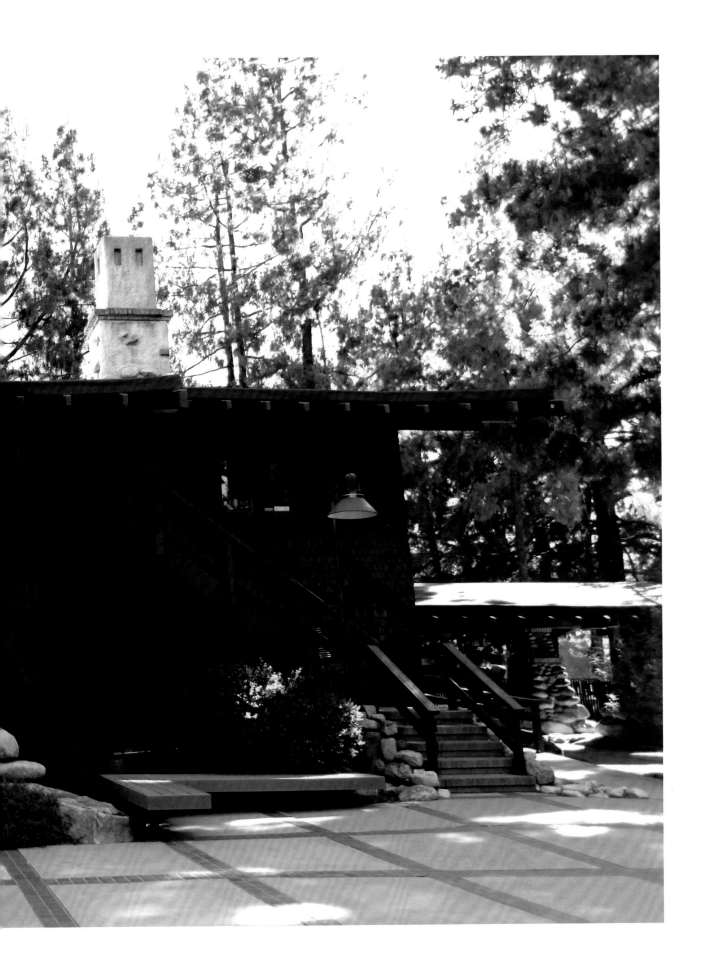

The Gamble House,
1908-09,
4 Westmoreland Place,
Pasadena,
California, USA.
Architects:
Greene & Greene.

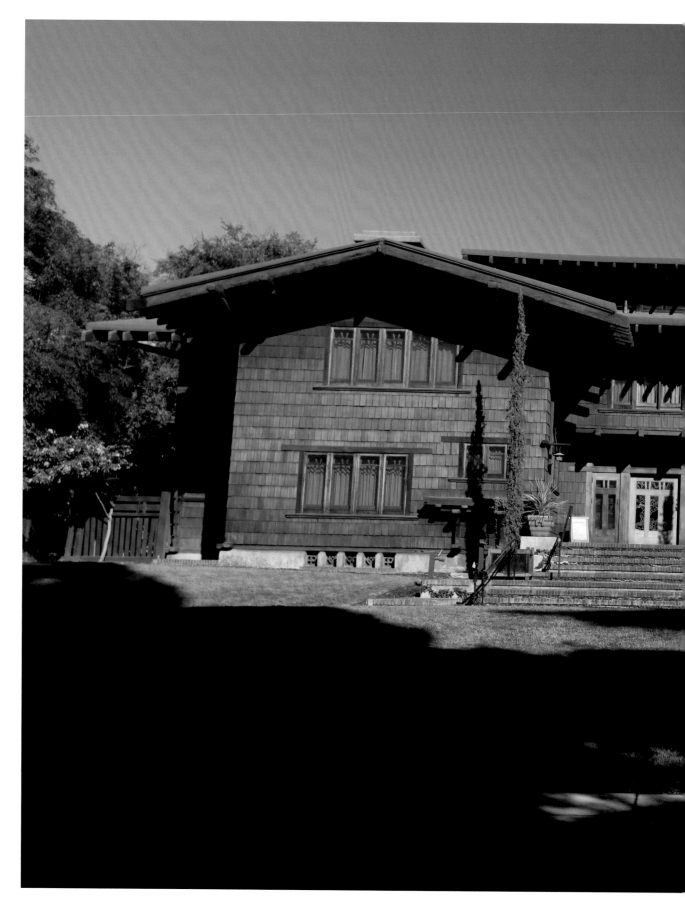

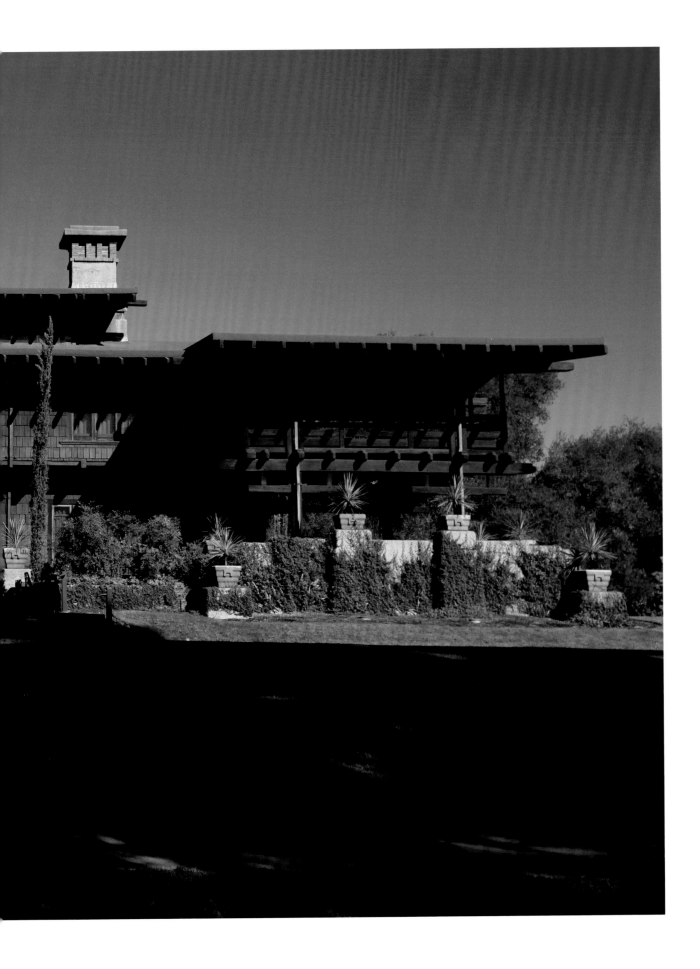

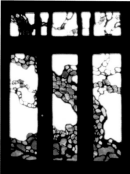

Above:
Leaded-glass window,
and right:
Front doors,
The Gamble House,
1908-09,
4 Westmoreland Place,
Pasadena,
California, USA.
Architects:
Greene & Greene.

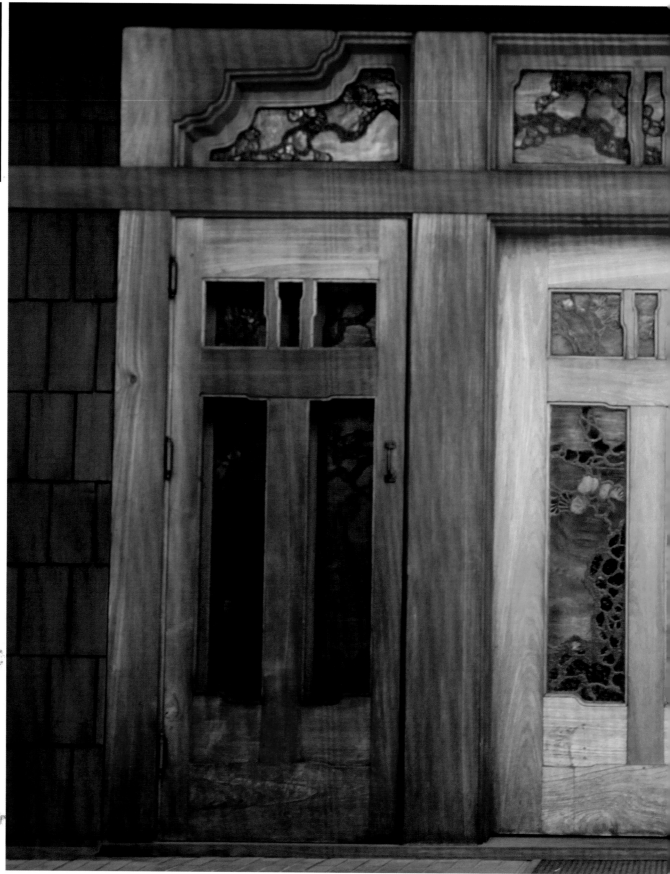

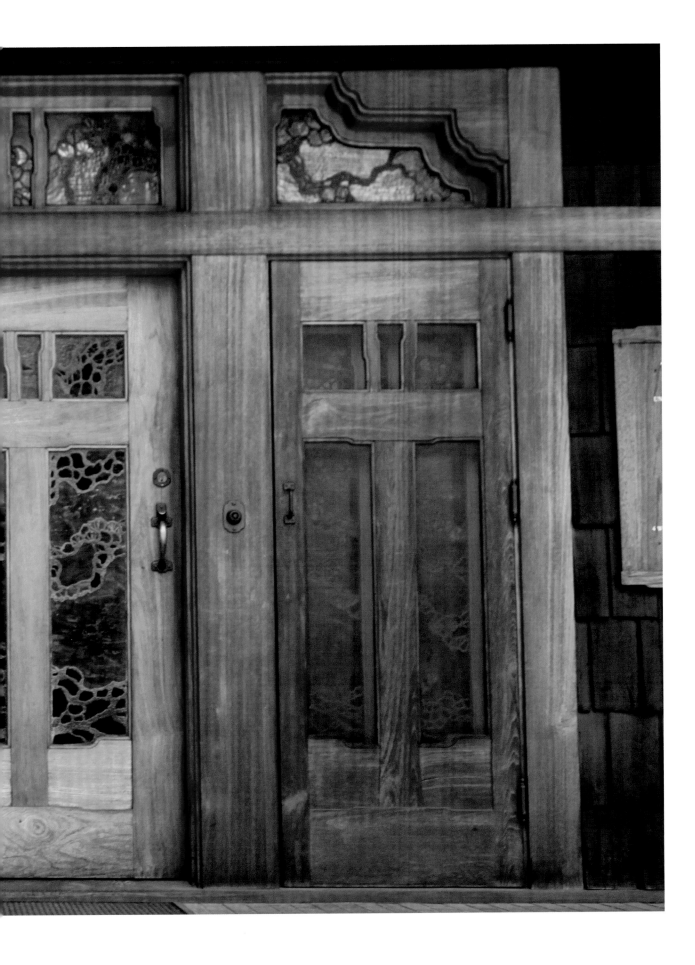

This page and opposite:
Exterior lanterns,
The Gamble House,
1908–09,
4 Westmoreland Place,
Pasadena,
California, USA.
Architects:
Greene & Greene.

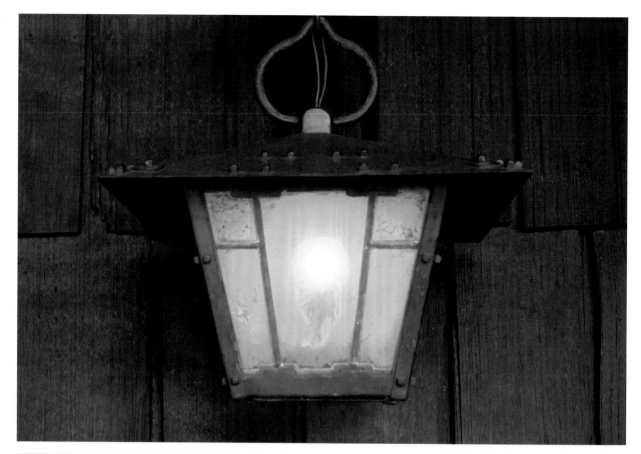

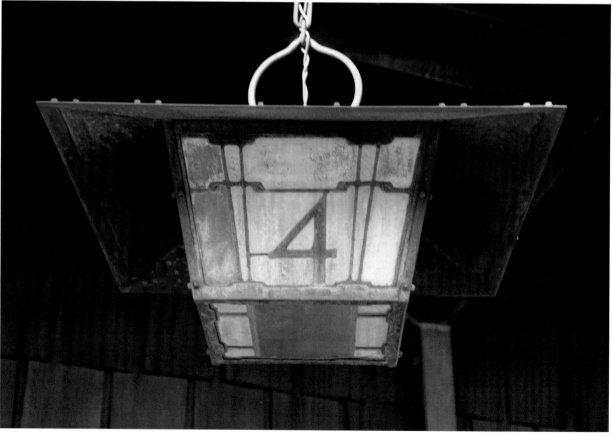

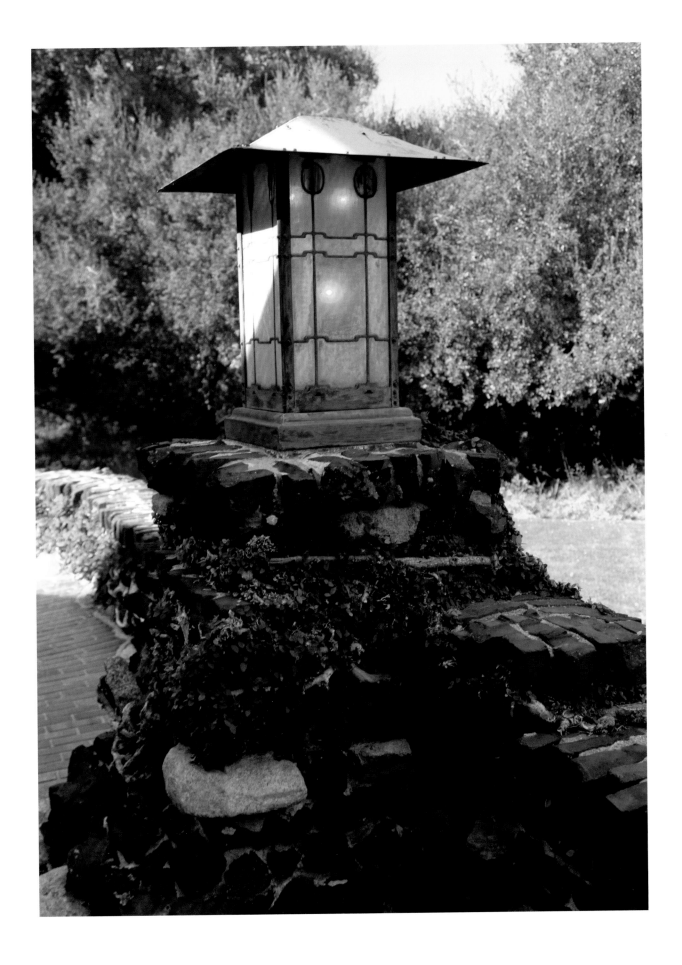

Side elevation,
The Gamble House,
1908-09,
4 Westmoreland Place,
Pasadena,
California, USA.
Architects:
Greene & Greene.

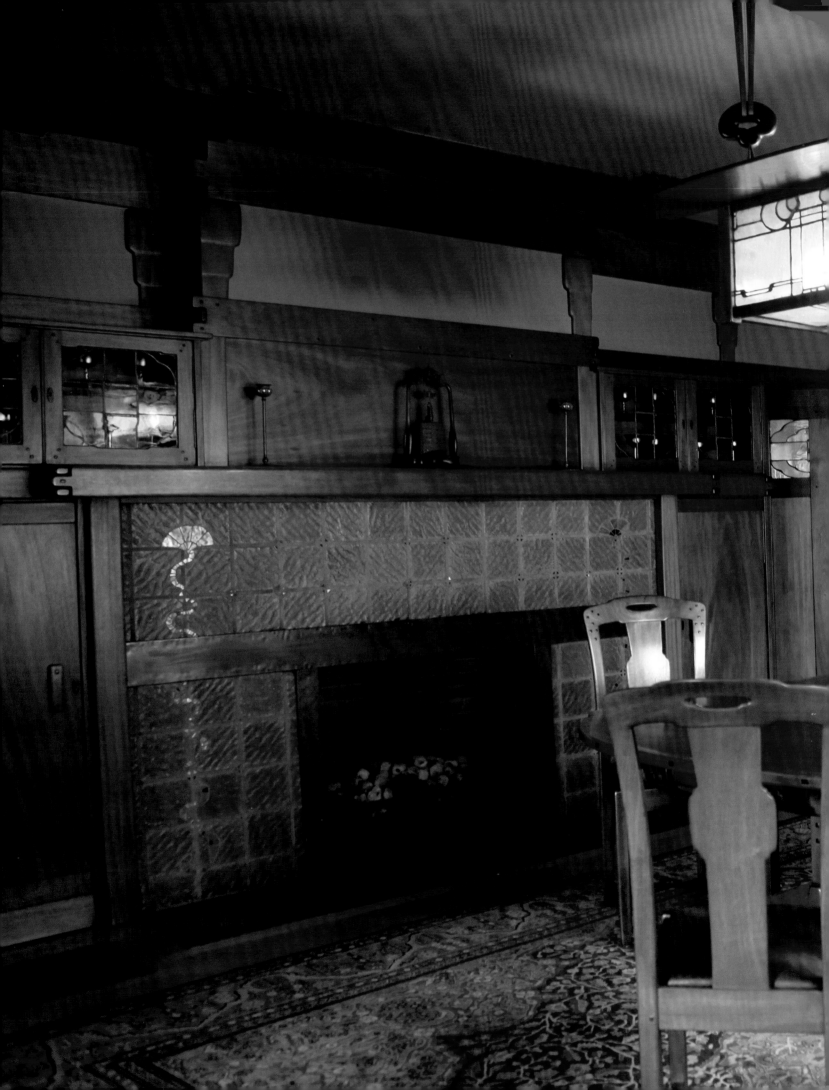

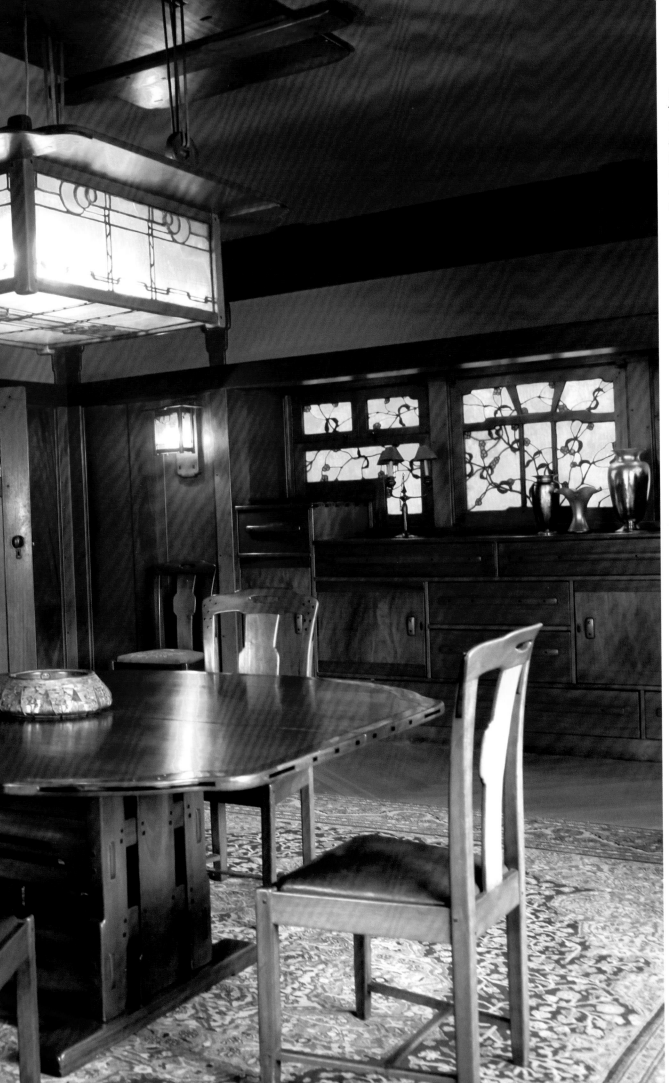

Dining room,
The Gamble House,
1908-09,
4 Westmoreland Place,
Pasadena,
California, USA.
Architects:
Greene and Greene.

Overleaf:
Sitting room,
The Gamble House,
1908-09,
4 Westmoreland Place,
Pasadena,
California, USA.
Architects:
Greene & Greene.

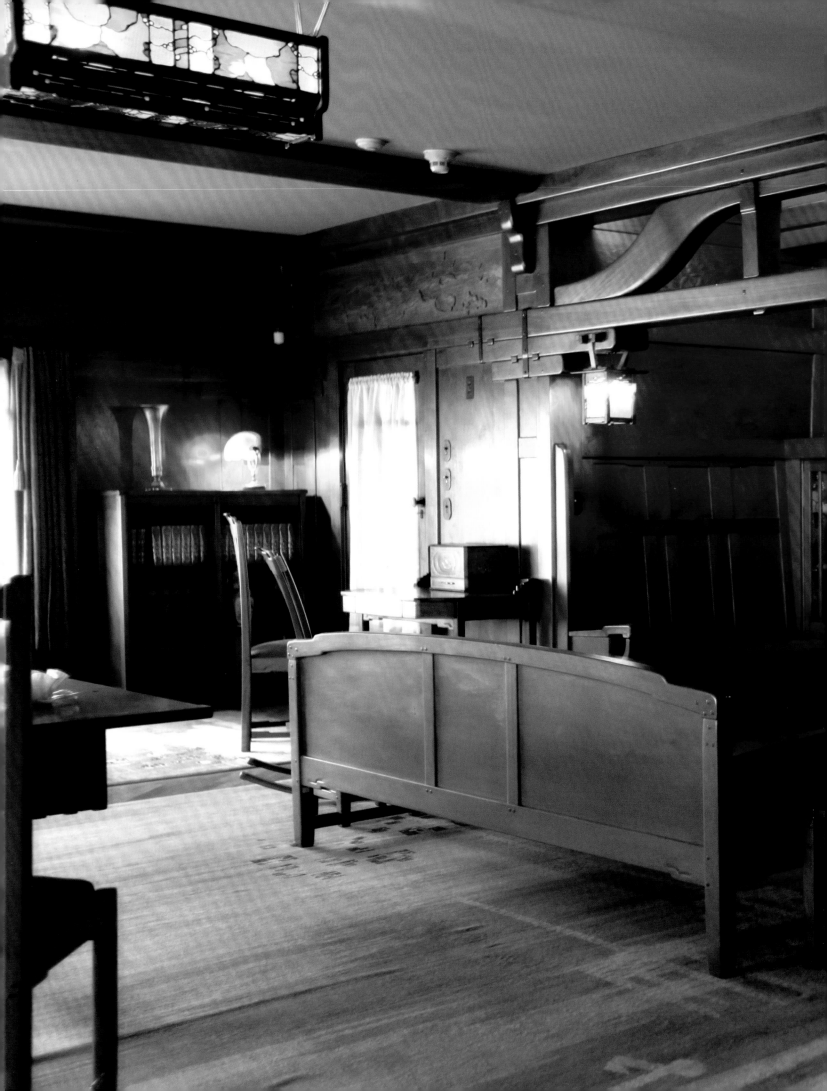

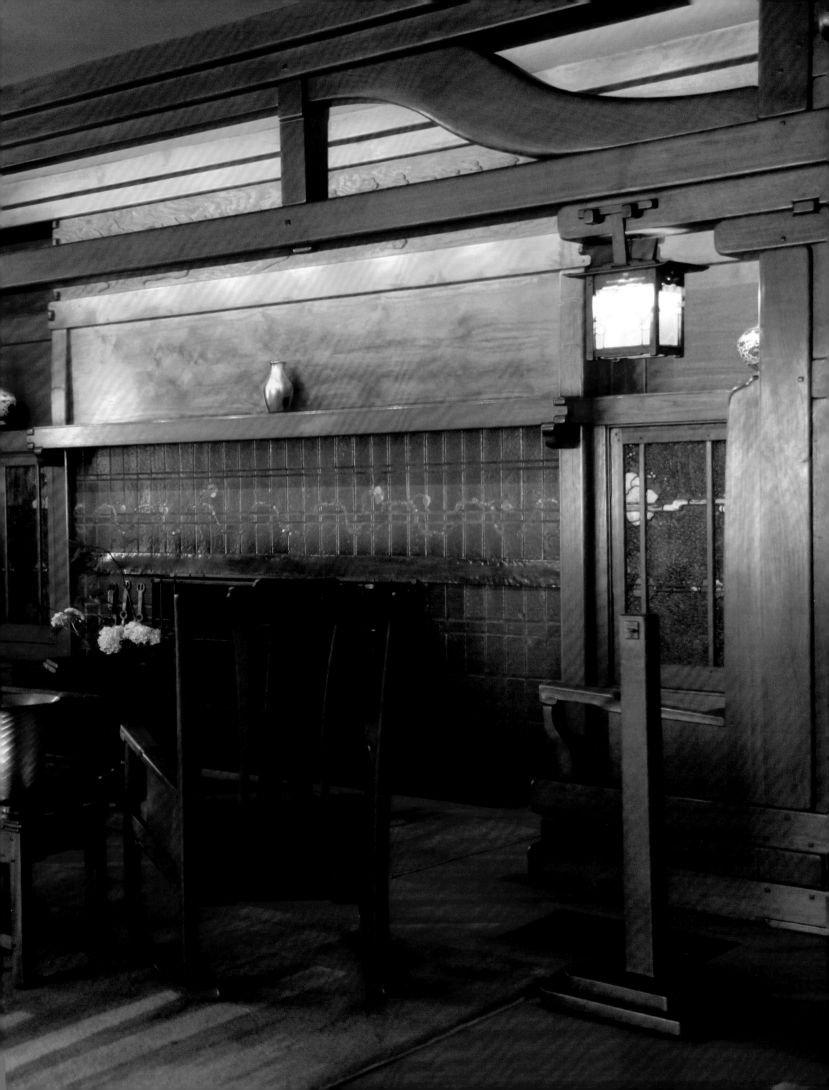

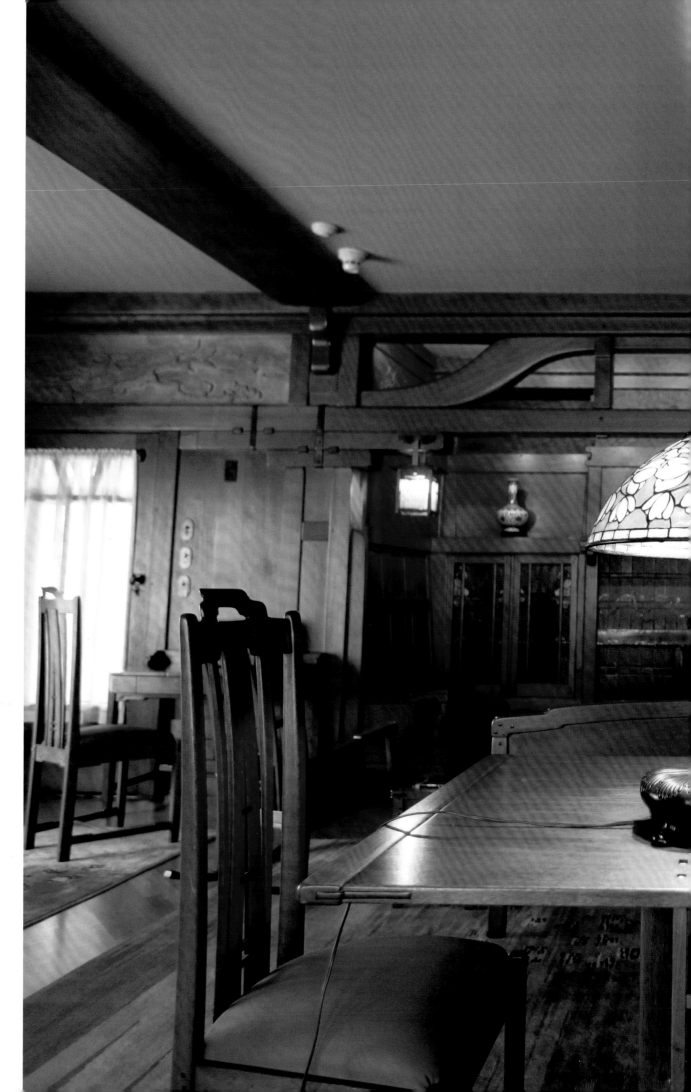

Sitting room,
The Gamble House,
1908-09,
4 Westmoreland Place,
Pasadena,
California, USA.
Architects:
Greene & Greene.

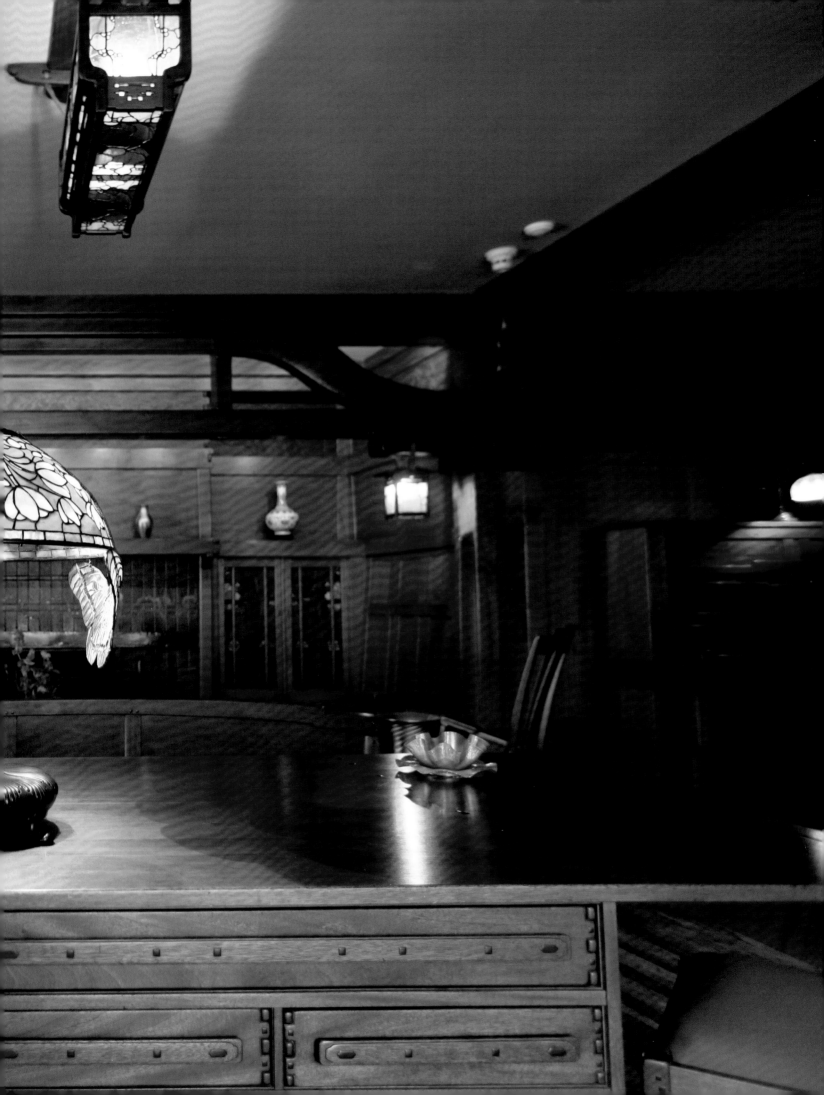

Detail,
dining room,
The Gamble House,
1908-09,
4 Westmoreland Place,
Pasadena,
California, USA.
Architects:
Greene & Greene.

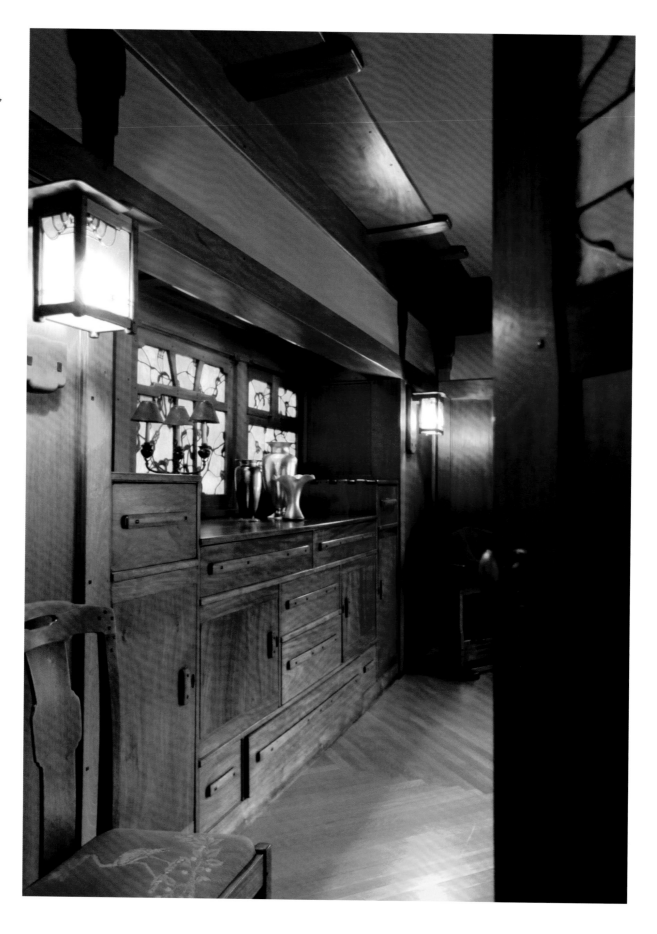

210

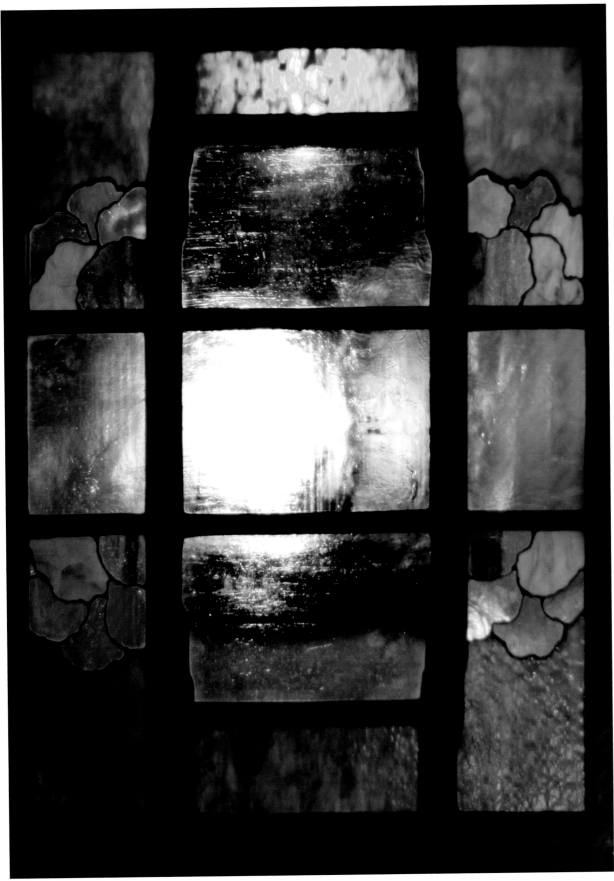

Stained-glass window,
stairwell,
The Gamble House,
1908-09,
4 Westmoreland Place,
Pasadena,
California, USA.
Architects:
Greene & Greene.

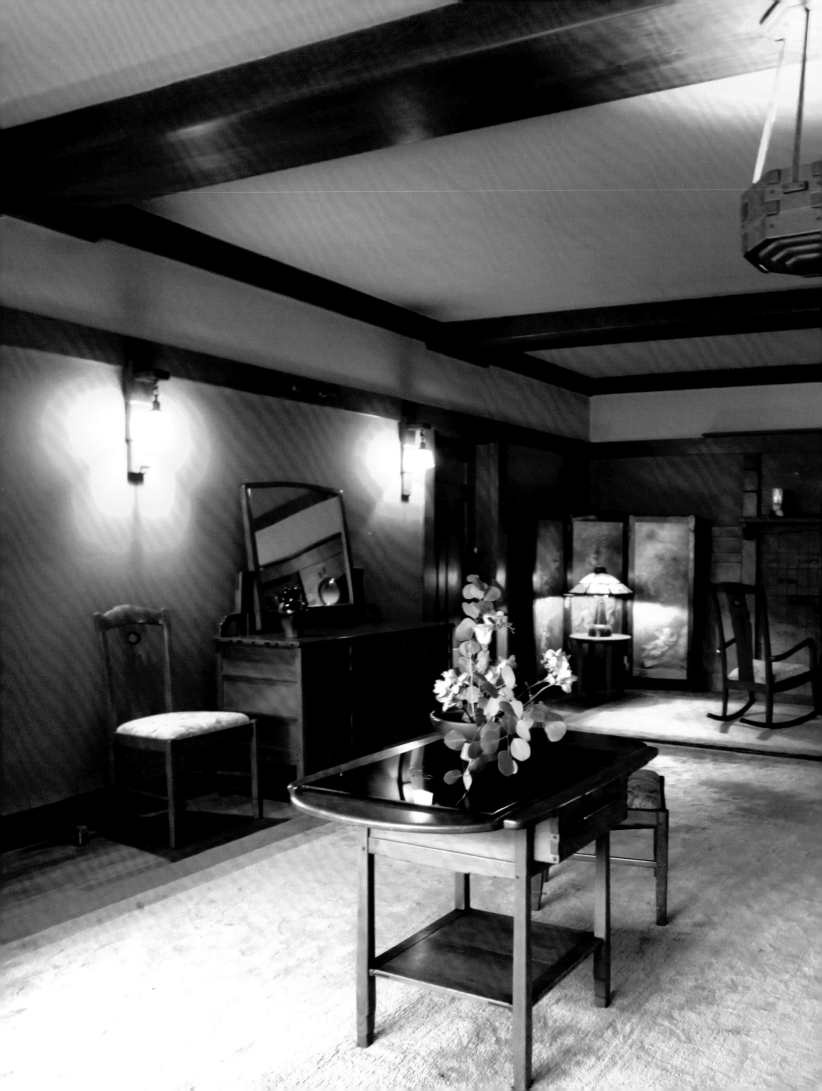

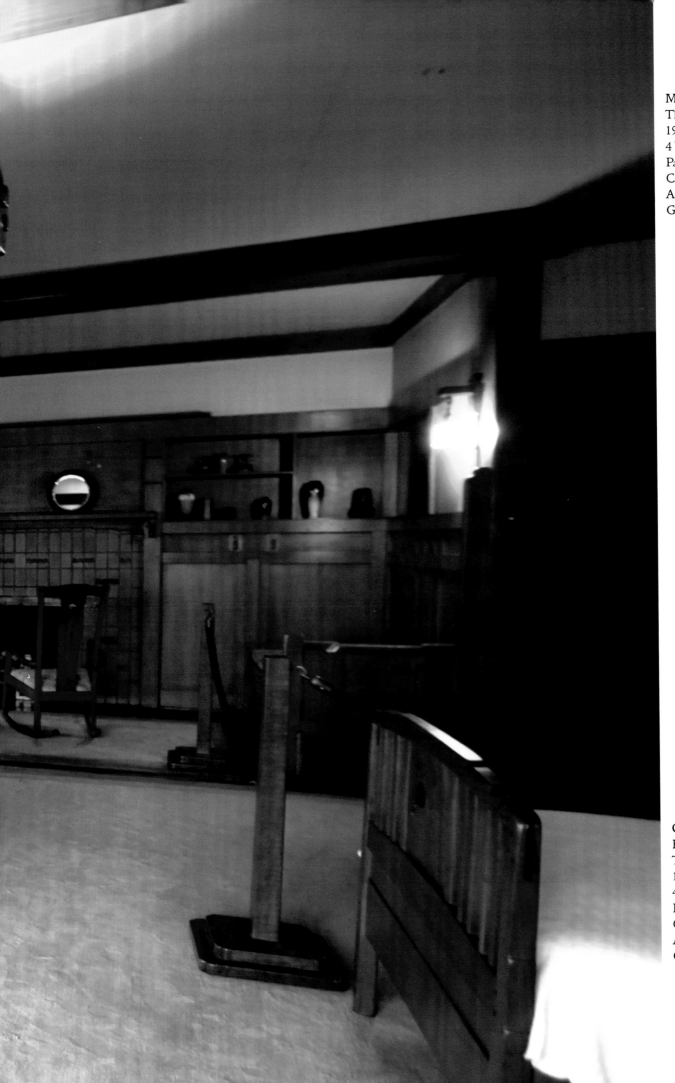

Main bedroom,
The Gamble House,
1908-09,
4 Westmoreland Place,
Pasadena,
California, USA.
Architects:
Greene & Greene.

Overleaf:
Fireplace, bedroom,
The Gamble House,
1908-09,
4 Westmoreland Place,
Pasadena,
California, USA.
Architects:
Greene & Greene.

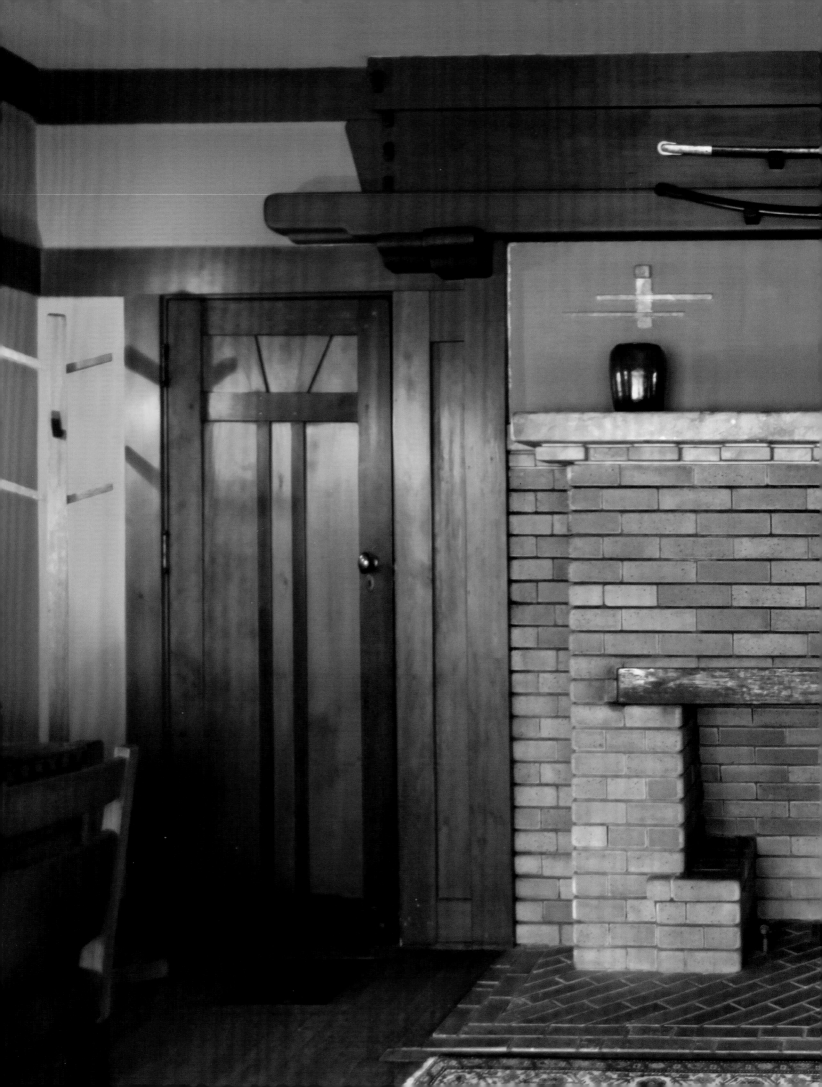

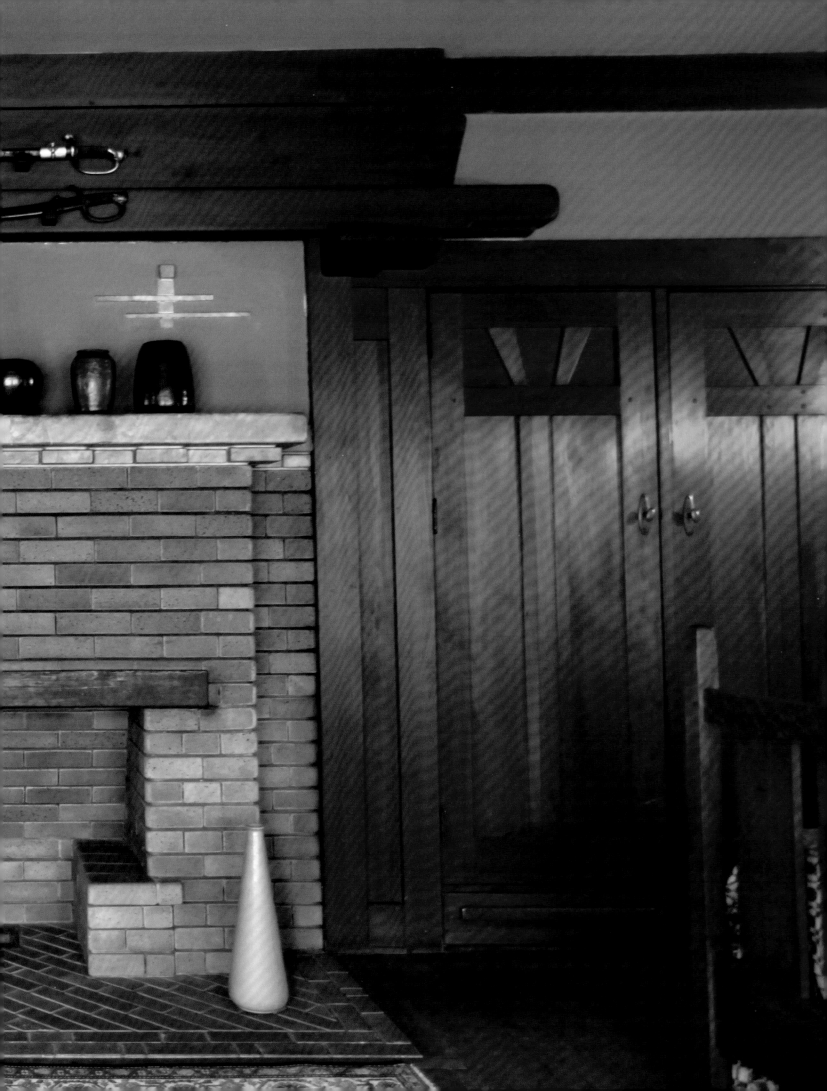

Above:
United States Postal
Service stamp.

Right:
Living room,
Stained-glass window,
The Aline Barnsdall
Hollyhock House,
1919–1921,
Barnsdall Art Park,
4800 Hollywood Blvd,
Los Angeles,
California, USA.
Architect:
Frank Lloyd Wright.

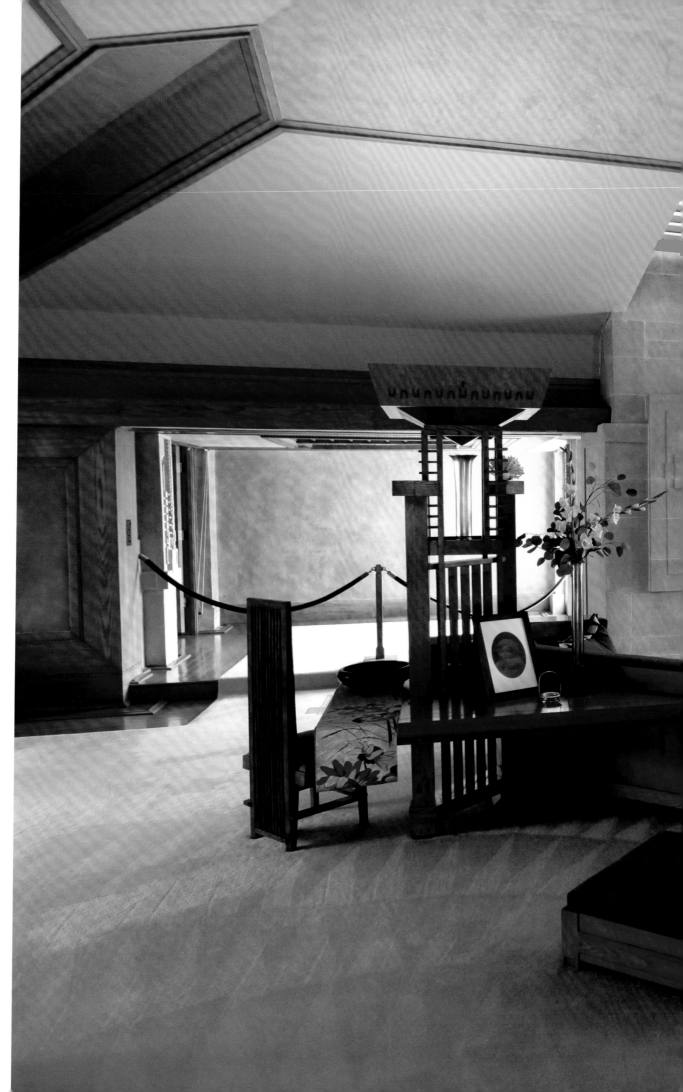

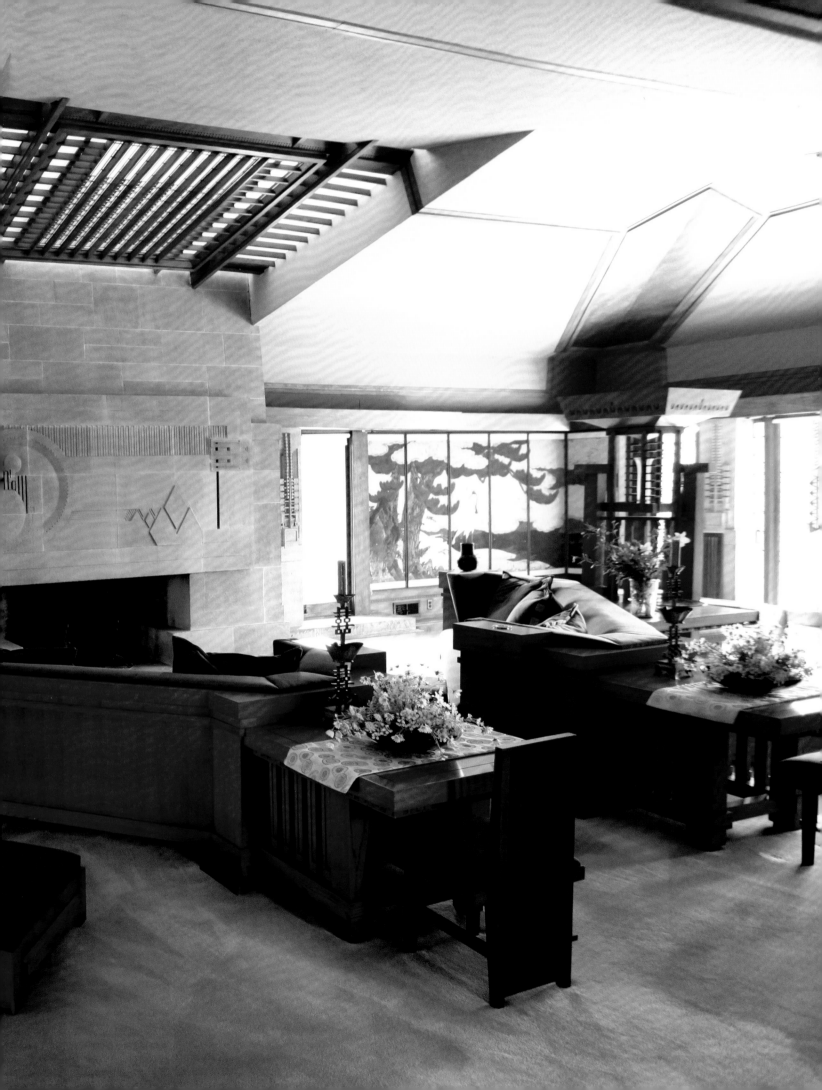

"Earth",
concrete bas-relief
fireplace.
Designer:
Frank Lloyd Wright.
The Aline Barnsdall
Hollyhock House,
1919-1921,
Barnsdall Art Park,
4800 Hollywood Blvd,
Los Angeles,
California, USA.
Architect:
Frank Lloyd Wright.

Frank Lloyd Wright,
1867-1959. American
architect, interior
designer, writer
and educator.

Other notable structures:
Fallingwater, Taliesin,
Frank Lloyd Wright
House,
Storer House and
Ennis House,
Los Angeles,
California, USA.

"The space within
becomes the reality
of the building."

"The architect should
strive continually to
simplify; the ensemble
of the rooms should then
be carefully considered
that comfort and utility
may go hand in hand
with beauty."

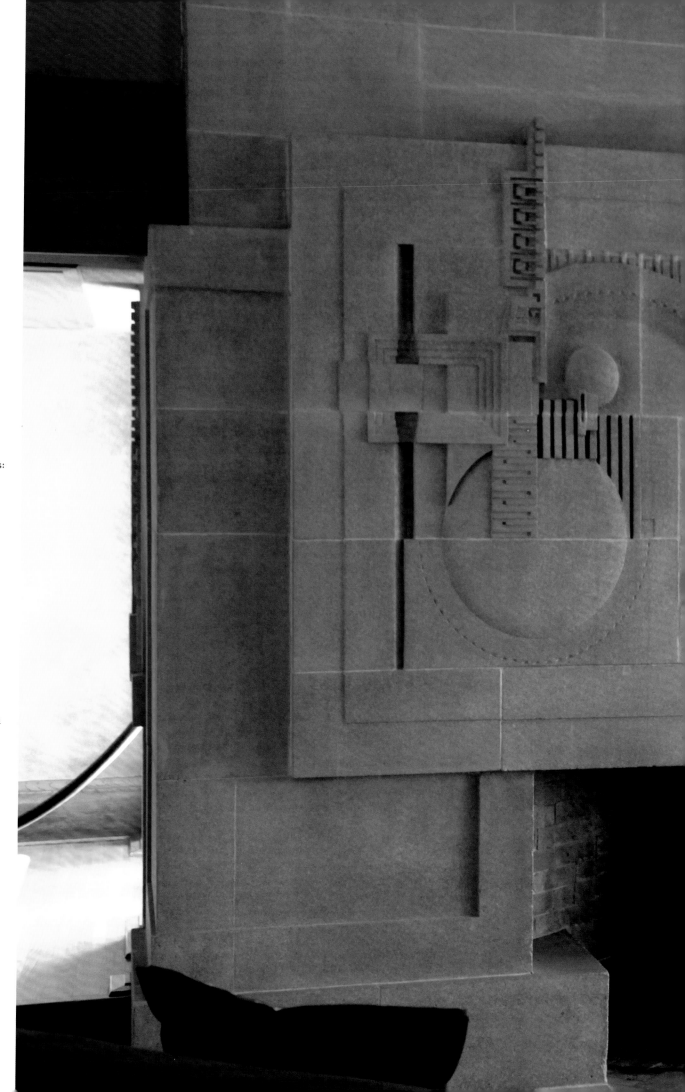

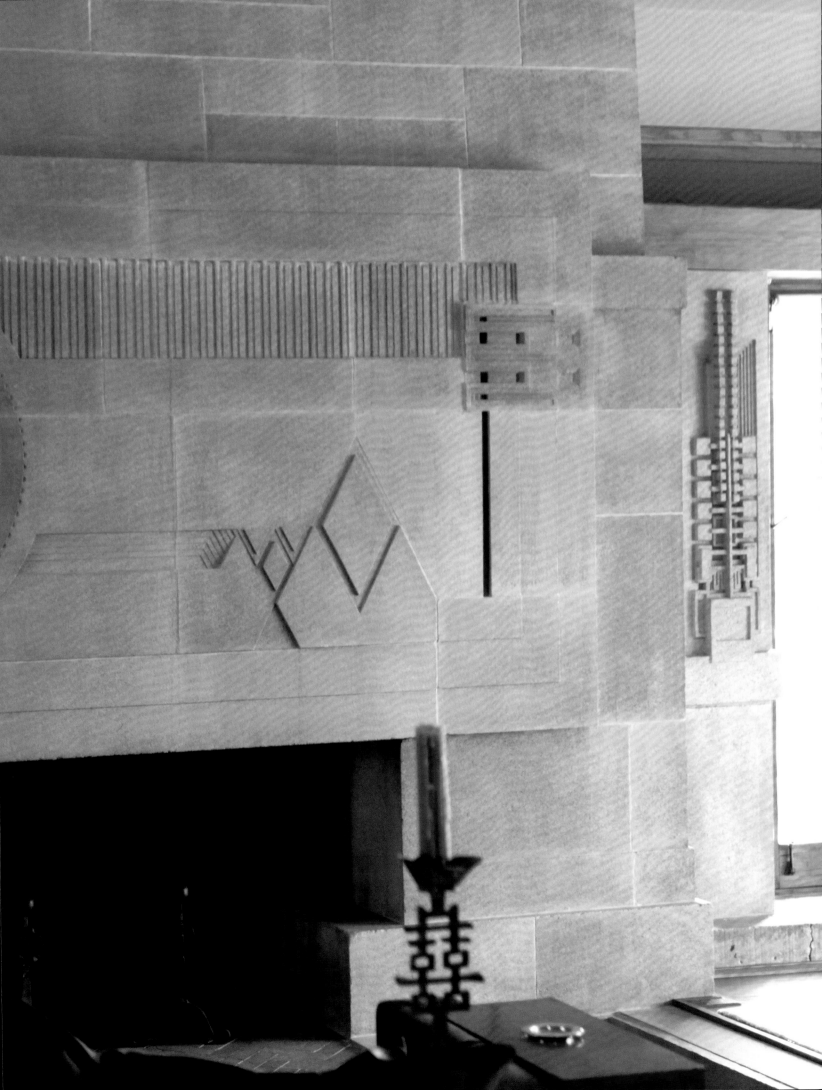

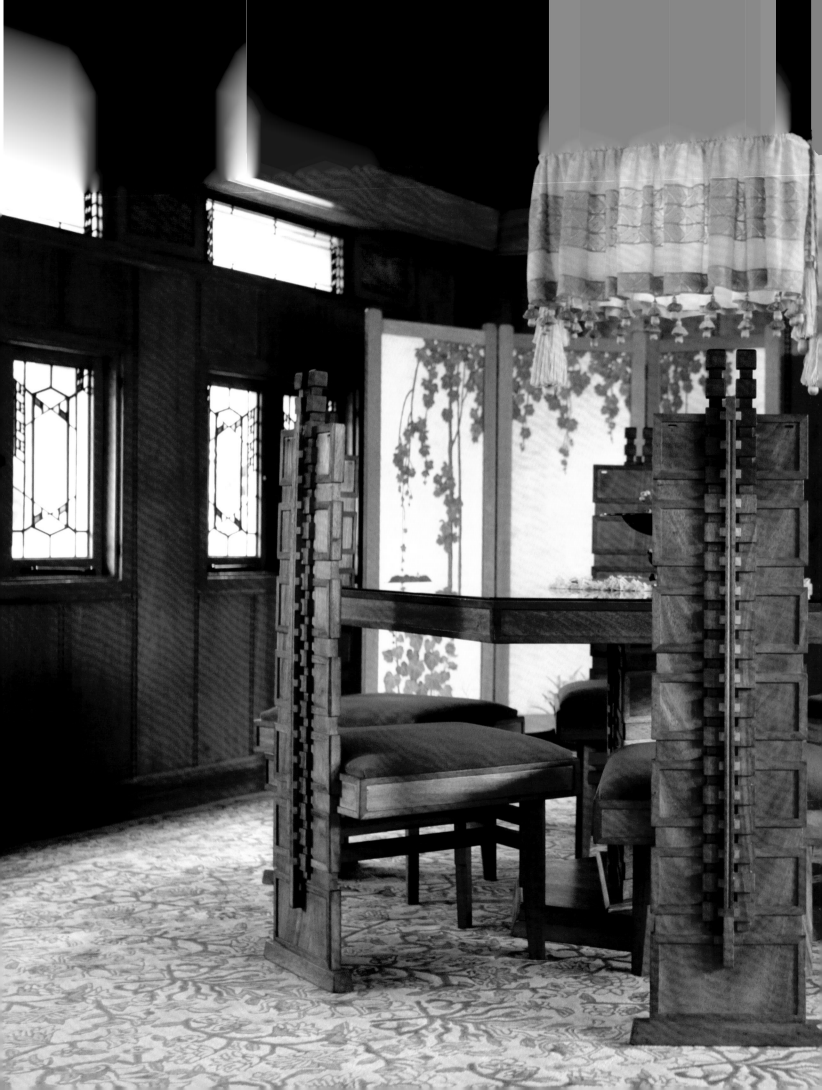

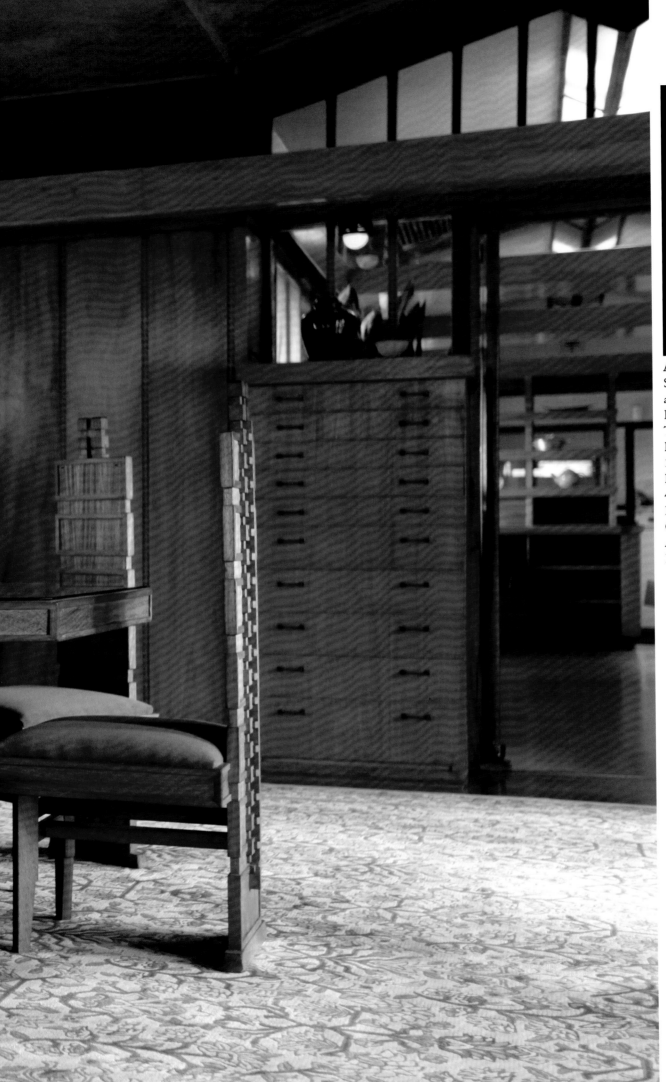

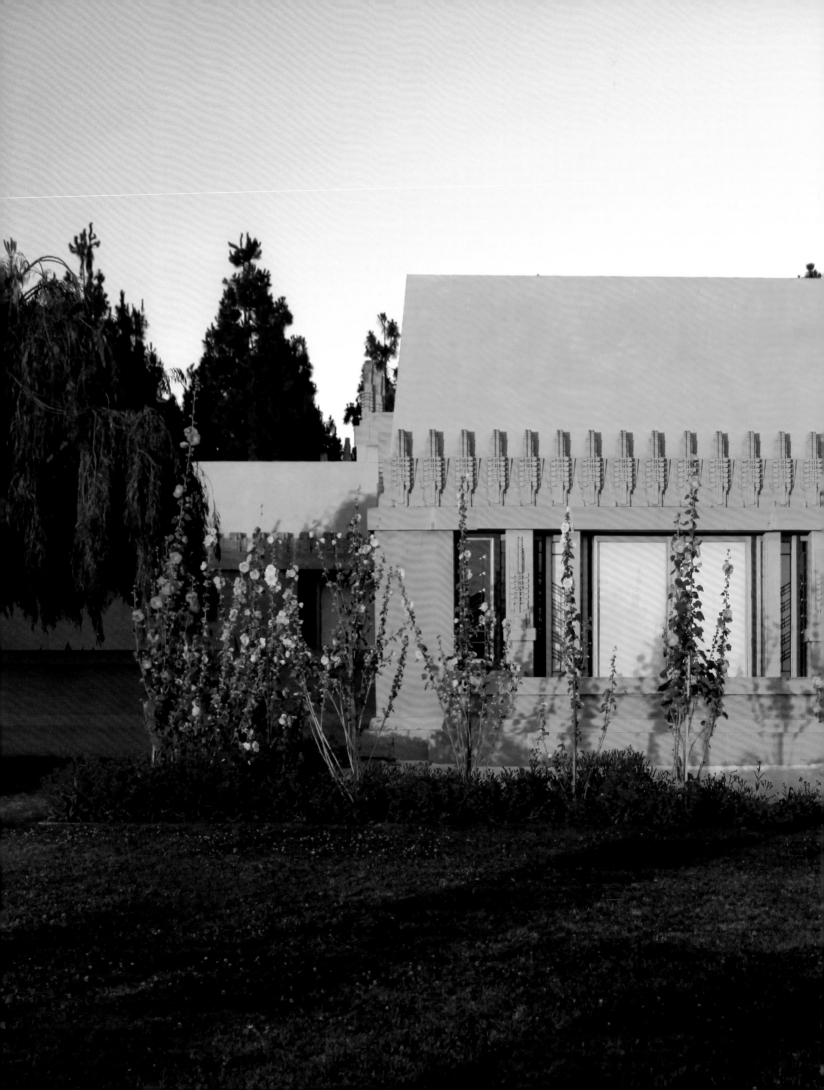

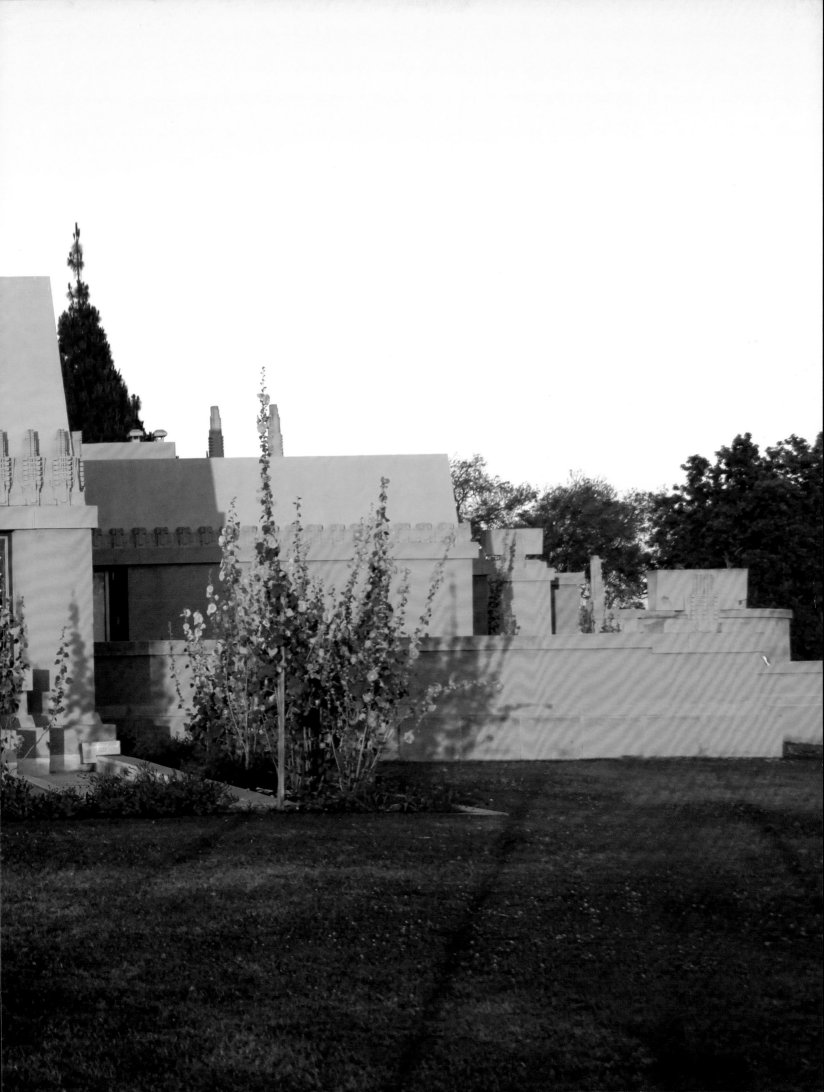

Cast concrete
decorative sculpture,
The Aline Barnsdall
Hollyhock House,
1919–1921,
Barnsdall Art Park,
4800 Hollywood Blvd,
Los Angeles,
California, USA.
Architect:
Frank Lloyd Wright.

"When we build, let
us think that we build
forever. Let it not be for
present delight nor for
present use alone. Let
it be such work as our
descendants will thank
us for; and let us think,
as we lay stone on stone,
that a time is to come
when those stones will be
held sacred because our
hands have touched them,
and that men will say, as
they look upon the labor
and wrought substance
of them. 'See! This our
father did for us.'"
— John Ruskin.

Acknowledgments:
Gamble House.
Glasgow School of Art.
Hollyhock House.
Holy Trinity Church.
The Huntington Library,
Art Collections and
Botanical Gardens.
Red House.
Bradford Museum
and Library.
James Brazier.

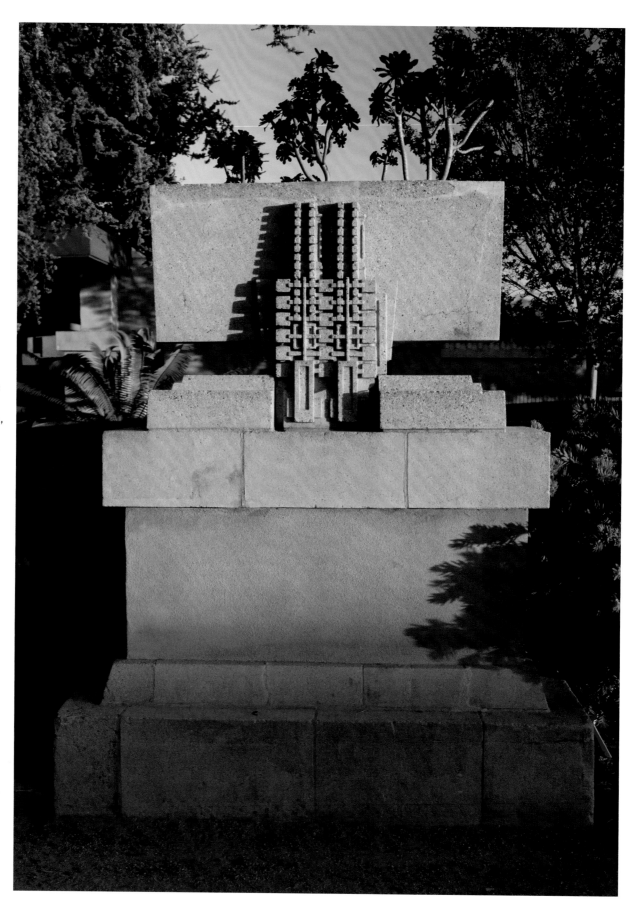